THE EVERYTHING
Photography
Book

Dear Reader,

Since I first picked up a camera at the age of ten, I've thought that taking photographs is a little bit like being a magician—time-consuming and sometimes tricky, but well worth the effort.

When you have successfully captured a fleeting moment in time, you will never be the same. You are not only an artist, but a historian as well. You've captured a unique event that will become increasingly precious and significant as the years pass.

Whether you are just taking up photography or have been shooting for a while, you undoubtedly have some questions about the whole process. There is a learning curve as you master the technical side of any skill, and there are many tips and techniques that can transform you from average to excellent.

That is where *The Everything*® *Photography Book, 2nd Edition* will help. Regardless of your skill level, you will find something useful in this book. My goal has been to present the information in a very accessible way, which will allow you to expand your expertise quickly.

It is my hope that as photographers transition from analog to digital cameras, more and more people will acquire an interest in photography, its history, and its future. This wonderful new technology allows you to take your pictures into a digital darkroom, where the only limitations are your imagination and technical skills. Even professional photographers who have been involved with film for decades find they can scan their prints and breathe new life and artistry into them in the digital darkroom.

I cordially invite you to visit my website, *www.mellissart.com*, to see my work, talk about your own work, or to chat about any questions or comments you may have about this book.

Melissa Martin Ellis

Welcome to the EVERYTHING® Series!

These handy, accessible books give you all you need to tackle a difficult project, gain a new hobby, comprehend a fascinating topic, prepare for an exam, or even brush up on something you learned back in school but have since forgotten.

You can choose to read an *Everything*® book from cover to cover or just pick out the information you want from our four useful boxes: e-questions, e-facts, e-alerts, and e-ssentials.

We give you everything you need to know on the subject, but throw in a lot of fun stuff along the way, too.

We now have more than 400 *Everything*® books in print, spanning such wide-ranging categories as weddings, pregnancy, cooking, music instruction, foreign language, crafts, pets, New Age, and so much more. When you're done reading them all, you can finally say you know *Everything*®!

QUESTIONS?
Answers to
common questions

FACTS
Important snippets
of information

ALERTS!
Urgent
warnings

ESSENTIALS
Quick
handy tips

PUBLISHER Karen Cooper

DIRECTOR OF ACQUISITIONS AND INNOVATION Paula Munier

MANAGING EDITOR, EVERYTHING SERIES Lisa Laing

COPY CHIEF Casey Ebert

ACQUISITIONS EDITOR Katrina Schroeder

DEVELOPMENT EDITOR Elizabeth Kassab

EDITORIAL ASSISTANT Hillary Thompson

Visit the entire Everything® series at *www.everything.com*

THE
EVERYTHING®
PHOTOGRAPHY BOOK
2nd Edition

Foolproof techniques for taking sensational
digital and 35mm pictures

Melissa Martin Ellis

Avon, Massachusetts

This book is dedicated to my mother, Mary Gibbons Martin, whose beautiful face inspired my first pictures; to the very talented Mark Ellis, my husband, who has patiently and tirelessly supported all my artistic endeavors; and to my dear daughter, Deirdre DeLay, a never-failing source of artistic inspiration and knowledge.

An Everything® Series Book.
Everything® and everything.com® are registered trademarks of F+W Media, Inc.

Published by Adams Media, a division of F+W Media, Inc.
57 Littlefield Street, Avon, MA 02322 U.S.A.
www.adamsmedia.com

ISBN 10: 1-59869-575-4
ISBN 13: 978-1-59869-575-5

Printed in the United States of America.

J I H G F E D C B A

Library of Congress Cataloging-in-Publication Data
is available from the publisher.

This publication is designed to provide accurate and authoritative information with regard to the subject matter covered. It is sold with the understanding that the publisher is not engaged in rendering legal, accounting, or other professional advice. If legal advice or other expert assistance is required, the services of a competent professional person should be sought.

—From a *Declaration of Principles* jointly adopted by a Committee of the American Bar Association and a Committee of Publishers and Associations

Many of the designations used by manufacturers and sellers to distinguish their products are claimed as trademarks. Where those designations appear in this book and Adams Media was aware of a trademark claim, the designations have been printed with initial capital letters.

Photographs by Melissa Martin Ellis.
Laughing baby photo © iStockphoto/brebca

*This book is available at quantity discounts for bulk purchases.
For information, please call 1-800-289-0963.*

Contents

Acknowledgments

Special thanks are in order to everyone who helped make this process go so smoothly, but extra special thanks go out to my husband, Mark Ellis, my editor, Kerry Smith, and my agent, Gina Panettieiri, for all their support and good advice.

Also, many thanks are due the members of the Photographers' Guild of the Newport Art Museum for years of inspiration, guidance, and camaraderie. Friends and Guild officers Don Jagoe and Sylvia Hampton have been particularly supportive and savvy. I am also grateful to Betty Lou Wright, who raced to my rescue with the loan of her Graflex box camera when mine was nowhere to be found.

Where would a photographer be without models? Many thanks to Kevin and Stephanie Bongiovanni and their photogenic sons, Avery and Evan; more thanks go to the boys' grandparents, Paul and Linda Bongiovanni and Dennis and Anne Poole, who also appear.

Finally, many thanks to Emily Chenault and her parents, Stacey and Mark, and Queli and Tommy Grimes's parents, Martin and Heather, who graciously gave permission for their children's appearances in this book.

Top Ten Things You Should Know about Photography

1. You can become a good photographer, armed with the right equipment, mindset, and knowledge.

2. Choosing the appropriate camera—the one you will be comfortable with and use frequently—is the key to quickly gaining new photographic skills.

3. Choosing the right lens and other photographic accessories is essential. Learn how to buy lenses and other equipment you'll actually use.

4. Reference material is vital to becoming a good photographer. Find out where to find books and magazines that will help you answer your questions and address any problems.

5. Learn about light and lighting—if you understand the impact light has on all your shots, you are in control.

6. Learn the rules of good composition. They're not hard to master, and they can transform your style in no time.

7. Shutter speeds and aperture aren't hard to understand. They will be explained in terms that will make them clear, even if you are currently using a point-and-shoot camera.

8. What kind of shooter are you: Plain or artsy? Landscape or portrait? Conventional or digital? Amateur or pro? You'll soon know the answer to that question.

9. Learning to use digital technology and digital darkrooms—even if you shoot film—will strengthen your artistic endeavors. The new technology can transform your photographs.

10. Printing and exhibiting your work isn't hard, but it helps to know exactly what approach works best.

Introduction

▶ PHOTOGRAPHY IS BOTH a science and an art. Luckily, you don't have to enroll in a physics course to be able to take good pictures. Today's cameras—both film and digital—are sophisticated electronic devices with tiny computers built into them. These little brains figure out the many variables involved in taking pictures so you don't have to. They allow beginning photographers to take the sort of photos that master photographers could barely achieve a century ago.

We have come a very long way technologically in a short time, and there is every reason to believe that we will achieve breakthroughs that are even more amazing in the near future. However, all of the innovations in the world cannot replace the human element in photography. Only the human factor can breathe true heart and soul into a picture. The vision and enthusiasm of the photographer are what truly make all photos come to life. Only practice and perseverance can give the photographer the experience necessary to capture a moment in time.

Integral to the process is one important insight: Photography is not just record keeping; it is an art form that speaks to the ages. As twentieth-century photographer Henry Cartier-Bresson said, "I suddenly understood that a photograph could fix eternity in an instant." Only when photographers have achieved this insight can their work become something truly extraordinary.

More than ever before, modern photographers have the opportunity to express themselves and explore the many possibilities of their photographic worlds. Formerly, we had to worry about many technical

factors and undergo a long and sometimes complicated process to take a photo from conception to execution, from inspiration to completion.

We have come a great distance both in time and technology since the world's first photograph, "View from the Window at Le Gras," was taken by French photographic pioneer Joseph Nicéphore Niépce, using a process he called heliography. The photographic plate exposure required about eight hours. How many of us would undertake photography if we had to deal with bulky photographic plates and lug a large view camera around, as early photographers like Dorothea Lange and Ansel Adams did?

Whether you are just dabbling in photography or looking to polish your photographic skills, you will benefit from the support this book provides. All photographers will find useful information within these pages, from an overview on current photographic technology to handy and practical tips about everyday shooting.

If you think you would enjoy taking pictures but have been hesitant to get started, this is your chance to take inspiration from the world around you—just pick up your camera and get shooting!

There are few things in life that are as immediately rewarding or constantly inspiring as photography. It isn't necessarily hard or expensive to get started, and once you start shooting, you may be amazed at the world of possibilities that open up for you.

CHAPTER 1

The Expanding Universe of Photography

These days, people take the world of photography for granted, but not so long ago the technology that makes it easy to capture an image did not even exist. As recently as ten years ago, most people hadn't even heard of digital photography. While the essential concepts of photography have been understood for hundreds of years, the pace of discovery and innovation has begun to accelerate at an unprecedented rate. Understanding what is involved in today's photographic fields will offer an insight into the skills that are needed to become a proficient photographer in today's rapidly changing world.

The Dance Between Light and Darkness

No one knows exactly when or how it happened, but at some time in ancient history, someone noticed that when light came into a darkened room through a small hole, it created an upside-down (and laterally reversed) image of what was outside on the wall opposite the hole. Centuries later, this optical principle was given the name *camera obscura*, which is Latin for "dark room."

QUESTION?

What causes the *camera obscura* image to appear upside-down and reversed?
Under normal conditions, light travels in a straight line. When you see an object, you're actually seeing the light reflecting off the object's surface. When the light that is reflected off an object passes through a small hole in thin material, only the light heading in specific directions passes through the hole, converging at a point and then projecting onto an opposite surface upside-down and laterally reversed.

The earliest mention of a *camera obscura* was by the Chinese philosopher Mo-Ti in the fifth century b.c.e., who called the darkened room a "collecting place" or "locked treasure room." The Greek philosopher Aristotle also recorded the optical principle of the *camera obscura* after he viewed a solar eclipse through the holes of a sieve and through the tiny gaps between the leaves of a tree.

In the tenth century, Arabian scholar Ali Al-Hazen Ibn Al-Haitham, also known as Al-Hazen, used a portable *camera obscura* to observe solar eclipses. An expert in philosophy, physics, and mathematics, Al-Hazen was a serious researcher. He was the first to explain how the eye can see. Among his many other observations was the fact that the image projected by the camera's pinhole became sharper as the hole became smaller.

Bringing Things into Focus

The earliest *camera obscuras* were primarily used for observing solar eclipses and other scientific applications. The images they projected

remained primitive, as only the size of the pinhole could refine them. In the sixteenth century, a focusing lens was added to the pinhole opening, which sharpened the images that appeared on the viewing wall. The lens also made possible a bigger pinhole that would let in more light and create larger and better images. Another important advancement was a mirror that turned images right-side up and reflected them onto a viewing surface.

If you still don't quite understand the concept of *camera obscura*, don't worry; it isn't essential to know every technical aspect of photography. This information would be important if you were planning on building a camera, but let's figure out how to take good pictures first, okay?

Once the *camera obscura* had practical applications, artists and drafts-men used the table-top-sized devices to project images onto paper that they could then trace with pen, charcoal, or pencil. Over time, the *camera obscura* was refined and made even smaller so it could be used in the field. However, there was still no way to permanently capture the images themselves for later use.

Technological Advances

Hundreds of years before the photographic process was invented, people had already noticed that certain objects and elements changed color when left in the sun. What they didn't know was whether these changes were caused by light, heat, or air. In 1727, German professor Johann Heinrich Schulze decided to perform experiments to determine whether heat would cause silver salts to darken when he baked some in an oven. It did not. He then decided to test light's effect on the chemical. He carved some letters out of a piece of paper, stuck the paper to a bottle filled with the salts, and placed it in the sun. The sun darkened only the exposed parts of the chemical. The parts underneath the paper remained lighter. He had the answer to his question.

In the early 1800s, Frenchman Joseph Nicéphore Niépce (pronounced "neep-ce") captured the view outside his window by placing a sheet of

paper coated with silver salts at the back of a *camera obscura* and exposing it through the lens. Since he didn't know how to protect the image from further exposure, however, it eventually vanished when the paper was exposed to full daylight. But Niépce was inspired to experiment further.

Several years later, he devised a way to make a permanent image on a metal plate coated with bitumen, another photoreactive substance. It took about eight hours for the image of the view from his window to form on the light-sensitive material. Niépce called his process *heliography,* meaning "sun writing."

The Daguerreotype Develops

Louis Jacques Mandé Daguerre, another Frenchman, was experimenting with photoreactive chemicals at the same time as Niépce. A noted artist, Daguerre regularly used a *camera obscura* as a painting aid, and he wanted to find a way to make images last. He learned of Niépce's work in 1826 and formed a short partnership with him that ended when Niépce died in 1833. After his partner's death, Daguerre continued his quest for a permanent image. Instead of heliography, however, Daguerre worked on developing a new process that would yield faster exposure times.

The daguerreotype, as Daguerre called his process, was a significant advancement in the quest for a permanent photographic image, but it still had many flaws. The image was transferred onto a polished, mirror-like surface of silver halide particles produced by iodine vapor. Since it was a positive process, it only yielded one-of-a-kind images, and the photographic plates were extremely delicate. Exposure times were still lengthy, about thirty minutes or so, which ruled out portraiture.

Improving Photography

Over the years, the process was further refined and exposure times were reduced to mere seconds, making daguerreotypes the first photographic process to permanently record and fix an image. Exposure times were reasonable for use in portrait photography, which in turn made it the first commercially viable photographic process. A patent for daguerreotypes was obtained in 1839 by a London patent agent, Miles Berry, on behalf of Louis Daguerre. In the United States, a flourishing market in portrait photography

developed by the 1840s, as itinerant practitioners of the medium traveled from town to town.

FACT

Portrait photography was immensely popular, particularly for those of modest means. For the first time in recorded history, people could get likenesses of themselves and their loved ones at a very reasonable price. The wealthy mostly ignored the new craze and continued to commission portraits painted by fine artists, considering the photographic portraits inferior.

The First Negative

An idea occurred to William Henry Fox Talbot, a researcher, mathematician, chemist, and member of the English Parliament, while he was on his honeymoon in Italy. He was attempting to sketch a scene with the help of a camera lucida, a device used by artists of his day, which threw an image onto paper as an aid to sketching. Frustrated at the results, he was determined to find a way to permanently capture the beauty of the scene before him. He mused "how charming it would be if it were possible to cause these natural images to imprint themselves durably, and remain fixed upon the paper. . . . And why should it not be possible?"

Further Advances and Developments

Talbot jotted down thoughts about experiments he could conduct at home to see if the beauties of nature could be permanently captured through the action of light on certain material substances. As a consequence of his experiments, he developed a process he called "the art of photogenic drawing."

Talbot used paper embedded with silver chloride, which he topped with various objects and exposed to the sun. This process created a negative image, rendering dark objects light and light objects dark. He then soaked the paper negative in oil, which made the light areas translucent, and made a positive print by shining light through it onto another piece of

photosensitive paper. He patented his process in 1841, and the following year he was awarded a medal from Britain's Royal Society.

Talbot's negative-to-positive process made it possible to create multiple copies of the same image. However, the images it produced were crude and fuzzy compared to Daguerre's crisply rendered plates. Most people preferred the latter, and Talbot's invention was never widely employed, although it did represent a vital step in the development of modern photography.

FACT

William Talbot's negative-positive system most likely predates the daguerreotype. Although Daguerre's invention was announced earlier, Talbot's letters indicate that he had invented his system in 1835 but chose not to announce it until he perfected it. When Daguerre's invention was made public in 1839, Talbot then rushed to publicize his own work.

Talbot's inventions didn't end with the negative-positive process. In the next few years, he also came up with the following techniques and ideas:

- The calotype (from the Greek *kalos*, meaning "beautiful"), or latent image. This was an accidental discovery, made after Talbot underexposed some photosensitive paper. Instead of tossing it, he applied more silver compound and the images miraculously appeared. This discovery significantly decreased exposure times—before it, photosensitive materials had to be exposed long enough for light alone to darken them.
- Using a fine mesh screen to create a halftone image for printing purposes.
- Photoglyphy, a photoengraving process he patented in 1858.
- Flash photography, which he demonstrated in 1851 when he photographed a newspaper using the light from an electric spark. He did this to demonstrate how a moving subject (the newspaper was spinning) could be captured sharply by a very short-duration flash; in this case, less than 1/10,000 of a second.

Talbot displayed how well several of his inventions worked in 1844, when he published *The Pencil of Nature,* the first book to contain photographs. A true visionary, he also predicted such technologies as infrared photography, photo duplication (copy machines), and microfilm.

FACT

The earliest known surviving photographic negative on paper was taken by Talbot in 1835. "Latticed Window," an image of a window in his home, Lacock Abbey, resides in the photographic collection of the Science Museum at the National Museum of Photography, Film and Television in Bradford, England.

Inspired by Daguerre and Talbot, English astronomer Sir John Herschel also began experimenting with the photographic process. He discovered that hyposulfite of soda, the chemical now referred to as hypo, would fix images on photosensitive paper by stopping the chemical action of silver salts.

The Advent of Wet and Dry Plates

In 1851, the new science of photography was further refined by Frederick Scott Archer's invention of wet-plate collodion photography. This process involved spreading a mixture of collodion—a wound-dressing material made of nitrated cotton dissolved in ether and alcohol—and other chemicals on sheets of glass. It delivered more highly refined images than either Talbot's or Daguerre's methods. In 1871, English physician Richard Leach Maddox took Archer's discovery a step further with his dry-plate process, which used an emulsion of gelatin and silver bromide on a glass plate.

The Birth of Modern Photography

At the same time that Talbot and others were experimenting with the chemical side of photography, advances were being made in the design of the camera itself. A shutter was added to control exposure times, which had

grown significantly shorter due to the advances in imaging materials. With exposure times now shortened to as little as 1/25th of a second, not only were shots that stopped action now possible, but people didn't have to hold a pose for minutes at a time to have their portraits taken. Although the cameras of the period were bulky and large by our modern standards, their size had to be able to accommodate the large imaging plates of the time.

Enter the Kodak Moment

In the late 1870s, American George Eastman, a junior bank clerk and avid amateur photographer, began experimenting with gelatin emulsions in his mother's kitchen at night. In 1880, in Rochester, New York, he established a manufacturing company to make dry plates based on his formula. Eastman continued to refine the process, and in 1885, he patented a machine that coated a continuous roll of paper with emulsion.

Three years later, Eastman introduced the Kodak camera. With the promotional slogan "You press the button, we do the rest," it sold for $25 and came already loaded with a 20-foot roll of paper film, enough for 100 exposures. (A year later, Eastman substituted the paper roll with one made of celluloid.) After all frames were exposed, the user sent the entire camera back to Eastman's company. There, the film was processed, printed, and the camera was loaded with a new roll, after which it was sent back to its owner with the negatives and a set of prints.

Eastman continued to refine his camera, making each new version a bit smaller and a little more technologically advanced than previous models. He was able to bring the cost of a camera down to $5—a good price for the time—but Eastman was determined to come up with an even cheaper product that anyone could afford to buy. In 1900, with the debut of the Brownie, he fulfilled his long-held dream of putting the magic of photography into the hands of anyone who wanted to snap a shutter. The Brownie cost just $1, and it used film that sold for fifteen cents a roll.

Large and Boxy

Old cameras were often clumsy contraptions.

The first Kodak cameras used film that was physically much larger than what we're used to today, as the chemicals used in film manufacturing and

the lenses of the time were somewhat crude. As time went on, emulsions and lenses became more refined, and the need for large-format film to produce acceptable images diminished.

Types of Cameras and Skill Levels

Over the years, and especially today, camera design and technology continues to evolve. Simpler, cheaper, and more capable of producing higher-quality results, there is now a camera available to fit the needs of almost everyone.

In the 1930s and 1940s, photo imaging made a giant leap forward. Color transparency film was introduced in 1935, and color negative film came along in 1942. The debut of the Polaroid Land Camera in 1947 made it possible to take a picture and develop it on the spot in a minute or less.

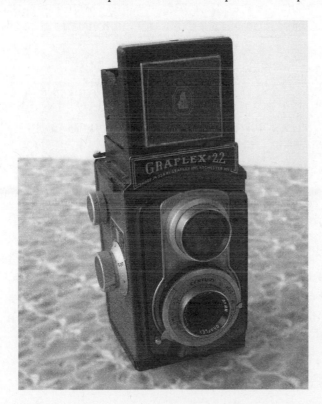

◀ FIGURE 1-1
The classic Graflex camera was marketed from 1952 to 1955 and had a Graftar 85mm f/3.5 lens. A reversed image was cast on a ground glass viewer on top of the camera.

Camera Design Becomes Streamlined

The cameras most widely used in the latter half of the twentieth century were the small 35mm handheld cameras used by both professional photographers and the general public, but Polaroid cameras were also popular. The Polaroid required less skill to operate and was less expensive than the average 35mm and was used widely for decades, despite the fact that there was no negative and if fixative was not applied to the image correctly, fading and yellowing would inevitably occur quite rapidly.

Disposable Cameras

The very end of the twentieth century saw the invention of disposable or single-use cameras, an innovation which rapidly became one of the best-selling point-and-shoots on the market. These inexpensive cameras took a lot of the stress out of picture taking for the casual photographer. The film was preloaded, the batteries preinstalled, and the buttons and controls simplified down to two or three easy-to-understand controls: the shutter, the film advance, and possibly a flash on/off button. Best of all, the disposable camera could be dropped off at the photofinisher without the picture taker ever having to touch it. It was amazingly convenient; even if you forgot to bring a camera, you could still get some shots. These cameras provided a virtually risk-free way to jump into the world of photography.

What Type of Camera Will You Use?

The subjects you choose to photograph and the equipment you decide to use will be determined by your budget, your interests, and your skill level. If you initially intend to take snapshots of your children as they grow but then decide you want to take your SLR camera on a photo safari to Africa, you will probably outgrow your camera—especially in these times when technology is evolving so rapidly.

The Single Lens Reflex Camera

The 35mm single lens reflex (SLR) camera, which debuted in 1960, ushered in modern-day photography; it continues to be the technology and for-

mat in widest use today. Unlike earlier 35mm cameras, SLR cameras featured special mechanisms that allowed photographers to see the same image in the viewfinder that the lens captured on film. With their interchangeable lenses and complete control over shutter speed, lens opening, and focusing, SLR cameras also offered photographers the tools to expand their creative abilities beyond what was previously possible.

Simpler Technology

For photographers wanting to take advantage of some of the versatility and creativity of the new cameras without having to learn the techniques necessary to master them, numerous manufacturers came out with easier-to-use (and cheaper) versions, including the point-and-shoot camera. In the 1980s, the introduction of capabilities like autofocus, autoexposure, and other automatic features allowed users to concentrate more on the images they wanted to capture and less on the mechanical processes necessary to create them.

Point-and-Shoot Cameras

In the mid-1990s, photography in the point-and-shoot world evolved further with the introduction of the Advanced Photo System (APS). Developed by an international consortium of camera and film manufacturers as a fully integrated photographic system for amateur photographers, APS features a special magnetic coding process that facilitates communications between the camera, film, and photofinishing equipment and makes for almost goofproof picture taking. APS cameras are smaller than 35mm cameras; they have smaller lenses and use smaller film as well. They're fully automatic and self-loading, which virtually eliminates any user errors. They feature three different picture formats—C, or classic, similar to a standard 35mm print (3.5" × 5" or 4" × 6"); H, or high vision (also called group or HDTV), measuring 3.5" × 6" or 4" × 7"; and panoramic, measuring 3.5" × 8.5" or 4" × 11.5". APS cameras also allow users to switch between formats on the same roll of film. Magnetic strips on the film record the exposure and sizing parameters for each picture. During processing, the photofinishing equipment reads the information recorded for each negative and makes the necessary adjustments.

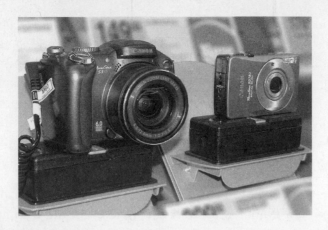

◀ **FIGURE 1-2**
Today's photographers have lots of good options and choices. These are both point-and-shoots, but the one on the left looks and functions a lot like an SLR.

While the APS system makes panoramic pictures a breeze to create, it's possible to make pictures in this format with 35mm cameras as well. You can also turn any print into a panorama shot by trimming off the top and bottom. This is especially easy with digital photos, where two images can be merged.

Digital SLRs Versus Point-and-Shoot Cameras

Digital imaging, which also debuted in the 1990s, is the latest step in the evolution of photography. Instead of recording images on film, digital cameras use tiny light sensors to convert images into electrical charges. A processor inside the camera then analyzes the information and translates it into a digital image comprised of pixels, or tiny dots. After the image is composed, it is stored either on a memory chip inside the camera or on a removable memory card or disk. Images can be transferred to a computer, where they can be viewed, edited, and printed out on a printer. Some cameras can even make short videos or have the capability to output images to televisions.

The technology behind digital cameras made them extremely expensive when they were first introduced, which put them beyond the reach of most photographers. Since then, they've come down substantially in price, with good-quality point-and-shoot cameras widely available in the $100–$300 range. Consumer digital SLRs can be bought for $500–$1,500.

CHAPTER 2

Point-and-Shoot Photography

For beginning to advanced photographers, the point-and-shoot camera offers an easy way to capture great-looking images. This popular type of camera is based on the 35mm format, and in this chapter, you'll learn more about the SLR's smaller, simpler, and generally cheaper cousin, the point-and-shoot camera. Available in both film and digital format, this camera gives photographers an amazingly convenient tool that can handle most photographic needs.

Point-and-Shoot Photography Defined

Point-and-shoot is a term widely used to describe a class of cameras that can remove almost all of the guesswork and a lot of the complexity from taking pictures. They range from inexpensive fixed-lens disposables to expensive cameras with high-quality lenses capable of capturing images of equal quality to those taken with the best SLR cameras. They all feature automatic controls that allow photographers to worry less about technical details and focus more on actually taking pictures.

While it may seem like point-and-shoot cameras are for rank amateurs only, this isn't the case at all. Many experienced amateur and professional photographers who use SLR cameras also own and use point-and-shoot cameras and sing their praises highly.

Cameras that fall into the point-and-shoot category include cheap single-use (disposable) cameras and more pricey 35mm compact cameras. While they're not technically 35mm cameras because of their smaller film size, Advanced Photo System (APS) cameras also fall under the point-and-shoot category, which encompasses digital cameras as well.

Point-and-shoot cameras differ from SLRs in several significant ways. For the most part, they don't have interchangeable lenses, although some of the top-of-the-line models may offer this feature. They also don't focus through the lens as SLRs do, instead using a separate viewing window. Some better cameras use a separate viewing lens.

Advantages of Point-and-Shoot Photography

Point-and-shoot cameras offer almost anyone the opportunity to take good pictures with predictable results quickly and without much effort. Because they automatically control how images are taken, users don't have to worry

about such things as focusing, f-stops, depth of field, or shutter speeds. Instead, they can concentrate more on other aspects of taking good pictures, such as point of view, anticipating the action, catching the decisive moment, finding the best direction and quality of light, and interacting with the subject. Many of these cameras have a tiny, built-in flash, which means you don't even have to think about lighting.

Point-and-shoot cameras are also called compact cameras or lens-shutter cameras. This is because their shutters are built into their lenses. You'll sometimes hear SLRs referred to as manual cameras because they give you the option of choosing the settings yourself.

A Simpler Approach

Point-and-shoot cameras have fewer moving parts, which makes them cheaper than comparable SLRs, as well as less likely to break and quieter to operate. They're lighter and more compact than the more complex film SLRs, which makes them easier for kids—or, for that matter, anyone with small hands—to handle and work with. Their size and lighter weight also make them great choices for taking on vacations.

Seizing the Moment

Much of photography really is about being in the right place at the right time. If a complicated camera intimidates you, or if you're worried about using one in certain situations, it will be in the closet instead of in your hands the next time you want to capture a special moment. Having a small, easy-to-use camera can do a lot to help this happen. With careful composition, close attention to light quality, a good connection to your subject, and a good idea of what the photograph is supposed to be about, the point-and-shoot could be the perfect tool, and it could prove to be the most reliable camera you use to meet your performance expectations.

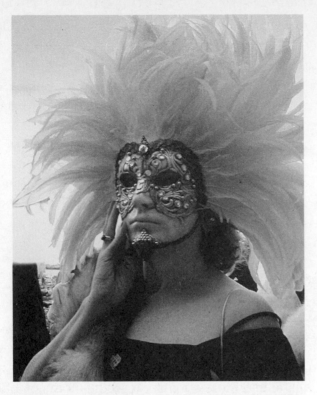

◀ **FIGURE 2-1**
Although taken with a point-and-shoot, there is sufficient detail and tonal range in this shot of some-one at a masquerade party.

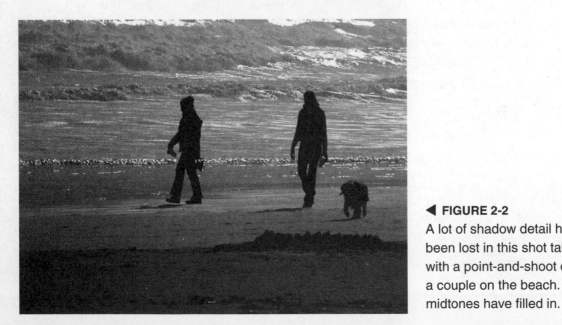

◀ **FIGURE 2-2**
A lot of shadow detail has been lost in this shot taken with a point-and-shoot of a couple on the beach. The midtones have filled in.

Disadvantages of Point-and-Shoot Photography

Now for the downside to the point-and-shoot method. With these cameras, you sacrifice the creative tools of selective focus and, with some point-and-shoot models, closeup or macro photography. Cheaper models will not give you the satisfaction of sharp, dynamic enlargements, subtle use of low light, and the many other creative and esthetic aspects of photography.

Other downsides to point-and-shoots include the following:

- **Inferior lens quality.** With the exception of the most expensive point-and-shoot models, the lenses on most of the cameras in this category are not the best money can buy.
- **Less accurate image framing.** Point-and-shoot cameras focus through a separate viewing window rather than through the lens, like SLR cameras do. This means you can't see exactly how the final picture is going to be composed. However, what you do see is fairly close.
- **Inaccurate viewfinders.** Viewfinders in point-and-shoot cameras may not be very accurate. Although you carefully center and compose your shot, the print may show the main subject too small and off to one side or too low in the frame.
- **Less sophisticated light-metering systems.** Exposures may be off in both existing light situations and with flash, resulting in badly exposed negatives that are harder to correct in the lab.
- **Lens-cap errors.** Because you're not viewing your subject through the lens, it can be amazingly easy to forget to take the lens cap off. To mitigate the problem, some point-and-shoot cameras have a sliding cover over the lens that either automatically opens when the camera is turned on or that is opened manually.
- **Other image-loss problems.** Because point-and-shoot cameras are so small, it's very easy to cover up their sensors, flash, or lenses.
- **Less creative range.** Photographers who desire to immerse themselves in the technical magic of photography will not get enough contact with it using a point-and-shoot.

Problems with Parallax

Users of point-and-shoot cameras also have to deal with something called parallax error or parallax effect. Because the viewing frame is offset from the lens, the image you see through the frame is different from what the lens sees. The difference isn't great at normal distances—that is, about ten feet or so away from the camera—but it intensifies as distances get shorter, making it increasingly difficult to see exactly what the lens will capture. You might think you're getting everything you're seeing in your shot, when in reality you may end up with parts being chopped off.

Most point-and-shoot cameras get around the problem by marking the viewfinder eyepiece to indicate the area that will be included in a closeup. More expensive models sometimes have parallax correction or compensation features built into the viewfinder to guide closeup composition.

Focusing Problems

Point-and-shoot cameras are notorious for fooling their users into thinking that images are in focus when they actually aren't. This happens because the viewing window is used for image framing, not for checking focus. Look near, far, or anywhere in between, and everything will look crystal clear through the lens in the viewing window. But due to the idiosyncrasies inherent in autofocus technology, what you'll actually see on film may end up being very different.

Unfortunately, there's not much you can do about this problem, aside from being aware of where the camera's focusing zones are and staying within them. More expensive point-and-shoot cameras do a better job of focusing, because they feature more zones than the less expensive models do.

Basic Features of Point-and-Shoot Cameras

Because they substitute electronic circuitry for some of the mechanisms found in SLR cameras, point-and-shoot cameras are some of the smallest available on the market today. They're also lighter than their film SLR coun-

terparts, but not necessarily too much lighter than digital SLRs. The less expensive point-and-shoots are usually made of plastic, which gets more durable as these cameras increase in price. Point-and-shoot cameras at the top end of the price range often have light but durable titanium bodies.

Autofocus

All but the cheapest point-and-shoot cameras have autofocus, which is activated by pressing down slightly on the shutter release. Most models use active infrared autofocus systems, which measure distances by shooting an infrared beam from the camera to the subject. A sensor then uses this information to move the lens into one of a number of focusing zones.

The simplest autofocus models generally have three zones that cover closeup (about five feet or so), medium-range (ten feet), and distance shots (twenty feet and farther). More sophisticated point-and-shoot cameras have additional ranges to provide more precise focusing. Most point-and-shoots also have focus lock, which allows for reframing the subject in the viewfinder after the focus has been set.

Autofocus isn't an option on the cheapest point-and-shoots, which almost always have fixed-focus lenses. Subjects within a certain range (say, six feet to infinity) will be in focus to a certain extent, but closer objects will be blurry.

Autoexposure

Autoexposure controls determine how the camera handles specific lighting situations to yield images that aren't under- or over-exposed. Most autoexposure systems on point-and-shoot cameras use a fairly simple setup, in which a front-mounted sensor measures existing light. When the shutter is pressed, the system reads the sensor and automatically sets the lens opening and shutter speed based on combinations already programmed in the camera's memory.

Some point-and-shoot cameras use through-the-lens, or TTL, metering, which is more precise and increases the accuracy of the exposure. Most TTL meters measure the overall light in a scene. Some more advanced TTL systems use center-weighted metering, which measures light at various points

in the scene—such as the middle, top, and sides. The camera's electronics then analyze all the readings, usually putting more weight on the central portion of the scene.

The least expensive point-and-shoot cameras use a fixed exposure, meaning that the shutter speed and lens opening never change. With these cameras, choosing the right film (high speed for indoor, slow speed for outdoor) is what it takes to get decent pictures. Some let you have a little control over exposure by flipping a switch between outdoor and indoor settings.

Flash Features

Almost all point-and-shoot cameras have an automatic flash feature provided by a little electronic flash unit built into the front of the camera body. This guarantees that you'll get an image even in darkness. However, that's about all they guarantee. Camera-mounted flashes tend to do a poor job in most situations, as they wash out highlights and flatten detail. (However, the same flash can be useful to even out the light in very contrasting situations, like on a very sunny day.) The flash units on point-and-shoot cameras also tend to be fairly limited in their range, resulting in underexposed images in dim lighting. Knowing the camera's limitations and staying within them is the best way to avoid this problem.

Red-Eye Reduction

This is a feature that minimizes the eerie effect that flash creates when people photographed in dim light or darkness glance directly into the lens. This is another standard feature on most point-and-shoot cameras.

Auto Wind and Auto Rewind

These two features are standard on almost all point-and-shoot film cameras. As their names imply, they automatically load the film, advance it, and then rewind it when all frames are exposed. On some cameras, you may have to push a button to activate auto rewind. That same button will let you rewind film in the middle of a roll.

Advanced Features of Point-and-Shoot Cameras

As point-and-shoot cameras move up in price, they offer both better technology and more features. Images taken with these cameras can, and often do, rival those created with the best SLRs. For some users, the advanced features offered by top-of-the-line point-and-shoot cameras are well worth the high price tags these cameras often come with. For occasional users, or those who are only buying a point-and-shoot as a backup for their SLR cameras, the additional bells and whistles on sophisticated point-and-shoots may simply not be worth the additional expense.

Better Lenses

Instead of single-focal-length lenses, more advanced point-and-shoot cameras often have lenses that offer a choice of two focal lengths for more versatility. They might also have zoom lenses that offer even more opportunities to fill the frame with the subject. Zoom lenses available on point-and-shoot cameras vary. They can do a good job with portraits or capture a crowd of people in a small space. Point-and-shoots with dual focal length or zoom lenses often have real image viewfinders, which move along with the lenses and provide a better idea of what the final image will look like, enabling the photographer to accomplish better framing.

Flash Modes

The more advanced point-and-shoot cameras often offer flash modes that provide more control over the camera's built-in flash. Flash-off mode

lets you cancel the flash when you don't want it to automatically fire. This is great for taking night shots or for taking photos in places where flash is not allowed. The use of fill flash softens ugly shadows that shooting in daylight can cause, or helps in creating a more evenly lit image.

Nighttime flash mode combines flash with a longer shutter speed. The flash lights up the objects close to the camera, and the longer shutter speed captures the ambient light in the scene.

Shooting Modes

Many point-and-shoot cameras let you optimize their settings to match your general or specific shooting situations. These shooting modes are sometimes very specific. Single frame versus continuous shooting, for instance, lets you choose between a mode that fires the camera once each time the shutter button is pushed and one that fires the camera and shoots pictures as long as the shutter is held down.

Other shooting modes available on some point-and-shoot cameras include:

- **Portrait mode.** This option presets lens length and exposure for head-and-shoulder shots. It tells the camera your subject is close to the lens and you want all the distant scenery to be out of focus. It does this by using a large aperture and focusing on the nearest subject.
- **Backlight mode.** Backlighting (in which the subject has bright light coming from behind it) can fool an automatic camera into adjusting the exposure so the background is correctly exposed, but the foreground, where your main subject is, is way too dark. This mode compensates for backlit scenes.
- **Panorama mode.** This mode sets the camera for wide-angle landscape shots or action photos.
- **Nighttime portrait.** This mode combines red-eye reduction with nighttime flash mode.
- **Landscape mode.** This mode tells the autofocus camera to focus at infinity, no matter what. It won't try to focus on an unimportant object close to the camera. You would use this if people, foliage, or

other nearby objects occupied a part of your frame that the camera would ordinarily focus on as the main subject.

New Features of Point-and-Shoot Cameras

Advanced point-and-shoot cameras may also feature a few more bells and whistles that make the photographer's life easier. The cameras that have these features will usually come with a higher price tag, but look for them to become increasingly part of the standard package as competition in the point-and-shoot market increases.

- **Remote control.** This allows you to operate the camera from a distance. While a self-timer also works, a remote control lets the photographer choose exactly the right moment to take a shot. This is particularly helpful for situations where you need to minimize camera movement, as in low-light conditions.
- **Auxiliary viewfinders**. This lets you focus, through a second viewfinder on the top of the camera, while you're aiming at subjects from waist level. These can be great for capturing candid shots of your kids or at play, and, for that matter, for snapping candid shots of anyone at a lower level than you are.
- **Date imprint.** Many point-and-shoot cameras offer this feature. It prints the date the picture was taken on your negative in the case of film cameras, or on the image itself in the case of digital cameras. The date will also appear on your pictures when they are printed. You can usually turn this feature off.

Best choices can change quickly in the world of technology, but at the time of this writing, these are the top five contenders for the best point-and-shoot cameras.

HP Photosmart R742

This is a well-designed, smart camera with a sturdy 3.8" × 2.4" metal case that's flat and thin enough to fit easily into a shirt pocket, with a 2.5" LCD window. There are both program and automatic exposure modes.

Shooting modes include landscape, portrait, action, closeup, sunset, beach, snow, panorama, theater, and night modes, plus digital video that shoots at twenty-four frames per second.

- Max. Megapixels: 7.2
- Optical Zoom: 7x
- Weight (ounces): 4.5
- Media Slots: MultiMediaCard, SD Memory Card, SDHC Memory Card
- Priced Around: $90

Nikon Coolpix P5100

This prosumer camera offers optical image stabilization and face-priority autofocus features. It comes with good ergonomics, and a sturdy compact body with a 3.9" × 2.6" profile small enough to stow in a purse or jacket pocket. It also has aperture-priority, automatic, I-TTL program flash, program, shutter-priority, and manual shooting modes.

- Max. Megapixels: 12
- Optical Zoom: 3.5x
- Weight (ounces): 7.1
- Media Slots: MultiMediaCard, SD Memory Card
- Priced Around: $280

Canon PowerShot A590 IS

Customers rate this camera as one of the best for good reasons, as it offers manual controls, as well as fully automatic modes. The image stabilization feature allows crisp photos under less than optimum conditions and the option to use the optical viewfinder rather than LCD screen can help prolong battery life. It has face-recognition and motion-detection technology. The camera body is small, just over 3.7" × 2.6" × 1.6".

- Max. Megapixels: 8
- Optical Zoom: 4x
- Weight (ounces): 7.9

- Media Slots: SD Card
- Priced Around: $115

Canon PowerShot 590

The 590's 2.5 LCD makes composing shots easy. For added creativity, wide or telephoto converter lenses can be attached. It has optical image stabilization and facial recognition technology. This camera is hard to beat for low battery usage, great zoom, fast startup, and manual as well as automatic shooting options at a low price.

- Max. Megapixels: 8
- Optical Zoom: 4x
- Weight (ounces): 6.17
- Media Slots: SD/MMC/SDHC Card
- Priced Around: $139

HP Photosmart R927

At 1" thick, the R927 isn't ultra-thin, but it does fit easily into a shirt pocket. An interesting feature is the processing options for those who don't like to edit their images on a PC. Images that look like an old sepia print or a watercolor painting or cartoon can all be done in-camera. It can also stitch panoramas together and display them on its big LCD. You can combine up to five shots, which you shoot either left to right or vice versa.

- Max. Megapixels: 8.2
- Optical Zoom: 3x
- Weight (ounces): 7
- Media Slots: SD Card
- Priced Around: $160

These cameras are perennial bestsellers, and the companies that make them come out with new versions of old favorites quite often. Check to see if there are any updates to your camera. Find out what the updates are and whether they would impact your picture taking.

CHAPTER 3

The Digital Revolution

Increasingly, digital photography is overshadowing film-based photography. More and more film-based photographers are embracing the new technology and making room in their camera bags for digital cameras, some to the exclusion of film entirely. Does adding one to your current equipment or buying one instead of a film camera make sense? This chapter will help you decide. If you decide digital is right for you, be sure to check out *The Everything® Digital Photography Book, 2nd Edition*.

Is Digital Right for You?

Being able to capture images digitally represents a huge advance in the evolution of photography, and, in many respects, is the next logical step. As digital technology reshapes all aspects of the world around us, it only makes sense that it should reshape photography as well.

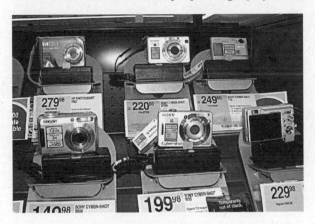

◀ FIGURE 3-1
Digital cameras come in all shapes, sizes, and price ranges. It is sometimes bewildering to make a decision about which is best.

Digital Gaining the Edge

There is no denying that digital imaging is the fastest growing area of photography, with improvements in products and techniques driving its popularity and acceptance. Digital imaging is also replacing much of film-based photography. Some experts say the days when film photography will cease to exist are only decades off, although many people believe it will never entirely disappear. *Today's* digital technology is becoming increasingly sophisticated, and film-based photography no longer has the edge when it comes to versatility, through-the-lens creativity, and image quality (although film aficionados might try to debate this point).

The Gap Closes

However, the gap between the two technologies will undoubtedly narrow even further in the next few years. Interchangeable lenses are already available on mid-range digital cameras. Continuing advances in digital technology have improved image quality and added features to digital cameras that rival those found in comparable SLR cameras.

Advantages of Digital Photography

The most obvious advantage to digital photography is the technology itself. By converting analog information to bits of data, processors can store images on digital media instead of on film. Those same images can be viewed immediately after they're taken, and you can delete them from memory if they are not acceptable. For photographers needing instant feedback, digital photography is the easiest and fastest way to get it. This is an enormous advantage if you are just learning photography. In practical terms, it tells the photographer immediately whether the shot was successful or not since the photo can be reviewed instantly in the LCD screen. If something isn't right about the photo—say, the shutter speed or exposure is wrong—steps can be taken immediately to correct the shot.

The creative possibilities of digital can be lots of fun, too. In the color insert, this can be seen in the picture of the beach and cliffs at sunset, rendered to look like a painting.

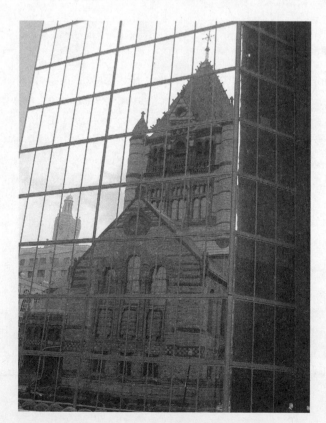

◀ FIGURE 3-2
There was little contrast in the original photo of a building in downtown Boston. Both the contrast and sharpness have been increased digitally in PhotoShop.

Instant Feedback

This quick feedback enables the photographer to rapidly understand what works. You can get instant feedback from a digital camera, instead of waiting for days to get your prints back from a photo lab and then trying to remember what the conditions were like when you took a particular photo. Digital also alleviates the anxiety of wondering if you got the shot at all; you will know instantly whether something needs to be rephotographed.

Taking pictures digitally also speeds up and streamlines the entire picture-taking process, and makes it far easier to add images to digital communications such as e-mail and websites. To get conventional film-based images into a digital media world, prints or slides must be developed and then converted to digital format by scanning them into a computer. Digital images, on the other hand, can be transferred directly from the camera to the computer—even directly to a printer in some instances. Some cameras can even transfer images through wireless infrared. The images in digital files do not degrade over time as they do in the world of film, and you can make perfect copies of digital files—no matter how many times you copy the same image, each will be identical to the first. With film, every generation will be worse than the previous ones.

Shooting digitally eliminates having to develop film, fuss with film cartridges, or worry about the quality of the film itself. Memory cards can sit inside a digital camera forever. Leave your film inside your camera too long and it's likely the images on it will be compromised.

Easy Editing

Images from digital cameras can be easily edited without taking them into the darkroom. All you need is the hardware and software necessary to do so, and these days almost everyone owns a computer. You can crop, straighten, and retouch images and adjust the color, saturation, contrast, and brightness. You can add words or special effects if you like. It is even

possible to scan old photographs into a computer and restore them with such programs as Adobe PhotoShop Elements.

Increasing Affordability

There are many economical digital point-and-shoot cameras on the market that are compact, quiet, and convenient, which makes them extremely popular. Most are small enough to slip into a pocket; some even small enough to fit on a keychain. As the cost behind the underlying chip technology has come down, so too have the prices of cameras. As in the world of computer technology, you see huge drops in price and amazing leaps in memory size and image quality when advances are made.

Color quality in digital photographs can often be so much better than images that are taken from film cameras. The pictures are more vivid, are sharper and brighter, and tend to have an almost three-dimensional look—which is very difficult to achieve in prints from film cameras.

Disadvantages of Digital Photography

Some of the advantages of digital photography can also be considered disadvantages. The technology itself is a small disadvantage when it comes to investing in image storage, although memory cards can be used over

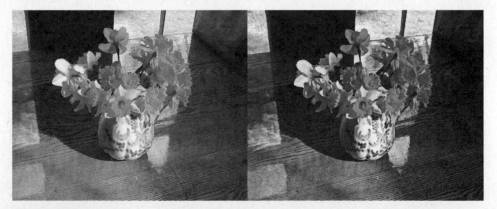

▲ **FIGURE 3-3** A low resolution shot of a flower arrangement (left) shows how much of the detail and subtlety can be lost from shooting an image that does not have the same number of megapixels as the one on the right.

and over again, and it is now possible to purchase one gigabyte memory cards for around $15. However, although the memory cards used for storing images in digital cameras are moderately inexpensive, they can still malfunction occasionally. Film might be of questionable quality at times, but it is widely available and relatively cheap. Most of the kinks have been worked out in today's digital cameras, but the cheaper models can have these drawbacks:

- **Less through-the-lens creativity.** While digital images can be endlessly manipulated with imaging software, the lenses on the low-end point-and-shoots can be limiting. Unless you can afford the higher-end point-and-shoots or professional digital setups with interchangeable lenses, or your camera can be fitted with auxiliary lenses, you're limited to the capabilities of the lens on your camera. However, this is true of film cameras, too.
- **Poor image quality on enlargements with low-end cameras.** Most digital cameras these days produce images that are as good as those achieved with film. In fact, you probably won't see any difference between digital and film images unless you enlarge them to 8" × 10"; then the difference can be noticeable on digital cameras of less than two megapixels.
- **Shutter lag.** Digital cameras have to analyze the scene before they record an image. This can cause a delay between the time the shutter button is pressed and the instant the picture is taken, which sometimes means you miss the height of action. This issue is rapidly becoming a nonissue as the technology improves; much depends on the make and model chosen. Casio's Exilim EX-S500 claims to have a shutter lag of only 0.008 of a second. The latest generation of processors in cameras are noticeably faster and allow the camera to do its job faster, minimizing shutter lag.
- **Cost.** The technology necessary to get good pictures is still a bit more expensive than using film-based cameras. The upside is you can see image quality before making prints.
- **Print quality.** It takes a special printer and special paper to make quality digital prints. However, they will be of the same quality as photographic prints. Prints made on industry leaders such as Epson

color printers are of archival quality and will last as long as traditional photographic prints. Those ordered commercially are of excellent quality also.

- **Other print problems.** When you shoot with film, technical mistakes such as bad color balance and poor exposure can be corrected in the lab. Digital imaging puts that responsibility back on the shoulders of the photographer. The result is that can you spend quite a bit of your time fixing pictures so they print properly. This is the digital equivalent of the home darkroom.

The truth is that there have been several generations of digital cameras, and most manufacturers have worked out their initial bugs and done a great deal to enhance digital technology.

Using a Digital Camera

Although the actual technical differences between taking pictures with digital and film-based cameras aren't all that significant, it still takes a certain mental paradigm shift to embrace digital technology. It isn't film-based photography, and it never will be. You have to deal with some of the quirkiness inherent in digital technology. If you want prints, you'll have the option of making them yourself or of uploading them to an online photo printing lab such as Snapfish, Flickr, or Ritzpix. It is also possible to take a memory card or CD to local photofinishers who can turn your prints around quickly and cheaply.

Technology Issues

There are definitely tradeoffs to digital photography. Some people enjoy the control and find it rewarding to edit digital images themselves. But not everyone enjoys this process or is willing to spend the time necessary to get good at it.

If you're a traditionalist, chances are pretty good that you won't be entirely comfortable with digital imaging at first; the process is just too different from traditional photography. But experts predict that in the not-too-dis-

tant future, digital technology will evolve to the point where the differences will hardly be discernible and it will become accessible to everyone who wants to explore what it has to offer. On the other hand, if you are already open to embracing new technology and you like the challenge of learning how to use it, you'll probably enjoy owning a digital camera.

Other Digital Problems

The basics of good photography—lighting, composition, framing, point of view, and so on—apply whether you're shooting with a digital or film camera. However, there are several factors you should keep in mind when using these cameras:

- **Parallax error.** Most low-cost digital cameras don't use SLR technology, which means the image you see through the viewfinder is different from the image the lens will capture.

- **Shutter lag.** Although newer cameras have significantly reduced this factor, on lower-end models there's sometimes still a discernible amount of time between when you snap the shutter and when the camera actually takes the picture. If you're taking action shots and you want to be sure to capture the height of action, choose a camera with continuous shooting mode, which will take pictures for as long as you hold the shutter-release button down.

- **Battery issues.** Digital imaging uses a lot of power. While it's never a good idea to leave any camera on for extended periods between shots, doing so with a digital might cause your camera to die in the middle of a shot. Digital cameras do vary as to power usage, but they all use far more juice than traditional cameras do, which can take some adjustment. If you are using a high-end point-and-shoot or SLR, an extra rechargeable battery in your camera bag will save you lots of annoyance. Likewise for the low-end point-and-shoots; keep an extra pack of lithium batteries handy. Looking through the viewfinder and using the LCD sparingly really helps conserve battery life, too. Most models now offer the option of turning the LCD screen on and off.

The best way to get to know any camera is to read the instruction manual thoroughly before using it, and this is particularly true with digital cameras. These cameras do operate a little differently, and it's easy to make handling errors that might damage them.

All the other considerations related to handling and storing a camera also apply to digital equipment. Because the point-and-shoots are so small, they often get knocked around more than they should. When your camera is not in use, store it in a cool, dry, well-ventilated area. Don't let it end up in the bottom of your briefcase or purse where it can get damaged. If it doesn't come with a case, buy one. Be particularly aware of the risks of bringing a camera to the beach, where sand and humid salt air can pose their own unique risks.

Understanding Digital Zoom

Although most digital cameras don't have interchangeable lenses, many models do have zoom capability. Optical zoom is the same sort of zoom technology as the lenses on traditional cameras. Since it actually changes the size of the image, it provides the best image quality. Beware of digital zoom, which only enlarges part of the image—its center—to give the appearance of a larger subject. Because images are just a portion of the original image, they contain few pixels and their image quality is poorer. You can achieve the same effect using your image-processing software on your computer, but you actually retain more control because you can see the image better on the computer monitor than you can on the camera's tiny LCD monitor or through the viewfinder.

Viewing Screens

One of the advantages digital photography has over traditional photography is the ability to see your images onscreen as you shoot them. Low-end digital cameras might not always have this feature, but most now do. Some LCD-equipped cameras don't have separate viewfinders. It's really more desirable to have both, as it's far easier to frame pictures using the viewfinder. LCD screens must be held several inches away in order to see them, which makes accurate framing difficult. However, you'll need the LCD

screen for shooting closeups because depending on the viewfinder can result in parallax error. Remember that overuse of the LCD screen will considerably shorten battery life.

How can I improve the visibility of my LCD screen in sunlight?
Little LCD screen hoods are widely available and don't cost very much. Some better cameras will let you adjust the brightness on these screens, too. Newer LCDs are also much easier to see in bright daylight.

LCD screens are also notoriously difficult to see in bright light, and they add extra weight as well as expense to digital cameras. But since this is one of the coolest features of these cameras, you may regret not having one if you opt for a camera without it. At times, especially when reviewing shots to make sure you have captured the image, they are invaluable. Just keep the battery drain issue in mind when using them, and use the viewfinder whenever possible.

Bells and Whistles

High-end digital cameras are available with the same creative controls that traditional cameras have, including the following:

- Autofocus
- Shutter priority
- Autoexposure
- Auto flash
- Aperture priority

Most digital cameras also have shooting modes that are similar to those found on traditional cameras, including:

- Auto
- Beach/snow
- Portrait
- Landscape
- Party/indoor
- Sunset
- Night portrait
- Backlight

While digital cameras don't use film, they record colors just like film does, except sometimes even more so! Exceptionally vivid color and brightness can be achieved with digital sensors. Most digital cameras automatically adjust colors according to different lighting conditions, including daylight, overcast, tungsten/incandescent, flash, and fluorescent. The more expensive ones will allow you to set these adjustments manually, which is desirable when you want an image with colors other than those set by the automatic system. Color can also be corrected and altered later with image-editing software such as PhotoShop Elements.

Choosing a Digital Camera

The process of choosing a digital camera is much the same as selecting any other camera. Set a budget, look for the camera with features that best suit your needs, do your research, and figure out where to buy it. The bad news is that there are so many digital cameras on the market that choosing between features and models takes a bit of time and due diligence.

Huge Price Drops

The good news about digital cameras is that their prices have come down significantly over the past several years. This means the technology required to take good digital pictures is no longer out of reach for the average consumer. Not surprisingly, as is the case with film-based cameras, the more you spend, the more camera you'll get.

Like traditional cameras, the price you'll pay for your digital camera will be determined by how many special features it has. Unlike film cameras, many digital point-and-shoot cameras have panorama shooting modes. Some will even shoot short movies.

Because the prices for digital technology have dropped so quickly in recent years, you'll see a fair amount of variation in prices on many cameras—it definitely pays to comparison shop for them. As is the case with

traditional cameras, you'll usually find better prices online or through mail-order houses than you will at your local camera shop. Online auction sites are also good places to shop for digital equipment. Just be sure you're clear on warranties and return policies when dealing with online stores. Check on restocking fees and who pays for shipping and handling in the case of returns.

ALERT!

Amazingly, it's now possible to spend less than $150 and get a well-equipped digital camera that can do everything you want it to. Pay much less than this, however, and you'll probably have to make some tradeoffs regarding features.

Recommendations and Tips

The field is wide and confusing, but here are some great recommendations for models, features, and prices currently available. Be aware that information changes rapidly, especially when it come to features and pricing. Be sure to check the Internet and photography publications for the latest news and special offers.

- **$100 and under:** Kodak EasyShare seems to lead the pack in this price range for image quality and ease of use. Reviewers seem to recommend both the four megapixel (MP) Kodak EasyShare C330 and the five MP EasyShare C340, saying they produce relatively high-quality photos. The 6 MP Fujifilm FinePix A600 produces nice images, but some say its awkward design and mundane features hold it back.
- **$100–$300:** As far as point-and-shoot cameras go, the 5 megapixel, 4x zoom Canon PowerShot A530 has good overall image quality for around $130. It makes great 5" × 7" and even 8" × 10" prints. The Sony Cyber-shot DSC-W55/L for around $200 offers good 7.2 MP picture quality in its tiny body. The 6 MP Canon PowerShot A540 has manual and automated exposure and focus controls, 4x optical zoom, and good solid image quality. The Canon PowerShot A630 is

an 8 MP camera with a 35mm–140mm-equivalent lens with accessory lens mount, all for under $200. The Panasonic Lumix DMC-TZ3 at around $300 pulls ahead of the point-and-shoot pack with a Leica lens and a 10x optically stabilized optical zoom (28mm–280mm 35mm equivalent). Likewise, the very compact Casio 7 MP Exilim Hi-Zoom EX-V7 has 7x optical zoom and image stabilization technology.

- **$300–$500:** The Canon PowerShot A640 at about $335 is 10 MP and has a large 2.5" LCD that folds out. Image quality is excellent, and the camera has a good complement of manual options and more than twenty-one shooting modes. The Canon PowerShot A710 IS is 7 MP, but employs IS (image stabilization) technology, 6x optical zoom, autofocus and manual controls, 2.5" LCD, and more than twenty shooting modes, including full manual. Battery life and speeds are good, too. If you want to go wireless, the Nikon Coolpix P3 at around $340 is a good choice for Wi-Fi fans. It is 8 MP and has 3.5x zoom and digital image stabilization. Primarily a point-and-shoot camera with a few manual settings, the camera also has a good movie mode and a large 2.5" LCD.

 The Sony DSC-T100 Digicam has an 8.1 MP image sensor, 5x optical zoom, and a big 3" LCD, plus image stabilization. It runs on Sony's Bionz image processor and has a face detection system so your subjects' faces are always in focus. A fully charged battery will last about 380 images. It is priced around $400.

- **$500 and up:** The following cameras all have rechargeable lithium ion batteries, and all are SLRs with features such as interchangeable lenses and image stabilization.

Camera model	Features	Price
Canon EOS Digital Rebel XTI EF-S	DigicII Image Processor for enhanced image capture, 10.1 MP	$375
Olympus E-520	With face-detection technology and image stabilization, 10 MP	$600
Canon EOS 50D	DigicIV Image Processor for fine detail, 15.1 MP	$1,300
Nikon D90	Face-recognition technology and 3" color LCD monitor, 12.3 MP	$950

Understanding Digital Cameras

Digital cameras record images on computer chips comprised of rows of tiny light-sensitive cells. Also called photosites, these cells register color and light and convert them into electrical signals. How much detail a digital image can contain depends on the number of cells that are on the chip and the size of the chip itself.

Pixel Count

The quality of the images digital cameras can produce is dependent on their megapixel capacity. One million light-sensing cells is equal to one megapixel. As pixel counts go up, images get better. If you're planning to print your images in a size larger than a 5" × 7", a higher megapixel model is a must.

Understanding Image Size

In the digital world, image size refers both to the physical size of a picture and to its resolution. It also indicates how large prints can be before image quality degrades and they become noticeably pixilated, which is the digital equivalent of being grainy.

A pixel can be considered a unit of length. However, in this case, that unit can change. For example, an image that measures 1600 × 1200 pixels is 1600 pixels wide and 1200 pixels high. The next step is the resolution of the image. Resolution is measured in dots per inch (DPI) and refers to the number of pixels set side by side that will fit in an inch.

A typical 6 megapixel digital camera will offer five different image sizes:

- **2832 × 2128 pixels:** Best resolution, but images contain a lot of data and take up a large amount of storage space. They're also slow to upload and download. On the plus side, images in this format will yield at least 8" × 10" prints.
- **2832 × 1888 pixels:** Good resolution; will yield at least 6" × 8" prints.
- **2304 × 1728 pixels:** Good resolution; will yield at least 6" × 8" prints.

- **2048 × 1536 pixels:** Yields good image resolution but smaller prints. Images also display well on large monitors. Roughly 5" × 7" print size.
- **1200 × 900 pixels:** Yields good image resolution but smaller prints. These images also display well on large monitors or can be used in emails. Roughly 5" × 7" print size.

Most cameras allow you the option of changing your picture's resolution. If you want to save space on your memory card, you can opt for a lower resolution. If you want to take high quality pictures, select the higher resolution.

Memory Considerations and Image Manipulation Software

Most digital cameras on the market today use removable memory cards or memory sticks for storing images. Not surprisingly, the more images the card is capable of storing, the more it costs. Recent drops in the price of digital memory cards have been quite encouraging for digital photographers, who had worried about the capacity of the cards versus price. This results in images and cameras that need cards with much greater memory capacity. The market average today is around $15–$20 for a 2 gigabyte memory card. Sony has a memory stick, which has a 2 gigabyte capacity; it retails for around $15.

As with batteries, having an extra memory card or memory stick is a very prudent idea. Don't think you could ever fill up a 2 gigabyte memory card? Don't be too sure. If you don't have the opportunity to upload your images to a computer and you are shooting at a very high resolution, you may easily find yourself wishing you had more storage capacity.

Also, consider the issue of backup. Just as film can get jammed or other unforeseen circumstances can throw a wrench in your plan, memory cards can occasionally malfunction. When this happens to you (although hope-

fully it never will), wouldn't it be nice to have that extra card to slip into the camera so you can continue shooting?

Image Manipulation and Photo Magic

The ability to take a bad or mediocre photo and turn it into one you'd be proud to show to friends and family is a powerful tool to have at your disposal.

The image manipulation software currently on the market can do some absolutely amazing things. Although the learning curve can be pretty steep on programs such as Adobe PhotoShop Elements, it is well worth the investment of time and money for serious photographers. Even beginning photographers should consider using this technology; you can resize and straighten pictures and do basic color and contrast correction.

▲ **FIGURE 3-4** Sometimes it is amazing how much detail and contrast can be derived from an ordinary image.

Basic features on most image manipulation programs are:

- Cropping tool
- Image rotation
- Red-eye removal tool
- Brightness and contrast tool

- Sharpen tool
- Blur tool
- Dodge and burn tool
- Eraser tool
- Type tool

FACT

Software programs commonly used by photographers include Adobe PhotoShop, Corel, Bibble, PhotoShop Elements, and PaintShop Pro. Free or inexpensive programs include Google's Picasa, the GIMP, and Paint.NET. Apple Aperture 1.5 and iPhoto are specifically designed for Mac users.

The more expensive programs have greatly expanded features that allow you to isolate areas to retouch, and extremely sophisticated tools for all sorts of image correction problems. There are even healing and cloning tools, which can transform how you think about photography. Some of these programs are downloadable from the Internet on a trial basis. Be advised that Adobe PhotoShop has excellent tools and is used by many pro photographers, but it comes with a hefty price tag of around $600. PhotoShop Elements is much more affordable at around $100. Beginners should download free or trial programs—it's a good way to take a test drive to see if the technology is right for you.

Freeware, Shareware, and Bundling

The good news is that most photographers will not necessarily need to buy any software. Your scanner probably came with some sort of image manipulation software, and it may even have come bundled with your printer. Many scanners come with a scaled-down version of Photoshop known as Photoshop LE (Limited Edition). Another bundled software is Picture Publisher from Micrographix. These programs will more than likely include all the functions most beginning photographers need.

Another Adobe product often bundled with scanners and printers is PhotoDeluxe, and with a little exploration you may find that it, too, has fea-

tures you can use. Software such as Corel Draw also provide basic image editing. Some versions come with Corel Photopaint, a program that also provides much, if not all, of what most photographers need. One of the oldest, best-known free software (shareware) packages is Paint Shop Pro. It is a low-cost alternative to Photoshop for people who don't need all of Photoshop's features.

Digital Camera Enhancer (DCE) from Mediachance does a good job of noise reduction and color and tonal correction in digital images. It is available both as a free program and as a part of the Photo-Brush software, which is worth considering for its low price. Photo-Brush does not have the selection tools that make Photoshop essential for photographers, but it does have some other important features, particularly noise and dust-removal and retouching tools. The Gimp, another free program, runs on almost any computer platform, Mac or PC. It was designed to offer features similar to PhotoShop.

Picture Window is a free program designed by programmers who were photographers, with their specific needs in mind. If you like this program, the more expensive Pro version, which is still cheap compared to Photoshop, may be right for you.

Digital Photo Printers and Online Printers

At the beginning of the digital revolution, many people embraced the new technology and loved it. They used their new cameras to take pictures of the kids or the new puppy and e-mail them to friends and family far away. The average digital user almost never saw or made real-world prints of their digital photos. Why? Simply because there was no easy way to do it. The average home printer did not produce a print that in any way compared to the quality available from film cameras. That has all changed.

Better Printing Technology

Printer manufacturers such as Epson, Canon, Samsung, and Hewlett-Packard stepped into the photo printer market, and Epson soon emerged as the photo printer of choice for photographers using digital technology.

Epson printers were aimed specifically at digital photographers with archival inks and paper designed exclusively for use in their own brand of printers. They were the first to develop a product line that produced a print that was indistinguishable from one done in a commercial photo lab. The race was on to grab this ever-growing consumer market. Soon HP and Canon had developed photo printers of their own, and at prices consumers could afford.

With the help of image-processing software, digital photographers were soon printing their own work. Many enjoyed the process immensely, but others did not like learning how to use the software and dealing with the sometimes-finicky printers. But soon, enough consumers were printing their photos at home to impact commercial photo labs, who soon saw their sales dropping with no end in sight.

Photo printers popular with photographers can change rapidly in today's market, but the following all offer good prints, have color LCDs, slots for memory cards, USB-port connection, and the ability to adjust color, black-and-white, and sepia tones:

- Samsung SPP-2040
- Kodak EasyShare Photo Printer 500
- Canon Selphy DS810

Small Printers

The following printers are smaller but are definitely worth investigating if you are looking for a photo printer for snapshot-sized prints:

- **Epson PictureMate Flash.** Conveniently equipped with multiple media card slots for direct printing, this printer also has a built-in CD-RW drive. There is also a USB port to hook up external devices like hard drives or USB flash drives. Images can be viewed and edited on the printer's 2.5" LCD screen. A convenient handle and optional rechargeable battery make it perfect for prints on the go.

- **Canon SELPHY CP740.** Weighing in at only two pounds, the Selphy is quite portable, with lots of convenient features: multiple media card

slots, a 2" LCD, a built-in cable for camera connections, and a USB port for computer printing. Remote printing from a compatible camera is even possible via phone, infrared, or an optional Bluetooth adapter.

- **HP Photosmart A716.** This printer has a 2.5" color LCD, creative editing options and a 4 GB internal hard drive. It can be connected to a television to run slideshows or edit and print images. An optional rechargeable battery is available, so the printer is portable.

Savvy labs quickly assessed this market trend and added digital print making to their roster of services. At first this was a pricey concern, but as online sites operated by reputable photo processors such as Kodak and Fuji entered the market, competition began to force the price of digital prints down until they were comparable with film print prices. Photo kiosks for making digital prints popped up in drug stores and malls, a good option for those not interested in investing time and money in home photo printing.

Online Photofinishers

The following photofinishers' websites have good reputations for digital image storage and printing:

- **Photoworks** *(www.photoworks.com).* A site particularly geared to those who would like to see their work printed in an album format. Secure online albums.
- **Ritzpix** *(www.ritzpix.com).* A fun and easy way to order images, with prints available for pickup at your local Ritz camera within an hour of uploading.
- **Shutterfly** *(www.shutterfly.com).* Shutterfly's Pro Gallery creates a virtual storefront for you. Pros can give their web address to customers and let them order prints.
- **Dotphoto** *(www.dotphoto.com).* Good quality, low prices. Fast turnaround, easy-to-use interface.

- **Flickr** *(www.flickr.com).* Online albums, prints, calling cards, photo books, slideshow-DVDs, postage stamps, and more.
- **Adoramapix** *(www.adoramapix.com).* A great choice for both amateurs and professionals who want to download color profiles and upload TIFF images. Quality is great and the forty-eight-hour turnaround time is terrific.
- **Webshots** *(www.webshots.com).* Photo-sharing community with photo printing. Good quality and pricing.

These sites are a good option if you do not have a photo printer or do not have the time to master using one. You may want to try a few of these services to see which one best suits your needs.

Single Lens Reflex Photography

Single Lens Reflex, or SLR, cameras are what the pros use. They are sophisticated mechanisms capable of capturing the most minute details on the tiniest objects and then, with a quick change of lens, of bringing faraway images up close. The 35mm SLRs, both film and digital, give photographers almost complete control over how they choose to create their images. One of the most versatile and widely used cameras, SLRs come in both film and digital versions.

4

All about the Body

The main part of the SLR camera, the body, packs a lot of punch in a small package. Most SLR bodies are made of high-impact plastic or a lightweight metal, which makes them both light and durable. Some manufacturers combine the two. They're designed to fit comfortably in your hands. Most come with a built-in grip—almost always on the right side—to help you hold them securely. Most film SLR camera bodies are hinged on the back to facilitate film loading and unloading. On older cameras, the back might come completely off.

Although most digital SLRs are designed to look like their film counterparts, the back of the camera does not open, as there's no film to load. They do contain ports to connect by USB to computers and printers for file upload, as well as a slot for memory cards or sticks.

SLR Bodies

The bodies of SLR cameras sport a number of features. Here are some you can expect to find on both digital and film SLRs:

- **Accessory shoe.** A small bracket on top of the camera used for mounting a flash unit.
- **Shutter release button.** Usually located on the right side of the camera—either on the front or on the top—as it's facing away from you.
- **Command dial.** For controlling automatic features and shooting modes.
- **Lens release button.** For using multiple lenses, in succession, on the same camera.
- **Cable release connection.** Used to fire the shutter from a distance to prevent vibrations during long exposures.
- **Tripod socket.** Used to attach the camera to the tripod.
- **Power switch.**
- **Self-timer button.**
- **Viewfinder.**
- **Built-in flash.**
- **Film cartridge information window.** Found in film cameras only.

- **LCD panel.** Displays shooting information, including number of exposures taken, shooting mode, shutter speed, exposure, focus mode, and other information.

Types of Lens Mounts

One feature you'll find on the front of SLR cameras is the lens mount. As the term suggests, this is the place where the lenses attach to the camera. Most SLRs available today are equipped with bayonet mounts, which couple the lens and the camera together with just a quick turn. Other types of mounts, primarily on older film SLRs, include screw mounts and breech-lock mounts, in which a ring on the lens secures it to the camera. Some older lenses with screw mounts can be adapted for use on cameras with bayonet mounts.

On cameras with autofocus capability, you'll see a set of small pins just inside the lens mount. These are electronic contacts, which transmit data back and forth from the camera to the lens, controlling such things as autofocus and aperture settings. Look on the back of an autofocus lens, and you'll see a series of flat contact points that match precisely with the electronic contacts inside the lens mount when the lens and camera are correctly joined.

Inside the Camera

Today's SLR cameras pack a lot of technology into their small bodies. They house multipart viewing and shutter mechanisms as well as a host of electronic components that make such features as automatic focus and automatic exposure possible. You can't see the mechanism for many of these features—and for the most part, you really don't have to worry about them—but it's a good idea to know where they are and what they do.

Finding the View

Take the lens off an SLR camera body and you'll immediately see the single-lens reflex mechanism. This is the technology that separates SLR cameras from all others.

When you look through the viewfinder on an SLR camera, what you actually see is a reflected image that's been turned the right way around before it even reaches your eye. First, the mirror takes the image that shines through the lens and reflects it upwards to the translucent glass, which functions like a miniature projection screen. The pentaprism, located above or behind the glass, flips the image on the screen, making it appear right-side-up, and redirects it to the viewfinder window.

The single-lens reflex mechanism consists of a slanted mirror positioned between the shutter and the lens, a piece of translucent glass, and a five-sided prism or pentaprism. It allows you to see exactly what the image on the film will look like.

When the shutter is clicked, the camera quickly flips the mirror out of the way so the image is directed to the film or—in the case of digital cameras—to the sensors. As long as the shutter stays open, the mirror, which is connected to the shutter timer system, stays up. Because the mirror is moved out of the way, the image can no longer be seen in the viewfinder, but this momentary blackout is barely noticeable. Once the image is captured, the shutter closes and the mirror flips back down into place. This is the reflex motion that gives the camera its name.

On modern SLR cameras, viewfinder windows do more than simply facilitate framing and focusing. What you'll also see in the window, depending on the camera's particular features, are indicators for things like shutter speed, focus, red-eye reduction, flash, depth of field, and camera-shake warning, which indicates situations where handheld snapping will yield blurry images due to camera movement and slow shutter speeds.

Snapping the Shutter

Most SLRs have mechanisms inside that are called focal-plane shutters. These devices are basically a couple of pieces of flexible cloth or metal blades that expose the film or sensors by very quickly opening and closing when the shutter release is pressed. In conventional cameras, the shutter is

positioned in the back of the camera, just in front of the film; in digital cameras, it is placed just in front of the sensor array.

Storing the Image

Conventional SLR cameras all have internal film handling systems, consisting of a film holder to keep the film in place while it's being exposed and a film-transport system that controls how the film moves through the camera. Digital cameras make use of memory cards or sticks, which store the image until it can be uploaded to a computer, commercial print processor, or home printer. These memory cards can be erased and reused.

SLR cameras are sometimes very intimidating to beginning photographers, but they need not be once the basic principles are understood. Most SLRs can be used in automatic mode until the photographer grasps the fundamentals of aperture and shutter speed.

SLR Features and Functions

SLR cameras fall into two basic categories: manual and automatic. Each type has its own unique advantages and drawbacks. When you're considering which one is right for you, you should be aware of certain factors that greatly affect ease of use and the type of creativity and flexibility you can achieve.

Manual SLRs

With manual SLR cameras, you—not the camera—set the focus and often the aperture and shutter speed as well. This can be great for people who know a lot about the technical side of photography or who want to take the time necessary to learn about it. It also lets you use a wider variety of lenses, so you're not limited to those that only work on automatic focus cameras. However, this lack of automatic features makes manual cameras difficult for inexperienced users to operate.

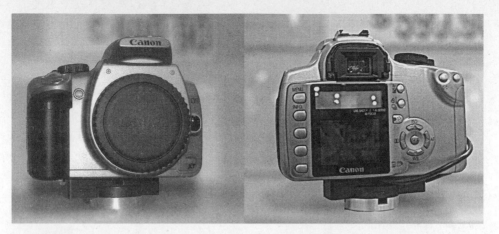

▲ FIGURE 4-1 Both front and rear views of a typical SLR. An LCD screen, viewfinder, menu access, and toggle controls are standard features.

Automatic SLRs

SLR cameras with such features as autoexposure and autofocus take a lot of the guesswork out of photography. They usually offer shooting modes for landscapes, portraits, and macro shots that let the user override the automatic controls when she wants to operate the camera manually. Because they make the actual picture-taking process easier and there is a much easier learning curve, most consumers prefer them, which means there are far more automatic SLRs than manual ones on the market today.

Advantages of SLR Photography

For people who have mastered using an SLR in manual mode, the opportunities for better technical shots and creative approaches to difficult lighting situations offer a big advantage not found in other cameras. Better control of aperture and shutter speed gives SLR users an unrivaled flexibility and adaptability in challenging shooting circumstances. The better lenses available, plus the ability to swap out lenses as shooting conditions change, give the 35mm SLR user a distinct edge over those shooting with less sophisticated equipment.

Preset Program Modes

Another feature of automatic SLR cameras is preset shooting programs or program modes. The most fully automatic of them, often referred to as full program mode, selects the aperture and shutter speed, switches on the camera's built-in flash unit if necessary, and focuses the lens. All you have to do is snap the shutter.

Other common automatic program modes include the following:

- *Depth-of-field or landscape mode*, which automatically chooses the smallest possible aperture that will allow handheld photography
- *Action or sports mode*, which evaluates existing light conditions and sets the fastest shutter speed possible
- *Portrait mode*, which blurs the background on these shots by setting as large an aperture as possible
- *Closeup mode*, which exposes only for images close to the camera
- *Silhouette mode*, which underexposes a foreground subject against a brightly lit background to create a silhouette

Aperture and Shutter Priority

When not in fully automatic mode, SLR cameras offer two different methods for setting exposure. Aperture priority allows the user to set the aperture, after which the camera automatically sets the appropriate shutter speed. This priority setting allows you to control depth of field.

Shutter priority lets you choose the shutter speed you'd like to use, and the camera takes care of the aperture. This priority setting is good for times when you want greater control over how action scenes are shot, such as using a fast shutter speed for stopping action or a slower speed for blurring it.

Another feature on many SLRs is exposure compensation control. This allows complete control over the camera's autoexposure system and makes it possible to set the camera to over- or underexpose your image by up to two or three stops in either direction. Exposure compensation is good for working in backlit situations to shed more light on foreground subjects, or for other times when you want to use a different exposure than the camera's metering system suggests.

Autofocus Mode

This technology, which was introduced in the 1980s, helps eliminate blurry images and is probably the most popular feature on SLR cameras. There are two types of autofocus systems: active and passive.

Passive autofocus uses the light rays that pass through the lens to measure the contrast and adjust the focus until it's as sharp as it can be. The more focus points a camera has, the faster and more easily it will focus.

Active autofocus systems work by sending a beam of infrared light from an emitter on the camera body. A sensor then measures the distance from camera to subject according to the length of time it takes for the infrared light to bounce back from the subject. Active autofocus works in the dark and can handle pictures with few high-contrast areas to focus on, but it can also be fooled by objects closer to the camera and by reflective surfaces like window glass. Most SLRs have passive autofocus capability, which you need to handle the variety of lenses that go on the camera.

Autoexposure Mode

SLR autoexposure systems measure the brightness of the scene and then set the shutter speed and the aperture accordingly for the correct exposure. Some systems use a sensor on the front of the camera. Most SLRs, however, use through-the-lens metering, which is more precise and increases the accuracy of the exposure. TTL metering systems use several methods to measure light:

- Center-weighted metering takes a reading from the center of the viewfinder.
- Matrix or evaluative metering divides the picture area into a grid and then analyzes the contrast and brightness in each part of the grid to come up with a suggested exposure.
- Spot metering takes a reading from a small circular area in the viewfinder and then sets the exposure for the entire picture based on this reading.

The specific metering system varies depending on the camera model. Center weighting is the most common, with matrix metering and spot meter-

ing usually available on more expensive models. Some cameras offer all three, allowing the photographer to choose the metering method that best suits the situation. Spot metering, for example, is great for scenes with lots of contrast, as it allows you to take a series of readings from specific areas of a picture and then decide which readings you want to use for the effect you're trying to achieve.

Film Advance

Also called a motor drive, this mechanism automatically moves the film through the camera each time the shutter is clicked. On many automatic film SLRs, it can be set to allow you to fire the shutter once every time you push the shutter release button, or continuously for several frames—as long as you don't run out of film—while you hold the shutter release button down. Digital SLRs have basically the same feature, a "burst" mode that allows you to capture multiple pictures with one firing of the shutter release button.

Auto Load and Auto Rewind

These are common features in automatic film SLR cameras. Drop in the cassette, pull the film leader across to the correct spot (if necessary), close the back, and the film advances to the first frame. Most systems also set the film speed automatically to make sure it's exposed correctly.

Auto rewind is activated when the roll is complete and the camera senses that it can't pull any more film out of the cassette. The camera then automatically activates a motor that rewinds the film. Film can also be rewound before all the frames are exposed by pressing a film rewind button.

Disadvantages of SLR Photography

While SLRs have a lot to recommend them and can provide the skilled user a great deal of satisfaction as far as quality control goes, there are some disadvantages to both manual and automatic SLRs in both film and digital models, which should be understood before making a decision about purchasing one.

◀ FIGURE 4-2
Sometimes you have
to move fast to capture
the moment, and the
auto setting allows a good,
spontaneous shot.

Working with Automatic Settings

Because it depends on electronics, autofocus can fail. Other drawbacks to autofocus systems include the following:

- Difficulty operating autofocus lenses by hand with the camera in manual focus mode.
- Noisy camera operations due to autofocus mechanisms.
- Less durable lenses. To cut down on the weight of autofocus lenses, which contain computer circuitry and other mechanisms necessary for the autofocus process, some manufacturers make them with plastic barrels.
- Inconsistent operation in cold weather. Low temperatures can affect the action of autofocus lenses. It also weakens the batteries that power autofocus systems.
- Drains battery resources.
- Focusing difficulty. Can potentially focus in on something in the foreground or background if the photographer is not careful.
- Metering problems can occur when the camera is in full automatic mode. The reading, taken from a small circular area in the view-finder, may set an incorrect exposure for the entire picture.

Higher Purchase Price

The higher quality and control offered by both film and digital SLRs comes with a higher price tag. Extra lenses, gadgets, flashes, batteries, and gear bags can also add up very quickly. Even though the prices for digital SLR cameras have dropped dramatically in recent years, they are still not within everyone's budget, especially those who are just looking to take quick snapshots of the kids or those who take pictures infrequently. SLRs require more of an investment of time and money.

CHAPTER 5

Overview of Buying Basics

Buying a camera is a lot more complicated than just walking into a store and snapping up the first one you like that fits your budget. With so many different types of cameras to choose from, you need to do your research to find out what is available and determine what you need your camera to do. Once you've done that, you can find the best camera to suit your needs.

Buying Basics

No single camera is the right choice for everyone. The key is knowing your tastes, judging your aptitude for learning a new camera, and zeroing in on what you want to photograph. This allows you to choose a camera you will happily use for many years.

First, consider your needs and interests. Are you planning to use your camera for portraiture? Then you should consider purchasing a model that zooms to at least 70mm. This allows you to stand back from the subject for a more flattering shot. On the other hand, architectural photographers do best with a nonzooming lens that takes in a wider view of the subject. Sports photographers need a camera that zooms to at least 120mm.

Get the Right Fit for You

The most important thing about the buying process is ending up with a camera that's right for you. Regardless of your individual needs, it should be a piece of equipment that does no more and no less than what you want it to do. Buying more camera than you need will only break your bank—and all for features you may never use. Buying a camera that's less than what you need will frustrate you and put you in the market for a new one sooner than you should be.

In the case of digital, you may be apprehensive that the technology will overwhelm you. If you choose a basic, moderately priced model, you will quickly be able to tell whether or not you are ready to handle digital shooting. As your skills and confidence increase, you will be able to move up to a higher-end model.

As the technology changes so rapidly, upgrading later to higher megapixels and models with more features will just make sense, as digital technology can radically improve and change within, say, a two-year period.

Setting a Budget

Realistically, one of the first things you need to think about is how much you want to spend on your camera. These days, it's possible to purchase a good camera fairly inexpensively, but it's also possible to needlessly spend a lot of money on camera gear that sports the latest technology. Having a general dollar amount in mind before you begin shopping in earnest will help you narrow your choices fairly quickly, especially online, where you can plug the amount you wish to spend into a shopping search engine. Thorough research will also help you decide between buying new or used equipment.

If you're thinking of buying an SLR, whatever amount you decide on should cover the cost of a camera body and a lens (or possibly two), along with some other necessary accessories such as a camera strap, lens hoods, a lens cleaning kit, batteries, memory cards, and a gear bag. A point-and-shoot might also need a camera case and strap, if they don't come packaged with the camera.

FACT

Since there are so many lenses available, most SLRs are sold as a "body only," which means you'll have to choose a lens before you can start taking pictures. Moderate zoom lenses may be attractive, but a fast, fixed focal length lens is sharper, lighter weight, and better in low-light situations. A 50mm f/1.8 lens is the best one to start with.

Doing the Research

While it is possible to just ballpark a number that feels good when setting a camera budget, it's a far better idea to take the time to do thorough research to come up with a realistic figure. Start by reading a few photography magazines and checking out photo websites to do thorough research. Not only are they chock full of articles on camera equipment and how to use it, but the magazines also run lots of equipment ads placed by camera shops and mail-order houses. Most also compile buyer's guides, which are excellent resources. There are several Internet sites worth checking out—

check Appendix B—that also provide resource information for websites and magazines. Photography websites are a particularly good resource, as they often have reviews by consumers who have purchased the latest model cameras and want to share their experiences with would-be purchasers. This information can be invaluable, as most are not professional photographers and they probably have skill levels comparable to your own.

After you spend some time exploring these resources, you'll begin to get a general overview of the features and functions that are available within certain price ranges. Although it's impossible to list all the features available in each price range, here's a rough idea of what you can expect to find:

- **Under $100.** Basic film point-and-shoot, most likely without zoom and possibly with a plastic lens instead of glass. Inexpensive construction. In digital, a 2–4 megapixel camera with limited zoom options.
- **$100–$200.** Better point-and-shoots with autofocus zoom lenses made of glass and more shooting modes. Entry-level manual and autofocus SLRs. Durability can still be an issue. This is a good price range for most beginning amateur photographers.
- **$200–$300.** Point-and-shoots with higher-quality lenses and more functions. Manual and autofocus SLRs with more features and more durable construction. Sometimes bundled with a consumer quality standard lens or moderate zoom lens in the 28mm–80mm or 35mm–70mm range.
- **$300–$400.** Point-and-shoots with even more sophisticated features and better lenses. SLRs with many more features and shooting modes, again possibly bundled with moderate zoom lenses. This will usually cover a good, basic setup for more serious photographers, with some room for expansion and upgrades over time, if the hobby turns into a business.

Once you get above $400 or so, prices translate into both point-and-shoot and SLR cameras with more advanced features, such as titanium bodies. On point-and-shoots, lenses get significantly better as well.

Determining How You'll Use Your Camera

Once you've set an estimated budget, it's time to refine the selection process by thinking about how you're going to use your camera. This will give you a better idea of what features and functions you'd like your camera to have.

First, ask yourself what you are most interested in photographing. Do you love capturing flowers kissed with dew at daybreak? Or maybe you're a crafter, and you want to take good closeups of your creations for promotional purposes. In both cases, you'll need either an SLR camera equipped with a macro lens or a point-and-shoot with macro capabilities.

How much you're willing to learn about photography can have a significant impact on the type of camera you'll choose. If you'd rather the camera did most of the work, point-and-shoot may seem ideal; if you're always trying to push the envelope or get frustrated if your tools aren't flexible enough, you'll probably prefer the versatility of an SLR.

Want to be able to take casual snapshots of the kids as they're growing up? A point-and-shoot camera with its ease of use and automatic modes might be the perfect fit, but you might also prefer the creative flexibility you'll get with an SLR camera.

Point-and-Shoot Versus SLR

To get the best idea of the type of camera you want, you'll have to decide between point-and-shoot and SLR at some point. The following are situations in which a point-and-shoot makes good sense:

- High-theft areas
- Travel requiring minimal weight and bulk
- Well-lit scenes
- Only enough time for two quick snapshots at a graduation ceremony
- Unlikely to need a print bigger than 5" × 7"

- Only moderate flash range needed (4'–15')
- Fear of gadgets
- Photos needed only to record the condition and appearance of subjects
- Toddlers likely to find and play with fancy photo equipment

These situations make an adjustable single-lens reflex camera a necessity:

- Event photography for pay
- Formal portraiture
- Prints size 8" × 10" and larger needed
- Slides needed
- Copy work
- Closeup work
- Precise composition and framing required
- Extreme wide angle needed, such as in tight interiors
- Extreme telephoto needed, such as wildlife or sports

For more shooting options without jumping to SLRs, consider buying two cheap point-and-shoot cameras with different lenses. You might try one with a wide-angle option and the other with more of a telephoto option. Buy yet another, and you can be shooting both color and black-and-white! This combination gives you flexibility without the cash outlay a big 35mm system requires.

What's Your Personal Style?

Aside from the quality advantages and adaptability of an SLR, a more complex camera may also meld more with your personality. Would you enjoy a camera that needs your attention and rewards your investment of time in making artistic decisions? Consider how you experience and relate to important moments in your life, the way you enjoy your quiet time, and how you participate in family life and parties. The adjustable

SLR can require an investment of more time and thought than the point-and-shoot. Giving your camera that extra attention takes you out of the moment in some ways, but in other ways it brings you more into the present. Operating your SLR camera can be an experience that seduces you, slows you down, and inspires you to pay attention to your surroundings, feelings, and perceptions.

Getting Really Specific

You've set a rough budget for your purchases, you have a pretty good idea of your comfort level with technology, and you have a clear idea of what you want to shoot. Now it's time to research specific camera manufacturers and models to determine which ones offer the features and price point you want.

▲ FIGURE 5-1 The Internet is a wonderful resource for comparison shoppers who want to find the best deal on new equipment.

Be prepared for some sensory overload here! There are hundreds of cameras to choose from, and it's easy to feel overwhelmed with so many choices. With digital cameras, a careful comparison of features, megapixels, and shooting modes is needed. Fortunately, it is possible to find sites online that let you do a side-by-side comparison of features.

Comparison Shopping Function and Features

Once again, photography magazines and websites are great places to start. Check manufacturers' sites and independent sites that review equipment—you'll find many good ones in Appendix B, which lists resources. As you go through them, take notes on the different models. You might find it easier to keep track of which camera has which features by charting the information on a simple table, organized by the model and listing all the features and functions it has that you are interested in. Keeping notes on the prices and accessory options is another must.

Customize your table to reflect the features and functions you're most interested in, and leave enough room to write in all the information you find.

SAMPLE BLANK CAMERA FEATURE CHART

Manufacturer	Model	Functions	Features	Special Options	Price

Understanding Gray-Market Merchandise

While you're doing your comparison shopping, you may see some camera equipment described as "gray market." This term refers to items that are sold overseas at low prices, then purchased and resold at a higher price in other countries, usually at a lower price than the going retail rate.

This equipment often has no warranty coverage or is covered by a foreign warranty, which means you would have to send it back to the country of manufacture for any repair work. Not only does sending equipment overseas for repair mean waiting months to get it back, but there's no guarantee you'll ever see it again. The shipping rates will also be higher, and many warranties require the consumer to foot at least half the bill.

The companies offering the lowest prices are often selling gray market goods. While there's nothing particularly wrong with this, there is a definite risk involved in buying this equipment. Sticking to gear that's made for use in your home country is a far better way to go.

Cameras can vary significantly in their pricing, depending on who's selling them. While this isn't something to obsess over, it's a good idea to get a general feel of the price range for the models you're considering.

Get a Camera in Your Hands

Now it's time to see what your dream camera looks and feels like. The best place to do this is in a good local camera store. Sales staff in the good stores go through hours of product training, and they're also trained to help shoppers identify the right camera for their needs. If you're not quite sure what you're looking for, they know the questions to ask. Many are photographers themselves, and they are often more than willing to get you started out on the right foot and pass along advice based on their own experience.

If there are no camera stores in your area, big chain office supply stores such as Office Depot, Staples, or Office Max or big box retailers such as Sam's Club, BJ's Wholesale, or Wal-Mart also carry digital cameras. These stores

sometimes have a surprisingly comprehensive inventory and good prices and specials, such as cameras bundled with photo printers. Don't expect the sales staff at these stores to be able to discuss the features, advantages, or disadvantages of their products in great detail. They are not specialists and may not be able to answer even the simplest questions about the cameras they carry. It's a very good idea to jot down models you're interested in and go home to do some research before making a purchase.

Try out every camera you're interested in. Let the salesperson show you how they work. They are motivated to treat you well because they want your business, and they want to have satisfied customers who will continue to shop with them in the years ahead.

Learn all you can about the cameras, particularly the basics—where the batteries go, how to open and close the lens, how to turn them on and off, and all the other basic features that impact how comfortable you will be using the equipment. Even check to see how to change the date and time if that feature is available.

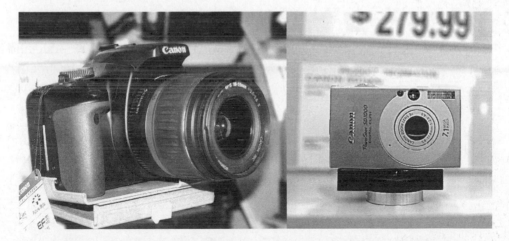

▲ FIGURE 5-2 The SLR (left) and point-and-shoot (right) can be very different not only in size and weight, but in how they feel in your hands.

Just as hands don't come in one size, neither do cameras. Spend some time just holding the ones you're considering. Cameras vary somewhat in weight and design; some will feel better to you than others. You want to find a camera that feels the most comfortable in your hands, whatever size they are. Insist, even in the big-box or office supply stores, on being able to hold the camera and take a few test shots. You need to be able to play with the camera and explore the various features, and that means having the batteries installed and the camera activated. This allows you to check on such important features as shutter lag time, zoom control, and general responsiveness. You probably wouldn't dream of buying a car without driving it, so take your prospective camera for a test spin, too.

Don't immediately judge a salesperson by his age! Many people get into photography at a very young age, and once the passion strikes, it doesn't take long to collect an impressive amount of information on the subject. Younger sales people may know the digital world better than their elders, too.

Making Your Purchase

The time has finally come. You've done the research. You've price and comparison shopped, and you're ready to buy the camera of your dreams.

Where to Buy

If this is your first camera purchase, think seriously about buying from the camera store with the friendly sales staff that gave you so much assistance when you were merely looking. You'll most likely pay more than you would through other sources, but the level of assistance and attention you'll get may well be worth it. They'll also be a good information source to tap in the future when you have further questions about how to use your camera, what accessories are essential, and what can wait.

Buying Through Online and Mail-Order Sellers

Both online and mail-order sellers often offer better prices than your local brick-and-mortar camera shops, but they can be frustrating to deal with. If you're not comfortable buying through a website, most online sites have 800 numbers through which you can place an order. Be prepared to be assertive about what you want. Some companies, and some sales staff, have honed their pushy sales techniques into a fine art, resulting in customers who end up with equipment they didn't really want but got talked into buying anyway.

FACT

If you have to choose between putting money into a good lens or a good camera body, always choose the lens. The lens is the most important part of your camera. When you can afford it, move up to a better camera body and keep the old 35mm body as a backup.

The Downside of Online Buying

Here are some other possible issues to be aware of when buying online:

- **Bait-and-switch.** Sorry, they're out of the equipment you want, but they're more than willing to sell you something comparable—at a higher price. Say "No thanks" and try another site.
- **Restocking fees.** If you don't like the equipment, you can send it back, but they'll charge you for putting it back into their inventory systems.
- **Differences in prices quoted live and on the website.** What you see on the site and what you're told on the phone should always match, unless there's a special promotion going on that hasn't been added to the site. In that case, you should be offered a lower price or special deal. Shipping costs quoted online and by sales staff should also match. Print out the page with the information

about the camera you are purchasing and have it in front of you when placing the order. Always get the name of your salesperson and make a note of it.

If you're going to buy online, stick with one of the well-known camera retail stores as opposed to some fly-by-night company. Go to one of the business rating sites on the web and check the seller's customer satisfaction rating. If there are customer reviews of the store, read them.

Considering Used Equipment

While it can be a real thrill to unwrap pristine new camera equipment, buying new isn't the only way to go. For film camera users, used equipment can represent significant savings over new. Choosing used over new also lets you buy more camera than you might otherwise be able to afford. However, used digital technology is almost never a bargain.

Putting Used Equipment to the Test

Photographers often trade their used equipment in when they're upgrading or when they no longer need it. Whether it is worth buying has a great deal to do with exactly how much cheaper it is and what condition it is in. Researching new equipment costs will help you evaluate whether the used equipment you're thinking about buying is a good deal.

Being assured that used equipment is in good condition can be a bit problematic, but you can largely put your worries to rest if you buy from a local shop where you can see and test the equipment before you commit to purchasing it.

If you're buying really old equipment, say fifteen years or more, chances are very good that you won't be able to compare the selling price to what new equipment costs, as it's probably not being made anymore. If this is the

case, try looking through old photography magazines to see if you can find an ad for the camera that lists its retail price, or try contacting the manufacturer. In either case, the asking price should be significantly less than the original cost, unless you're buying a rare camera. Think long and hard before buying really old equipment.

Always examine used equipment thoroughly before buying it. Check both condition and function. Don't expect perfection—after all, it's used—but don't buy anything that's excessively worn, either. Acceptable condition changes for used equipment include the following:

- *Edge wear on the camera body.* This occurs naturally when the camera is used on a regular basis.
- *Small dents on the body or lens edges.* Again, these can occur naturally when the camera is used on a regular basis.

Here are a few totally unacceptable condition changes:

- *Large dents anywhere.* This indicates treatment more traumatic than just getting banged into a table or the edge of a desk.
- *Warped back.* If the camera back doesn't fit exactly right when closed, take this as a very bad sign and an indication of a prior trauma. It's also an opportunity for light to enter the body.
- *Deep scratches on a lens or on the imaging mechanisms inside the camera.* Slight scratches on a lens usually won't significantly affect performance. Some parts of a camera's imaging mechanism can be replaced, but the repair can cost as much as the camera did.
- *Lens fog.* This is an indication of a lens that has been improperly stored or that has experienced significant temperature variations. It may clear up, but don't take the chance.
- *Autofocus problems.* A lens that doesn't adjust smoothly could indicate improper storage or trauma.
- *Other technical defects.* Look for things like zoom lenses that are too loose or too tight in their movement or focusing that just doesn't feel right.

Finding Good Used Equipment

There are many sources for used cameras and equipment. Many major camera stores sell consignment or rental equipment, and some mail-order houses specialize in used gear. Since they have their reputations at stake, they're usually the best choices for buying used equipment, but you may find that the amount you save doesn't justify buying used. Online auction houses such as eBay are another popular source for used cameras and camera gear. If you decide to go this route, make sure the seller offers a money-back guarantee. You may have to pay shipping and restocking fees, but it's better than being stuck with an inferior piece of equipment.

QUESTION?

Are you thinking about buying a used flash at a bargain price?
You might want to think twice. Flash components, such as the flash tube and capacitors, do not age well. Capacitors weaken when they are not used for long stretches of time, so a mint condition four-year-old flash is still a liability.

Even when buying used, keep a written record of the purchase price and date. If there are any warranties associated with your used camera or if there's a limited time for returning defective merchandise, mark those dates in your date book or calendar.

It is also a very good idea to make a list of serial numbers of bodies, lenses, and flashes that you purchase, as well as the purchase date and price. If you ever go pro, this information will be useful on your tax forms. It is also good to have that information organized for insurance purposes.

Buying Used Manual SLRs

If you want to learn all the ins and outs of photography through using a manual film SLR, your chances of finding one will be greatly improved if you're willing to buy used. Most manufacturers no longer make manually operated SLRs, although there are some models that have manual override controls. Start shopping for used equipment, and you'll find older model

manual cameras that will be perfectly serviceable. They'll let you explore all you need to learn about shutter speed and apertures at a reasonable cost.

Bringing Your New Camera Home

First things first: unpack your equipment! Check the camera inside and out to make sure you've removed everything that was used to pack it. Remember to save all receipts and warranty cards for your new equipment in a safe place. If you need to return the camera shortly after purchase, stores like to get the warranty card back blank, just the way they sold it to you. Actually, you're protected by the warranties whether or not you send in the cards.

FACT

Never touch any glass surface, the mirror, or the shutter curtain with your bare skin. The tiny bit of oil and moisture your touch leaves behind can be damaging to fragile components.

Familiarize Yourself with the Equipment

Be sure you know the equipment and are comfortable with all the features. Spend some time simply handling the new camera and familiarizing yourself with it. Turn it around in your hands. Check out the various dials and buttons. If there are accessories, examine these, too. Put the strap on the camera and place accessories in the camera bag.

Read the Supporting Materials

Start reading your instruction manual. It is the best way to learn about everything your camera can do. Many have a quick-start section with enough information to get you started shooting within minutes. Usually there will be a page illustrating the camera, with callouts telling what the names and functions of the various dials and buttons are. Most digital cameras come with both instruction manuals and a CD with image processing software and a manual as well. Put the CD in a safe place and read the

"Getting Started" section of the camera's manual. It will usually walk you through getting the camera set up, with such essential information as how to put the batteries in, load the film or insert the memory card, and upload files. It will also tell you the location and function of the various controls and dials. Be patient and take a few minutes to really understand the basics before you start shooting, but if you can't restrain yourself, that's okay—film is cheap and memory cards are reusable. Who can blame you? An enthusiastic attitude toward photography is a wonderful thing!

CHAPTER 6

Getting to Know Your Camera

Whether your camera is brand-new or just new to you, you will need to get to know it thoroughly. This entails learning about how cameras take pictures, how to use and manipulate the camera's controls, and the role you play in the equation. It also involves learning how to handle your camera correctly and how to take care of it to ensure years of picture-taking pleasure.

Holding the Camera

There's no great secret to holding a camera, but it does take a little bit of practice to learn how to hold one for the best results. And it's a good idea to practice it, as silly as this may seem. If you're comfortable holding your camera, you'll also be comfortable operating it.

Basics of Holding Your Camera

1. Put both hands around your camera. Do it in a way that feels natural to you. Watch for fingers finding their way in front of the flash or the lens on tiny cameras. Check yourself in the mirror to see where your fingers naturally fall to see if they are getting in the way.
2. Press the camera to your face. Tight is good, but don't push it in so close that it's uncomfortable.
3. Drop your elbows down so they're against your body. This will help you steady the camera.
4. Plant your feet firmly on the ground, about shoulder-width apart or slightly less. You can shoot from other positions, but this one is the most solid.
5. When shooting, take a breath, exhale fully, hold your breath, then squeeze the shutter release button smoothly.

When you're using a long zoom or telephoto lens, use your left hand to support the lens by cupping it around the lens close to the camera body. Hold the camera in your right hand so you can activate the shutter.

Steadying the Camera

Small cameras are harder to hold than big cameras, and, without the inertia caused by the weight of larger cameras, they're more likely to move when you press the shutter. This can result in blurry pictures as the image captures both camera movement and the movement of your hands. The suggestions will go a long way toward helping you keep your camera steady as you're shooting. For slower shutter speeds or when you're not using a flash, make sure you brace your elbows against your body. You can also lean on a steady support to minimize movement.

Adjusting Your Camera

Spend some time working with the various dials and buttons on your camera so you know what their functions are and how to operate them. Some will have multiple functions and submenus. Never force anything into position; doing so may damage your camera or, in the case of conventional film cameras, the film. Camera controls should work smoothly, but if yours don't, take your camera into a good shop and have it looked at. If it is still under warranty, contact the manufacturer.

Leaving the Automatic Zone

If you've bought an automatic SLR, you may be tempted to leave the camera in fully automatic mode and snap away. This mode relies on the camera's light meter to adjust shutter speed and aperture, and it will automatically set the focus for you if you want it to. Most of the time, auto mode will deliver acceptable or better results. Objects will be in focus and properly exposed. When you are first learning to shoot, leaving the camera in auto mode can simplify things greatly, allowing you to concentrate on learning the other photographic skills you'll need.

Creatively Using Manual Controls

Auto mode is fine, and it's certainly easy, but it's not going to give you the best picture possible every time. Eventually you might hear a pesky little voice in your head asking, "Would the shot of the kids playing at the lake be better if I could see more details related to them and less of the lake's ripples and glints?"

The answer to this questions is, of course, yes! That's why it is so important to know how to take your camera out of auto mode and control such things as shutter speed and aperture yourself. It's also important to know how such factors affect each other and how to select the best settings to render the images you want.

Be prepared. This discussion can get rather technical. If you're not particularly technically oriented, you might even find it a bit overwhelming, so

take things slowly. Study each aspect thoroughly. It really helps to have your camera at your side so you can see what the various settings and controls look like.

Manual Controls and Point-and-Shoots

Keep in mind that much of the information that follows is more suited to SLR users who have either automatic cameras that allow manual settings or fully manual cameras. However, if you have a point-and-shoot that allows some manual overrides, you'll find plenty of information in this chapter that applies to you, as well.

Finally, this is all meant as a broad overview. The best way to learn more about the mechanics of picture taking is to take pictures. Lots of them. Use the information to guide your explorations; for specific help on leaving the automatic mode for your own camera, read the instruction manual that came with it or a guide written specifically for it. If you have lost your original manual, sometimes you can order or download one from the manufacturer's website.

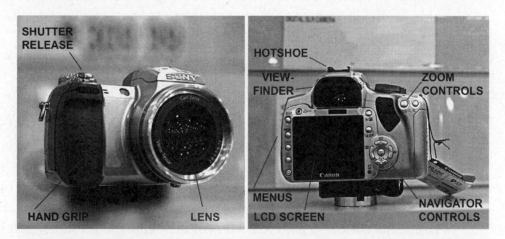

▲ **FIGURE 6-1** Whether they are point-and-shoot or SLRs, all cameras have certain features in common: a way to view the image, a way to adjust focus, and a shutter release.

Let There Be Light

Taking a picture in its simplest form means exposing the film to light. Two different devices—the shutter and the aperture—work together to determine how much light enters the camera and hits the light-sensitive surface.

Open and Shut Cases

The shutter controls the length of time that light is allowed to expose the light-sensitive surface. On modern SLR cameras, shutter speeds are usually indicated on a display panel or a shutter-speed control dial. Some older SLRs have a shutter speed control ring on their lenses, which you turn to select the speed.

Shutter speeds are measured in fractions of a second—a shutter speed of 125 means 1/125th of a second. Typical shutter speeds range from 1 second to 1/1000th of a second.

Understanding Shutter Speed

The higher the number, the faster the shutter opens and closes. Shutter speeds also allow precise control over how long light enters the camera. A speed of 1/125 will let light in for 1/125th of a second.

When working with shutter speeds, keep in mind that slow speeds—those of 1/30th of a second and longer—will require you to use a tripod or another very sturdy support. Slower speeds will capture every tiny movement the camera makes, so the camera must be held as still as possible. Some people with very steady hands might be able to take handheld pictures at 1/15th of a second, especially when shooting with a normal or wide-angle lens. Getting a steady shot with a zoom or telephoto at this shutter speed, however, would be nearly impossible.

The following list outlines the best shutter speeds for certain conditions:

- **B (Bulb).** Best for taking pictures at night when you need long exposures. Keeps the shutter open for as long as the shutter release button is held down. Must use a tripod or other sturdy support.

- **1 second, ½ second.** Best for shooting at night and some dim lighting situations using narrow aperture settings. Good for photographing objects. Must use a tripod or other sturdy support.
- **⅛ second.** Good at letting in enough light when needed for small apertures in low light situations. Must use a tripod or other sturdy support.
- **1/15 second.** Taking pictures in existing light when using small apertures. Tripod or other camera support is recommended to avoid camera shake.
- **1/30 second.** Another good shutter speed for existing-light pictures. Slowest shutter speed recommended for handheld photography.
- **1/60 second.** Outdoor photography in overcast conditions and on brighter days when using a narrow aperture. Better than 1/30 for eliminating camera motion.
- **1/125 second.** Outdoor photography under bright light with wider apertures. Good for capturing moderate action. Also a good speed for using short telephoto or moderate zoom lenses.
- **1/250 second.** Outdoor photography with good light and wider apertures. Lets you capture faster action. Slowest shutter speed for handheld telephoto sports shots.
- **1/500 second.** Even faster action shots. Needs good light and wide apertures. Good shutter speed for fast-action photography with a long lens.

Once you get above 1/500 of a second, you'll be able to shoot even faster action. However, these shutter speeds require a lot of light or very wide apertures, which result in extremely shallow depth of focus.

All about the Aperture

The aperture is the opening in the lens that changes in size to let in more or less light. Numbers called f-stops indicate how large or small the opening is. When dealing with f-stops, keep in mind that smaller numbers relate to larger lens openings. Larger numbers refer to smaller openings.

As you move up the f-stop ladder, each number lets in half as much light as the previous one. For example, f/8 lets in half as much light as f/5.6.

For the technically minded, it is interesting to note that aperture numbers represent the ratio of the focal length of the lens divided by the diameter of the aperture. If a 200mm lens has a 50mm opening, you have a ratio of 200/50 and an aperture of f/4.

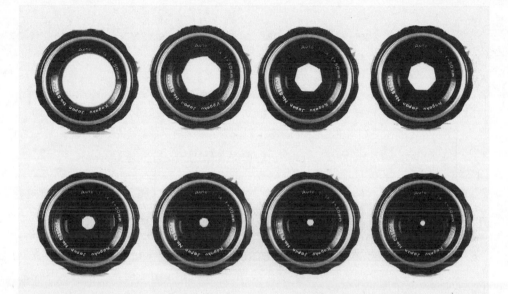

▲ **FIGURE 6-2** This is what the aperture openings look like on a 50mm lens. On the top row (left to right) are f/1.4, f/2, f/2.8, and f/4. On the bottom row (left to right) are f/5.6, f/8, f/11, and f/16.

Apertures and F-Stops

All SLRs have identical f-stop numbers, but the settings you'll actually be able to use will vary depending on the aperture range of the lens you're using. For example, the dial on your camera body may go down to f/2, but you might be using a lens that only opens down to f/3.5. In this case, although your camera can handle a wider aperture, your lens can't, and

you'll be limited to what the lens can do. Many zooms change f-stop as you zoom—f/2.8 when at wide angle, but f/3.5 when zoomed to telephoto. There are also zooms that have a constant aperture at any zoom.

F-stops can be confusing. For example, it may seem that an f-stop of 4 (f/4) would be double the light of f/8. There's a long mathematical explanation for why it's not, but it's perfectly acceptable—and easier—not to go into it. Just accept the settings for what they are, and understand how they relate to each other. This may seem a bit confusing now, but after a while it will become second nature.

QUESTION?

What does it mean when photographers talk about opening up a lens?
Opening up a lens refers to using a smaller f-stop number, which creates a wider, or larger, lens opening. The opposite is stopping down a lens, or choosing a larger f-stop number and a smaller opening.

Controlling Exposures with Apertures and Shutter Speeds

Aperture and shutter speed settings work together. Each approximately halves or doubles the light reaching the light-sensitive surface. Because they work in tandem, it's possible to get the same exposure with a number of different settings, like the combinations in the following table:

TABLE 6-1					
Aperture	f/5.6	f/8	f/11	f/16	f/22
Shutter	1/500	1/250	1/125	1/60	1/30

Approximately the Same Exposure

If your camera has automatic overrides for shutter speed and aperture control, you'll probably be able to see how these factors work together. Set

your camera for either aperture priority or shutter priority mode. Then manually adjust one or the other, depending on the mode you chose—if your camera is in aperture priority, adjust the aperture (f-stop); if it's in shutter priority, adjust the shutter. As you move through the settings for the priority mode you've chosen, you'll see the factors for the other change as well in your indicator window. More open aperture settings (such as f/2.0) will show higher shutter settings and vice versa.

Experimenting Will Help

If this all still seems a little confusing to you, try reading the instructions with the camera right in front of you and following along. You will better understand the relationship between shutter speed and aperture size when you have a practical example right in front of you. Try firing off a few test shots at the aperture and shutter settings listed above, then develop the film or upload your files to your computer to see how manipulating shutter and aperture change the actual photo.

Why Exposure Settings Are Important

Choosing the appropriate pair of exposure settings not only gives you the proper exposure, it also helps determine how much of your picture is in focus (depth of field) and whether moving objects are crisply rendered or blurred. A combination of f/22 for the aperture opening and 1/30 for shutter speed will give you greater depth of field and focus on more objects in the scene, but they'd better be perfectly still or you'll end up with substantial motion blur on the picture.

Which Setting Is Right?

The setting that is correct or takes priority depends a lot on what you're shooting. If the scene involves action, you'll definitely want as fast a shutter speed as you can use to capture all of it, so the shutter speed will be your first determination. To avoid underexposing the film, you'll also need to set a wider aperture to let more light in, or, if you need to shoot with a smaller aperture, you'll need extremely good light. There is slightly more

room for fixing exposure errors when shooting digitally, as the exposure can be tweaked a bit in an image-processing program.

FACT

The film you use will also influence your choice of shutter speed and apertures. Slow film calls for slow shutter speeds and wide apertures. Faster film allows for faster shutter speeds and smaller apertures. More information on film speed can be found in Chapter 8.

If you're taking a long shot of a mountain scene, you'll care less about the shutter speed and more about the aperture, especially if you want to make sure that as much of the scenery as possible is in focus. In this situation, you can use a smaller aperture and a slower shutter speed.

F-Stops and Image Quality

Another factor determining setting priorities is how the f-stop affects image quality. The largest f-stop for a lens will let in the greatest amount of light, but it will yield the minimum depth of field and the poorest image quality for the lens. Move up a stop, and image quality gets better. Go up to the middle of the f-stops possible on any particular lens, and you'll get the best image quality the lens can deliver. As you continue going up the f-stop scale to the smallest possible aperture for the lens, image quality will deteriorate again, primarily when it comes to sharpness, but not as much as on the other end of the scale. This is less of a factor in higher quality lenses and cameras.

Basics of Depth of Field

Depth of field describes how much of a picture is in focus. For general photographs, you want the subject in focus. It also refers to how much of the scene in front of and behind your subject can be seen clearly. Objects closest to the point of focus will look very sharp; those farther away will be less sharp but will still be acceptable, as long as they're within the depth-of-field

zone. The depth of field is shallower in front of a subject (in between the subject and the camera) than behind it.

Remember that three factors determine depth of field:

- The lens's aperture
- The lens's focal length
- The distance from the camera to the subject

Aperture and Depth of Field

Wide aperture settings result in shallow depth of field. Pictures taken this way will have the subject in focus and the foreground and or background out of focus. As apertures narrow, depth of field lengthens, resulting in more of the picture being in focus. Limited depth of field can be a great way to ensure that a cluttered background does not distract the viewer's attention from the subject.

Focal Length and Depth of Field

The depth of field rendered by each lens differs depending on its focal length. For now, just remember that depth of field is inversely proportional to the focal length of the lens. In other words, shorter lenses have greater depth of field; longer lenses have a shallower depth of field. A 50mm lens will capture more of the picture in sharp focus than a 100mm lens with exactly the same aperture setting.

Lenses are usually marked with scales that indicate their depth of field. If your camera or lens doesn't have depth-of-field markings, see if there's a depth-of-field scale in your camera or lens instruction manual. In manual mode, you can use these scales to determine how much of a picture will be in sharp focus from foreground to background before you snap the shutter.

Distance and Depth of Field

Depth of field is also directly proportional to distance. In other words, a subject that's farther away from your camera will have greater depth of field than one that is closer. Changing the aperture setting won't have a

◀ FIGURE 6-3 The moon was the primary subject of this shot. The leaves in the foreground are a much softer focus than the primary subject, allowing it to shine.

huge effect on the depth of field for a distant subject or if you're using a lens with a short focal length. However, it can make a big difference in closeup work, where you're dealing with a much shallower depth of field, or when you're using lenses with longer focal lengths, which have shallower depths of field.

Focusing—Automatic and Manual

Autofocus is a common feature on most 35mm SLRs and point-and-shoot cameras. There's really not much to using this feature; the camera does the work for you. All you have to do is look through the viewfinder to check whether the camera has focused correctly on what you want in the picture.

Autofocus Options

Autofocus can be a wonderful tool, especially for photographers with less-than-perfect eyesight. But there are times when autofocus can be a drawback, especially when using long zoom lenses. The focusing mechanism of a zoom lens can chatter back and forth rather loudly while it's determining its sharpest setting. When you're in situations where these adjustments might be distracting, such as taking pictures of wildlife, you'll probably need to focus manually.

Manual Options

There is really no great trick to manual focusing, other than being able to see well enough to focus things yourself. Just adjust your lens from automatic focus to manual and turn the focusing ring. The viewfinder will tell you when the image you're focusing on is clear.

Most autofocus cameras have a nifty function called focus lock that lets you try various ways of composing a scene without having to refocus all the time. To use it, get your subject in the center of your viewfinder, where the autofocus is located. When you have the focus set, push the shutter or focus lock button (depending on your camera's setup) to lock it into place. Then recompose the scene. Keep in mind, however, that your distance from the object needs to stay the same. If you move forward or backward, you'll need to refocus.

Camera Care and Feeding

Cameras are meant to stand up to some fairly rigorous use, but like all fine instruments, they will perform much better if they're well cared for. Heat, moisture, dust, oil, and shock are your camera's biggest enemies. There are procedures and practices that will help you keep your camera safe to ensure it will deliver years of satisfactory performance.

Cleaning Lenses

Cameras are pretty easy to keep clean, but they benefit from a periodic wiping down with a soft cloth to remove any oils, grime, or grit they may have picked up while being used. Some photographers polish their cameras each time they finish using them. It's not a bad habit to get into, but less frequent cleaning won't hurt things, either.

You can remove dust from the body by wiping it with a soft cloth. Be careful when wiping any sensors, the LCD screen, or the viewfinder. If the inner mechanisms need to be dusted or cleaned, use a blower brush. These are usually available in camera-cleaning kits. If it doesn't do the job, take your camera in for servicing. Aerosol spray dust removers might pack too

much of a punch for cleaning delicate mechanisms; check your instruction manual to see what your camera's manufacturer recommends.

Keeping Cool

Heat not only thins out the oils that lubricate a camera's moving parts, it also damages film, causing color film to shift in color and black-and-white film to fog. Film and camera manufacturers know their products will get hot, so don't worry if your camera occasionally gets toasty, but do try to avoid it when you can. Protect your camera by keeping it out of the sun as much as possible. Never store your camera in a hot car; it's just as bad as subjecting it to direct sun.

ALERT!

If you have to store your camera in the trunk of your vehicle, get a cheap Styrofoam ice chest. Don't fill it with ice—just put your camera in it and close it up. If you are shooting using a film camera, put your film in there, too. If you can't find a Styrofoam chest, any type of insulated cooler works just as well.

Keeping Warm

Cold can be damaging to cameras, too. In colder climates, cameras left for too long in unheated vehicles can be damaged or respond sluggishly when used. Don't let your camera remain overnight in a glove compartment or trunk. The same cooler that protects your camera in summer can insulate it in winter.

Keeping Dry

Cameras aren't fond of moisture of any type, which is why you'll find little desiccant packs tucked into the box when you buy new equipment. Your camera store might even give you a couple when you buy your camera. These packs contain pellets of silica gel that soak up moisture from the air, which can get inside your camera's mechanisms.

Keep a couple of desiccant packs in your camera bag at all times. If you store your equipment somewhere else, throw a few in there, too. If you're in humid conditions most of the time, it's a good idea to dry the packs out by sticking them in a low oven for a few minutes.

Moisture isn't much of a concern if you live in a dry climate, but it definitely is in more humid spots, or when going from air-conditioned rooms to the great outdoors in humid climates. In really humid conditions, moisture can cause fungus and mold to grow on your camera lens, which can etch the surface and cause permanent damage.

You can make your own desiccant packs with silica gel bought from a craft store (it's the same thing that's used to dry flowers), a garden store, or from the Internet. The best stuff has a pink/blue color indicator system that shows how much moisture is being absorbed. Put it in a small plastic bag that you've poked a couple of holes into. When the color changes from blue to pink, it's time to dry out the gel. It can be reused over and over again.

A short neck strap will keep your camera more secure and stop it from banging into tables and other things. If you lay your camera down, wrap the strap around the camera so that it doesn't get pulled onto the floor. Vibration caused by plane travel or bumpy car trips can loosen the screws on your camera equipment. Protect it in a padded camera bag.

Protection from the Elements

Although a little water won't hurt your camera, especially if you wipe it off right away, it's better to keep your equipment dry. Stick a few plastic bags in your camera bag for wrapping around your camera for times when you're shooting in inclement conditions. A lens hood or UV filter on your lens will help keep it safe as well.

Ocean beaches are not your camera's favorite vacation spot. Surf spray, even twenty feet from the water, will coat your lens. The salt corrodes gears over the years, and the sand gets inside the mechanisms, jamming them and wearing them out prematurely. In film cameras, sand can even get caught in the film path and cause scratches.

Wipe off any sea spray immediately with a clean cloth dampened with fresh water. Better yet, bring a disposable camera to the beach. If you do use your SLR, cover it with a plastic bag when not using it. You can even shoot through the bag if you cut a hole for the lens.

All about Batteries

Most cameras need batteries to operate. Some fully manual SLRs without light meters are fully mechanical, and require no power to operate. However, the vast majority of cameras out there, especially the ones you'll be looking at, require a power source. Your instruction manual will tell you which one your camera uses.

Lithium batteries will last the longest, especially with power-hungry automatic cameras. Always keep a spare or two around, as weak batteries will affect camera performance. Keep your fingers away from the contacts when installing batteries. The oil from your skin may cause electrical or battery problems.

Digital cameras in particular burn through batteries very quickly; small point-and-shoots with no optical viewfinder are the worst offenders. Using rechargeable batteries and always keeping a spare pack as backup in your camera bag goes a long way toward alleviating the short battery life problem. Many SLRs come with their own rechargeable battery. It is a very good idea to buy an extra and have it charging while the other is in the camera.

CHAPTER 7

Accessorizing
Your Camera

Photography is definitely a delight if you're a gadget lover. There's a seemingly endless array of products and devices to choose from. Some are essential; others you can probably live without, but they might make your picture-taking even more fun and enjoyable.

Bagging It

Something for storing and carrying your equipment is at the top of the essential accessories list. You could use just about anything for this—a backpack, briefcase, even a purse—but it's a better idea to invest in a good camera bag specifically designed for this purpose. It will do a better job of protecting your camera and other equipment.

Soft-sided camera bags are far and away the most popular ones out there. They come in lots of different shapes and sizes and are available in all price ranges.

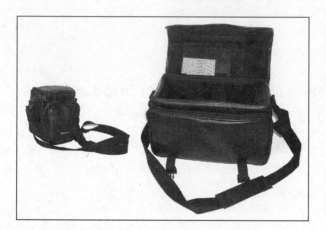

◀ FIGURE 7-1
The needs of those shooting with an SLR versus a point-and-shoot camera are very different. The small bag on the left will adequately protect a small camera, but a larger bag with room for extra lenses is needed for an SLR.

Bag Construction

Soft-sided camera bags are made out of several different materials. Heavyweight waterproof ballistic nylon is one of the most durable. A good choice is waterproof Cordura nylon.

ALERT!

Hard-shell camera cases offer the most protection for your gear, but they are heavy and often very expensive. They're also favorite targets for thieves. Unless you plan to travel a great deal with your equipment, there's little reason to invest in one.

All but the most basic camera bags have individual compartments or dividers to help keep your camera and lenses from rubbing together and banging into each other when you carry them. Higher-end bags often have adjustable dividers to allow for different camera bodies and lens sizes. Most bags also have at least one outside pocket for storing such items as lens covers, filters, instruction booklets, cleaning equipment, and so on.

Bag Styles

Camera bags also come in a variety of styles. The most popular—and the one favored by most professional photographers—are shoulder bags. These bags feature zip-around tops that flip open to reveal the equipment nestled in the bottom of the bag. They can be easily accessed as you carry them, and they are great for taking pictures on the fly, as you can reach in and assemble your equipment while you're walking (or running!).

Another popular choice, especially for hikers and others who like to shoot in the field, are photo backpacks. They're similar to regular backpacks, but with more padding to protect the equipment. They also have compartments like shoulder bags do. Waist packs or hip bags are options for people who don't want the weight of their equipment on their shoulders or backs.

Choosing Your Bag

Just like there's no one camera that's right for everyone, no one camera bag will fit the bill for all. Go to a good camera store and test drive the ones that appeal to you. Look for bags with good, solid construction and tight, even stitching. Check out the divider system—it should offer enough compartments for your camera and the lenses you plan to carry most often. More expensive bags will have adjustable dividers so you can custom fit the compartments to your equipment.

Here are some good features to consider:

- **Two-way zippers.** Lets you access the bag from both sides.
- **Waterproof material.** Unless they're designed for underwater use, cameras and water don't mix. If you're considering a bag made of waterproof Cordura nylon, which is notoriously tough on clothing, it

should have a material protector on the back. Another good water-protection feature is a rain flap over the zipper track. It'll help keep dust out, too.

- **Handle and strap.** Having both adds versatility to your bag. In a pinch, the strap on some bags can be used as a camera strap.
- **Detachable film pocket.** Allows you to remove the film when your equipment goes through airport scanners. They're also handy for long-term film storage. Just fill it up and stick it in your fridge.
- **Exterior pocket.** Makes it easy to get at filters, manuals, cleaning supplies, and so on.
- **Tie straps and d-rings.** Useful for carrying tripods and for attaching accessories such as waist belts or backpack harnesses.
- **Reinforced sides and bottom.** Essential with larger bags.

Finally, pick a bag that will comfortably handle the equipment you plan to use regularly. Pack a small bag with the equipment you need and leave the rest at home. If you can afford to buy two bags, get one with more capacity for storing all your equipment at home or to use when you need to carry more gear than your smaller bag can handle.

Strapping It On

Most cameras come equipped with a camera strap. While this particular accessory can seem rather awkward at first, you'll soon find that its functionality far outweighs the touristy image. All it takes is one moment of clumsiness to convince you of the necessity of this feature. Whether you use it to carry your camera around your neck or over your shoulder, or to secure it in your hand while walking or shooting, you'll soon find that a camera strap is an essential piece of gear.

If your camera came with a thin strap—less than 1" wide—think about replacing it with a sturdier model that will do a better job of distributing the camera's weight on your neck or shoulder, particularly if you're shooting with an SLR. One with rubber backing along the middle or with a rubber-backed shoulder pad will lessen the chances of the camera slipping off your shoulder and banging into something. If you plan on using heavy telephoto

lenses on a regular basis, you may want to invest in a strap that's specially designed to make it easier to carry this equipment.

Regardless of the type of strap you use, make sure it's securely fastened to your camera. The user's manual should have detailed instructions on how to do this. If you're not absolutely sure how to do it, have a clerk at a camera store attach the strap for you.

Keeping Things Steady—Tripods and Other Devices

When exposures require slow shutter speeds or when you're using long telephoto lenses that greatly magnify images, it's almost impossible for even the steadiest hands to hold a camera still enough to avoid camera shake. You have three choices for eliminating the shakes: avoiding situations in which they can occur, using flash to freeze motion, or buying something to support your camera. New image stabilization technology has gone a long way toward eliminating a lot of the blur that formerly plagued photographers, but you may still find a tripod a worthwhile accessory.

Tripods

Tripods are by far the most popular and widely used camera support accessory. They're made of various materials, ranging from wood to high-impact plastic to metals like aluminum or titanium. Depending on their construction, they can be light and portable or heavy and sturdy.

Keeping the camera steady is job number one for a tripod, which means choosing one that's rock solid, regardless of what it's made of. There are also other considerations when it comes to choosing a tripod, including:

- **Weight.** Heavier tripods are definitely more stable, but they're also difficult to carry and set up.
- **Height.** You'll want a tripod that extends to your eye level and remains stable there.

- **Head style.** Both pan-and-tilt or ball-and-socket heads allow cameras to be adjusted in almost any direction. Some tripod heads have quick-release platforms with plates that can be screwed to the camera bottom.
- **Size.** Choose a tripod that folds down to be small enough for easy carrying.
- **Center post length.** The center post, which also raises and lowers camera height, is not as steady as the rest of the tripod. The shorter the extension, the steadier the camera. Use the legs of the tripod to get the camera at approximately the height you want, and use the center post only for precision or quick adjustments.
- **Leveling bubble.** This feature is quite useful for keeping the center post vertical and avoiding tilt when you pan the camera.

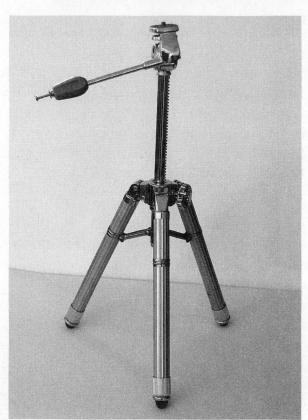

◀ **FIGURE 7-2**
This small tripod has a ball-head mount that allows the camera to be moved into almost any position.

Testing, Testing

Test drive any tripod you're thinking about buying by fully extending its legs and pushing down on its head with your hands. If you can move it easily, it won't be stable enough to support your camera. You can also test stability by sticking the heaviest lens you own on your camera and mounting it to the tripod. Again, it shouldn't move or buckle under this weight. Be sure to protect your camera from damage while doing this sort of testing.

Avoid tripods that only allow you to aim the camera in one direction. They're often cheaper than tripods that allow greater adjustment, but their lack of versatility limits their usefulness.

Operate the locking action on the tripod head, legs, and center column. All should firmly lock when you turn them finger tight. If you have to struggle to lock or unlock a feature, the tripod will become an unwelcome addition to your gear, and it won't get the use it should.

Monopods

Monopods are similar to tripods. As the name suggests, they have only one leg instead of three. They can be useful for steadying long and heavy telephoto lenses because they can be screwed into rings that many telephotos sport for this purpose. That's about all they're useful for, however. If you're in a situation where you need one, you can use a tripod with its legs collapsed.

Bean Bags

Beanbags are inexpensive and passable camera supports when you don't have better ones handy. You can find them in hobby stores and toy shops, or you can even make your own out of canvas and any dry and granular substances you have on hand—rice, dried beans, even sand. In any case, check to make sure the seams are tight. If you have a tripod that's a little on the tippy side, or if the tripod needs something to stabilize it due to

wind or other adverse conditions, you can hang a heavy beanbag from the tripod's center column to stabilize it.

ALERT!

If you're really pressed for something to steady your camera, fill a large plastic baggie about three-quarters of the way with rice, dried beans (lentils work particularly well), or sand. Choose a bag that seals tightly, and squeeze as much air out of it as possible before you close it.

Clamping It On

Camera clamps screw into the tripod socket on the camera and have jaws that can be attached to convenient objects, such as furniture, doors, and other firm anchor points. Some camera clamps have suction cups for mounting on smooth, flat surfaces, such as a window.

Please Release Me

A cable release—electronic, manual, or remote controlled—will further insulate your camera from movement. Some cameras don't offer this option, in which case using the self-timer function can give the camera and its support time to stop moving and then fire when everything is still.

Lens Gear

Accessories for camera lenses run the gamut from things that protect your camera gear to gadgets that enhance what the lenses do. It's always a good idea to buy a couple of spare lens covers, as they can easily get lost as you put them on and take them off, but there are other lens accessories that are also well worth considering.

Lens Shade

Lens shades increase picture quality by cutting out extraneous light, which can do nasty things to your pictures. Some lenses come with a shade.

If yours didn't and you want to use one, you'll need to buy one that fits each lens, both in terms of the filter size of the lens (the diameter of the threaded front of the lens) and the focal length.

ALERT!

A wide-angle lens can only handle a shallow shade. If you put a telephoto shade on a wide-angle lens or wide-angle zoom lens, you are likely to experience vignetting, or a darkening of the corners of your picture. You won't see it through the lens, but you'll definitely see it on your prints.

Filtering the View

Lens filters change the way in which light reaches the film. In so doing, they also change the way in which images will appear on film. Some filters simply enhance things, such as making colors look more true or eliminating glare and reflections from shiny surfaces. Other filters are used to create special effects such as softening the focus on portraits.

The one filter that's a must-have is an ultraviolet or UV filter. Also known as haze filters, they cut down the ultraviolet light, or visual haze, that you can't see but your camera can. Even more important, they protect the delicate lens of your camera from dust and other elements that can harm it. They're relatively cheap, so buy one to fit every camera lens you own, and keep it on the lens unless you're using another filter.

Other filter types to consider adding to your gear bag include the following:

- **Polarizing.** Just like sunglasses with Polaroid lenses, these filters cancel reflections and glare caused by shiny surfaces and enhance blue skies on color film. The best ones rotate 360° in their mounts to control how much they cancel reflections or darken the sky.
- **Star filters.** These specialized filters have grids etched into them that turn light into stars. There are several different types available; the best allow you to rotate the grids to control how many points the stars have, as well as their direction.

- **Light balancing.** These filters reduce the amount of light coming through the lens or balance the color of artificial light.

There are literally dozens of different types of filters. The categories of lenses listed above cover only your primary needs.

Tele-Extenders

Also known as teleconverters or extension rings, these tube-like devices increase the focal length of a lens and make it capable of greater magnification. Although the images they render aren't as sharp as those made with a true telephoto lens, they're a cheap alternative, especially if you don't plan to use one very often. Tele-extenders also require you to focus manually in most cases.

Improving Flash Photography

The built-in flash on most cameras makes quick grab shots easy and fool-proof, but they're not much on delivering quality flash photos. Attaching a flash unit to the accessory shoe on top of your camera is definitely a step up from using a built-in flash. Putting that flash on a bracket, however, will yield even better lighting and better photos.

FACT

Holding a camera, bracket, and flash in front of your face can put a strain on your wrists and hands. When you're not shooting, hold the camera in a way that rests them to avoid repetitive stress injuries and tendonitis.

A flash bracket is essentially an L-shaped piece of plastic or metal. One arm of the "L" screws into the bottom of your camera; the other arm holds the flash. Putting your flash on a flash bracket instead of mounting it on the top of your camera is one of the easiest ways to reduce or eliminate red eye.

You will probably find that a camera with a bracket and flash is clunky hanging from a strap around your neck. This means that when you aren't shooting, you may want to put the gear down on a table. A few expensive brackets are designed to be set down with the camera and flash sitting upright, but most brackets will be most stable when the camera is laying on its front or back.

More Useful Gadgets

These items aren't essential, must-have products, but they can definitely make life easier for most photographers, especially those who spend a lot of time behind the lens.

Film Changing Bags

These simple devices—lightproof bags with enough room for your camera and hands—let you open your camera in broad daylight. They can save the day when your film jams or the leader breaks and there's no dark place for you to safely open your camera and see what's going on. They can be one of the handiest things to have around, so buy one before you need it. Many photography stores have changing bags on hand to help photographers in this situation.

ALERT!

If your SLR is not snapping into focus, it is very likely because your diopter adjustment is set incorrectly. Adjust it by focusing your eye on lines or lettering visible in the viewfinder.

Help for the Bespectacled

Photographers who wear glasses have some special challenges to overcome when taking pictures. If they want to wear their glasses while focusing, they often can't get close enough to the viewfinder to see all four sides of the frame at once. One way to get around this is to use a tripod, which

will let you move your head up, down, and sideways in order to see all four edges of the frame.

Some cameras are friendlier than others to wearers of glasses. If you're farsighted, you can find SLR models with built-in, adjustable diopters that will let you see through the viewfinder without your specs. Other camera manufacturers make separate eyepieces with various corrections that can fit into your camera's existing eyepiece.

Reflectors

These handy devices are a photographer's secret weapon when it comes to dealing with tricky lighting situations. They're great for throwing light into shadows, diffusing light, or creating special lighting effects such as back-lighting. Some have special coatings that change the color of light. Portable reflectors are collapsible, making them easy and convenient to carry. There are also umbrella-style reflectors, which are more suited to studio work.

If you're going to invest in reflectors, buying a couple of light stands is a good idea. They can also hold additional lighting or backdrops. A light-stand bag, which should be big enough to hold your tripod and all the light stands you need when shooting on location, is also a good investment.

Viewing Loupes

These devices are great for looking at the details in negatives and prints. All you do is put it directly onto the surface you want to look at. Light coming in from the transparent sides of the loupe illuminates the image when you're looking at prints. It's helpful to have a light box or table when viewing slides or negatives, but you can hold them up to a strong light in a pinch.

A loupe may not seem like an essential piece of equipment, but you'll be surprised at how much you'll use it if you buy one. Never again will you have to squint at a negative to figure out if it's really the one you want to print, and that alone makes it a worthwhile purchase.

CHAPTER 8

Putting It on Film

If you've been taking pictures for any time at all,
you probably already know there are many differ-
ent types of film to choose from. What you may not
know is how to pick the right film for your needs.
It's not rocket science, but it does involve knowing
something about the various kinds of film and what
they can do.

Color Print Film

Far and away the most popular film in use today, color print film is versatile and easy to use, which makes it a great choice in almost any situation. It's widely available, cheap, and can be processed almost anywhere in less than an hour. If you need to see images fast, color print film is the way to go.

The Versatility Factor

One of the biggest advantages to using color print film is its versatility. You can under- or overexpose it to a certain degree, either intentionally or by accident, and it will still come out looking pretty good. Because it's not very fussy, it also works well in cheaper point-and-shoot cameras that don't have sophisticated metering systems. It also handles artificial light better than slide film, which means less fumbling with color correction filters.

FACT

Many color print films create images with vivid color and lots of contrast. If you feel your prints have too much oomph to them, try professional color negative film. It's more expensive than the rolls you pick up at your supermarket check-out stand, and you'll have to search for it (pro labs, camera stores, and online retailers are places to look), but the results will be worth it.

Correction Options

Many color and exposure problems can be corrected in the printing process. On the other hand, if the lab doing your work isn't up to the task technically, your perfectly exposed images can come out too light or too dark, or with unnatural colors.

Color Slide Film

Also called color reversal, color positive, and color transparency film, color slide film delivers unbeatable color and sharpness, and can render scenes

that are more vivid than real life. Professional photographers often use slide film, as it yields great color and sharpness and allows greater control for shaping images through the lens. It's a great choice for amateur photographers for exactly those reasons.

More Advantages of Color Slide Film

Slide film also gives you complete control over the images you take. Slides are first-generation images—they're captured directly onto film instead of being printed to paper—which means they can't be corrected (or messed up!) in the lab. When you shoot with slide film, what you see through your viewfinder is what you'll get on the finished slide.

With slide film, what you see is what you get. If you're shooting a particularly important picture, do what the pros do: Take the same shot with several different exposure settings (a procedure called bracketing) to ensure that you get the right one.

Great Options

Other reasons for shooting with slide film include the following:

- **Lower processing costs.** Instead of printing an entire roll of film, you can pick only your best shots for enlarging.
- **Easier to store and file.** You can easily fit more than a thousand slides in a storage container about the size of a shoebox. This same amount of images in prints would require several full-sized albums.
- **Best choice for testing new gear or perfecting your exposures.** Not only will your lab correct exposure problems with print film, it's also very hard to judge exposure by eyeballing a color negative. Any problems will be immediately visible on a slide.

Disadvantages of Slide Film

There are also a number of cons to shooting with slide film, including the following:

- **Less convenient for viewing images.** With slides, you need projection equipment—a slide viewer, light box, or projector—in order to see your pictures. You can make prints from slides and they can be copied, but they won't be as good as the original. You also can't get your hands on the images as quickly because slide film has to be sent to labs equipped for processing it.
- **Trickier to use.** Slide film is more sensitive to different kinds of light. If you're shooting indoors, you'll need to use tungsten film that will record indoor or incandescent light correctly. If you don't, you'll end up with a reddish or orange cast on your slides. Shooting outdoors calls for film that's balanced for daylight; using indoor tungsten film outside will result in slides with an eerie bluish tint. Color correction filters are available for converting indoor slide film for outdoor use and vice versa. The slides could also be scanned and corrected digitally.
- **Very little room for exposure errors.** Mistakes can't be corrected in the lab.
- **Creating first-generation images.** Because the slide is the image, it requires more careful handling. Prints (whether made from negatives or slides) are second-generation images, meaning you can handle your prints, give them away, or let the dog eat them, and always have more prints made as needed from your pristine originals.

FACT

Some manufacturers use letters as part of their film's names to indicate the film's characteristics. "S" means saturated; "N" means natural; "VS" means vivid saturated; "SW" means saturated warm. You can also find this information on the film box.

Slide film can also vary a great deal when it comes to tone and color saturation. Some types will make skin tones look cold, while others will deliver vibrant, saturated color that may not suit the situation or the subject.

Most photographers have their favorites when it comes to slide film. They also use different types of slide film, depending on the situation. Try film made by different manufacturers in various situations and see which you like the best. For example, saturated film will bring colors out better on overcast days.

Black-and-White Film

Shooting in black-and-white eliminates the distraction of unexpected or unwanted colors in a scene. Since color is eliminated, such factors as composition and contrast become more important. Special filters that lighten some tones and darken others can manipulate contrast while shooting. You can also play with contrast by increasing or decreasing the film's developing time, by using different exposures when printing it, or by printing it on different kinds of paper. Since black-and-white film records light in various shades of gray, it can be used with all light sources. Most black-and-white film available today is print, but slide film is also available.

Making the Most of Black-and-White Film

To realize black-and-white film's greatest potential, most photographers who shoot it process and print it themselves, giving them complete control over how the final image will look. If you aren't the do-it-yourself type or don't have the equipment to do it, you can buy chromogenic black-and-white film, which can be processed using conventional color print chemistry. Prints from chromogenic film, however, will look a little different from those made with traditional black-and-white film in terms of contrast, sharpness, and grain. Some will even have a strange color. If you're going for the true black-and-white look, shoot with real black-and-white film.

More Advantages of Black-and-White Film

True black-and-white negatives and prints will last decades longer than color because they contain silver, which doesn't fade like color dyes

do. However, the pollutants or chemicals emitted by some storage materials, such as nonarchival mount board, cardboard, and wooden frames and drawers, can damage them. Chromogenic black-and-white negatives and prints are more like color negatives and prints in that they can fade or change color over time.

Special types of film are in a class of their own. This group includes infrared film, which records part of the invisible light spectrum the eye can't see, often resulting in images with odd or false colors. Another special-use film is copy and duplicating film, which is used to make copies of color slides and negatives.

Film Speeds

A second factor determining film choice is its speed. This factor determines how sensitive the film is to light; the film's sharpness, or the amount of detail it can register; and its grain, which is the sandy or granular texture that's sometimes visible in prints (especially enlargements).

In general, slow films are less sensitive to light but deliver sharper, more finely grained images. Fast films are more sensitive to light, but the images they produce will have more grain. They also won't be as finely rendered as those on slow film. However, if you can't hold the camera still enough or your subject moves during longer shutter speeds, your pictures will be blurry no matter how slow or fast the film is.

ISO Numbers

Film speed is designated by an ISO number, which denotes a numbering system developed by the International Standards Organization. Because ISO numbers were developed to replace two older film speed rating systems—ASA and DIN—they're written as a combination of the older systems, such as ISO 50/18°. However, most people use only the first number when talking about film speeds.

Film speeds fall into three categories:

- **Slow**: Rated at ISO 50 or less. Film in this category is not very light sensitive and is sharp and fine-grained.
- **Medium**: Rated at ISO 64 to ISO 200. More light sensitive and still sharp and fine-grained, but not as fine and sharp as slow film.
- **High (or fast)**: Rated at ISO 400 to ISO 3200. Very light sensitive, not as sharp. Grain is larger and more visible, especially when enlargements are made.

The ISO numbers also indicate each film's light sensitivity when compared to other films. ISO 400 film, for example, is twice as fast as ISO 200. While it's not extremely important to know all of this in great detail, these facts do come into play if you aren't shooting in automatic mode. Film speed affects the two exposure controls on your camera: the shutter speed and the aperture, or f-stop. If you're shooting with slow shutter speeds in bright light situations with your lens wide open, you can use slow film. Fast shutter speeds, low light, and narrower apertures, which allow less light to enter the camera, require faster film for good exposures.

To give you an idea of how film speed will affect your picture taking, here are some examples of common conditions and shutter speeds (with reasonable f-stop settings for each).

TABLE 8-1 FILM SPEED CHART

Setting	ISO 100	ISO 400	ISO 800	Notes
Church altar	1/2 second f/4	1/8 f/4	1/15 f/4	All of these require a tripod
Bright shade	1/30th second f/5.6	1/125 f/5.6	1/250 f/5.6	You may need a tripod at 1/30th
Bright sun	1/125th second f/16	1/500 f/16	1/1000 f/16	All can be done handheld

For proper exposures, your camera needs to know what film speed you're using. Automatic cameras with built-in exposure meters (most cameras today) will electronically program film speed by reading the code on

the film cassette. If you're using a manual camera, you'll need to set the film speed yourself.

Choosing Film Speed

The best way to choose film speed is to know the conditions in which you'll be shooting. In general, the more light you have to work with, the slower the film can be. If you're shooting outside on an average day, medium-speed film—ISO 200—will probably be your best bet. If it's really sunny, you might want to switch to slow film, say ISO 100 or even ISO 64 if you're using a tripod. On overcast days, high-speed film—ISO 400 and up—will make the best of the light you do have.

ALERT!

Many beginning photographers are tempted to use the fastest film possible because faster film is more versatile. But increased light sensitivity comes at the cost of lower sharpness. In general, use the slowest film that allows a shutter speed you can work with.

Slow Film Versus Fast Film

There's always something of a tradeoff involved when choosing film speed. No one film will deliver everything you want in every shooting situation. Slow- and medium-speed films need longer exposure times, which limits their use when shooting action or using a telephoto lens. High-speed film is great for getting those action shots, as it allows for faster shutter speeds, but it's also grainier and less sharp. If you're not going to make prints larger than 4" × 6", grain isn't a factor; if you are going to make enlargements bigger than this, it is.

Unless you're shopping at a pro shop, you'll usually see film with ISO speeds of 100, 200, 400, and 800. In general, 100 is a good selection for shooting nonmoving subjects, brightly lit outdoor shots, and for tripod work; 200 works for daylight print film; and 400 and up is good for indoors, outdoors low light, and action situations.

Pushing Film

There are times when even the fastest film isn't fast enough. You might be shooting with existing light that's too dim, using a small aperture for good depth of field in a low-light situation, or using a fast shutter speed with a small aperture. If this is the case, it's possible to make your film even faster by pushing it.

QUESTION?

Will the X-ray machine at the airport affect my film?
For the little X-ray machine you put carry-on luggage through, probably not, unless you have to have it done repeatedly. However, checked baggage is subjected to a much more intense level of X-rays, which can be damaging. The safest approach is to ask to have your film hand inspected.

Film is pushed by setting your camera's ISO meter at a higher number than what's printed on the box, such as setting your camera to 800 for 400 speed film. You can also push film by setting your camera's exposure compensation dial to underexpose the film. Film that has been pushed needs special handling when it's processed. If you're going to try this technique, be sure you mark the film's cartridge with the speed it was pushed to. Take it to a lab that will process pushed film, and be sure to tell them what speed you used.

Film that has been pushed will result in pictures with greater contrast and more grain. Colors are altered as well. Such changes aren't necessarily bad; in fact, many photographers push their film so they can achieve stunning images with these effects.

Pulling Film

Film can also be pulled, or shot at a slower speed than what it's rated for. Keep this in mind if you're using a manual camera and you've shot a roll of film at the wrong speed because you forgot to reset the ISO meter (which can happen far too easily). Be sure to advise the lab of what you have done when getting the roll processed.

Buying, Loading, and Storing Film

Film can age and undergo all sorts of unexpected changes when not handled and stored properly. The emulsion that coats the surface of the film can be adversely affected by time, light, humidity, and heat. When buying film in quantity, remember that it must be used within a certain time span for optimum results. Likewise, follow a few helpful storage tips and you won't have to worry that your film has deteriorated.

Buying Your Film

It seems like film is available literally everywhere you go, which begs the question: Is it okay to buy it anywhere you see it? The answer, for the most part, is yes.

Film made for consumer use is designed to be relatively tolerant of condition changes, and it generally has a longer shelf life than professional film. About the only thing you need to worry about is its expiration date. All film deteriorates over time, and its light sensitivity and color balance changes. Out-of-date film isn't necessarily bad or unusable, but it may not deliver the results you want or expect. Check the box when you buy it, and use it before it expires for the best results.

The film box will also tell you what kind of film you're buying and what it's best used for. More information on exposure times and processing data is generally available inside the box or on an enclosed data sheet.

ALERT!

Steer clear of film that's displayed in direct sun or that might have been exposed to extreme heat or humidity. These conditions can make the film expire before its time and it is more likely to deliver far-from-desirable results.

Brand Versus Brand

Professional photographers often favor one brand of film over the others because they've used their favorite enough to know what it can do and

what they can do with it. For amateur photographers, brand isn't that big of a concern unless you're buying slide film. Since this kind of film varies somewhat significantly between manufacturers, buying by brand name will assure you of getting film with the characteristics you want. Print film also varies somewhat between manufacturers, but the processing process will determine how your images turn out more than the film does. Unless you're looking for specific properties that only a certain film from a certain manufacturer can deliver, buy the stuff that's priced right.

FACT

It's better to know whether a film will work for you or not before using it for important pictures. Always test a roll or two of unfamiliar film—regardless of its type or who made it—to make sure it performs the way you want it to.

Consumer Versus Professional

Camera snobs often swear by professional film even when they have no reason to do so. There's really not that big a difference between the two types, and pros often shoot with film made for consumer use because they like its characteristics and price.

What does distinguish pro film from consumer film is how it's manufactured, which affects its shelf life. Consumer film is made to tolerate a certain amount of abuse—temperature variations, sitting on the shelf for a long time, delays between shooting and processing—and still deliver good results. Since pros often buy large amounts of film at a time and shoot and process it relatively quickly, the film that's made for their use is manufactured to more exacting standards and isn't as stable as consumer film.

Film Loading

Most cameras on the market today have automatic film loading devices that make film handling a breeze. All you have to do is drop the film cartridge into the film chamber (located on the left side of the camera as it faces you), check to make sure the film is lying flat, then pull the film leader

(the part of the film sticking out of the cartridge) across to a mark on the opposite side, and close the back.

The automatic film loader does the rest, at least most of the time. Film-loading errors can happen, but they are usually the result of the film not being correctly caught by the sprockets in the loading mechanism. If your camera indicates the film wasn't loaded correctly, just open it up and do it again. Don't worry about touching the leader with your fingers; it's only there to facilitate loading the film.

When loading a camera that has an automatic film-loading device, simply pull the tip of the film to the mark indicated in the camera.

ALERT!

Never leave film in a hot car or anywhere else where it can heat up—you might end up with some very strange colors on your prints or slides. Black-and-white film may end up with fogging or contrast shifts.

If you're using a manual SLR, you will need to learn how to master the fine art of loading film manually. It can be a little frustrating, but with some practice you'll become a pro.

How to Manually Load Film

1. First, drop the film cartridge into the film chamber. You'll need to pull up on the film rewind crank (located on the top of the camera) to do this. When the film is in the chamber, push the crank back into place. Check to see if the film is seated correctly in the film chamber.
2. Next, pull the leader across to the film loading mark. (These steps are the same as above).
3. Rotate the film takeup spool (located on the camera's right as it faces you), until you see a slot in it. Insert the end of the film leader in this slot.
4. Check to make sure the holes on the edges of the film are lined up with the camera's sprockets. If they aren't, the film won't advance properly.

5. Manually advance the film forward a few frames by releasing the shutter. As you do this, watch the rewind crank to make sure it's moving. If it is, the film is loading onto the takeup spool.

6. Close the camera and continue advancing the film until the first frame shows up in the frame indicator. Keep watching the rewind crank—it should continue to move. If the back doesn't snap into place, you may need to reopen the camera and reseat the film cartridge.

7. Check to make sure there's no slack in the film by pulling up on the film rewind crank and giving it a slight turn backward. If it won't turn, your film is tight. If it will turn, rotate the crank until you feel good tension on it, then put it back into place. Don't turn it too hard—doing so may break the film.

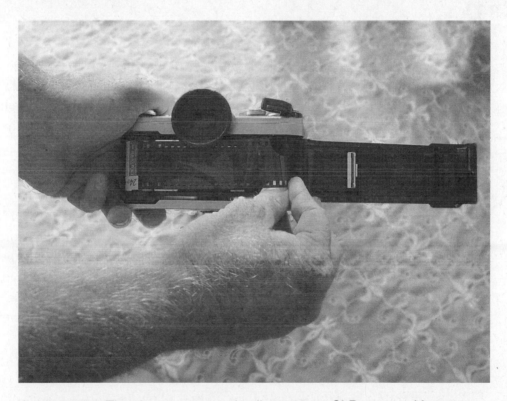

▲ FIGURE 8-1 There's no mystery to loading a 35mm SLR camera. It's easy when you carefully follow the steps listed. Although it is a simple process, it takes a little while to get truly comfortable loading a film camera. Beginners gain confidence the more they do it.

All cameras load pretty much the same way, but it's always a good idea to check your camera manual for specific instructions on loading your camera. It's always best to keep film in its box until you're ready to load it. Not only will it stay fresher, it's less likely to be damaged when it's wrapped. If your camera has a film reminder holder on the back, you can slip the box top into it so you'll know what kind of film you're shooting.

Be sure to turn the rewind film in the correct direction—the direction of the rewind arrow, instead of the other way—when checking for film slack. Turning it in the wrong direction can kink or jam the film.

Try to avoid loading or unloading film in bright sunlight. Put the camera in your shadow or go inside before you open it up. High-speed films are more sensitive, of course, and if you are doing lots of shooting in bright sun you might choose to work with a slower ISO film. Even so, get the film from the packaging to the camera and back in the shade.

Storing Your Film

If you shoot a lot, chances are you'll want to keep extra film on hand. This allows you to take advantage of sales and is a good way to be sure that you'll always have a few extra rolls, just in case you need them quickly. Film is happiest when it's kept cool and away from direct light. Storing it in your camera bag is fine if it's consumer film and you keep your bag in your home instead of your car (never a good place for equipment or film for extended periods of time).

Storing film in a refrigerator or freezer, as many professionals do, will slow down changes in its emulsion that can affect its performance. If you do store your film in the refrigerator or freezer, allow it to warm up to room temperature before putting it in your camera. Pro film, due to its shorter shelf life, should always be stored in the fridge or freezer.

By shifting your position relative to your subject, you can also change the lighting of your picture.

Color photography is most effective when color is the theme of the picture, as in this quick snapshot of vibrant tulips.

A shot like this takes time and patience to find. It is impossible to pose wild creatures and rare to stumble onto a perfect shot.

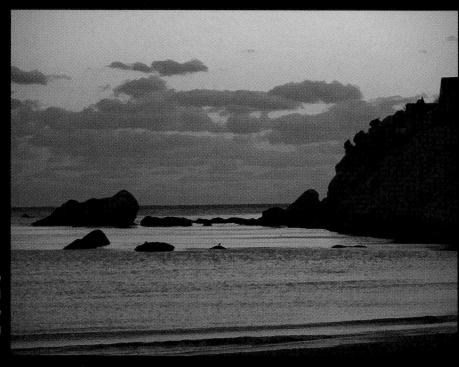

Experimenting with the settings on your digital camera allows you to explore new ways of capturing images.

Using a telephoto lens allows the photographer to frame amazing closeup shots without getting up close and personal with the subject.

This little rowboat provides a study in contrast and texture. The dynamic lines suggest motion and energy, but they also highlight the tension and distance between the various components of the photograph.

Learning different photographic techniques allows you to capture scenes that express your personality.

A colorful subject contrasts sharply with the misty background at the water's edge. This image is an example of how movement works in photo composition.

This image was shot with a standard lens, which means the objects appear similar in size to what your eyes would see.

This photo is a classic example of the rule of thirds, and shifting the center of interest off-center makes for a pleasing composition.

The contrast in this diffused light photo is so soft that it lends the image a dream-like quality.

The dramatic lighting before the storm provided rich color contrasts.

Dramatic lighting conditions—such as this sunset reflected on a wintry landscape—are fleeting and need to be photographed quickly.

Not all portrait shots need to be posed, sometimes it's just about capturing the moment.

Red eye was a major problem with this photo, as it is in many photos of animals, but digital tools were employed to erase the unsightly glare.

The contrast of the blazing sunset against the bare branches of the tree is a beautiful example of using the center of interest to draw a viewer in.

CHAPTER 9

The World
Through a Lens

It's often said that lenses are the eyes of the camera, allowing it to see up close, far away, and all points in between. You can create lots of good images with just one lens, but why stop there? There is a whole world of camera lenses; the variety goes far beyond the basics, making it possible to capture astonishing images and allowing for far greater creativity.

Learning about Lenses

A lens in its simplest form is a pretty basic thing: a piece of transparent material, usually glass, with two polished surfaces that modify rays of light. Before the advent of SLR photography, most cameras had built-in lenses that captured images similar to what people saw when they looked through the viewfinder. Such things as making far-away images seem closer or larger wasn't possible with these lenses.

The ability to make images larger and smaller and to have greater control over such aspects as depth of field, angle of view, and perspective is what made SLR cameras popular when they were first introduced, and what continue to be key factors in why more photographers use them than any other camera. The manor house and grounds in the color insert were shot with a standard lens.

Today, there are four basic types of lenses for SLR cameras:

- **Normal or standard:** Objects are similar in size to what your eyes can see (approximately 50mm for 35mm SLR cameras).
- **Telephoto:** Makes faraway objects appear closer.
- **Wide-angle:** Covers a wider angle of view than is possible with a normal or telephoto lens.
- **Zoom:** Combines the features of the first three types in one lens. Some zoom lenses operate strictly in the telephoto area. For example, a common zoom lens size is 100mm–300mm, which even at 100mm is going to enlarge what you see.

Focusing on Focal Length

What distinguishes each type of lens is a factor called focal length. Expressed in millimeters—such as 50mm—focal length describes the distance from the optical center of the lens to the film. It also determines the scale of the images in a picture. In general, lenses with short focal lengths make images look smaller; as focal lengths get longer, image sizes get bigger. If you were to stand in the same place and take a picture using lenses with different focal lengths, you would get the widest angle of view and the smallest images with the shortest focal length lens. As you went up in focal

length, images in the scene would look bigger, but you would see less of the scene itself as the angle of view narrowed.

◀ **FIGURE 9-1** In this photo of a cruise ship in Newport's harbor taken with a wide-angle lens, much of the surrounding area is included in the shot as well.

◀ **FIGURE 9-2** This photo was taken with a telephoto lens from the same spot as the previous one. Note how much larger the image of the cruise ship is and how much more it dominates the scene.

You can usually check the focal length of a lens by looking at the front lens ring, although some lenses have their length engraved elsewhere on the lens barrel. If the focal length of a lens is about the same as the diagonal of a frame of the film the camera uses, it's called a normal lens. If it is longer, it's a telephoto; shorter, and it's a wide angle. The diagonal of a 24mm × 36mm image (the size of the image on 35mm film) is 43mm, so a lens with a focal length of 43mm or thereabouts is considered a normal lens for the 35mm format. If you're using a camera with larger or smaller film, the focal lengths used to classify its lenses will be different.

Focusing on Field of View

Focal length also determines how much of a specific scene or area the lens can see. This is called field of view or angle of view, and it is measured and expressed in degrees. Lenses with short focal lengths have wide angles of view and cover more of a given scene. As focal lengths get longer, angles of view get narrower and you can see less from the outer edges of the scene.

Focal length and field of view are two of the most important factors to consider when choosing which camera lens to use. Together, they determine how much of a particular view you'll be able to capture and what the size of the images will be.

Always use a lens that will let you fill as much of the frame as you can with your intended subject. The pros call this "cropping in the camera." Doing so will deliver much better images than those that are enlarged and then cropped in the regular or digital darkroom.

All about Apertures and F-Stops

The second factor governing lens choice is aperture, which is the adjustable opening that regulates how much light passes through a lens. You will usually be most concerned with the largest aperture (smallest number). The lower the number, the better that lens is for low-light or high-speed use. The range of apertures varies from lens to lens, affecting exactly how much light they're capable of allowing in.

F-Stops

As discussed in Chapter 6, apertures are expressed in f-stops, such as f/1.8. This measure is a ratio that reflects the focal length of the lens (f) divided by the actual diameter of the aperture. The smaller the number, the more light the lens is capable of letting in. Lenses with extremely low

f-stops, such as f/1.2, let in a great deal of light and can handle fast shutter speeds.

Lens Speed

Lenses with low f-stop numbers are often referred to as fast lenses. Slow lenses are those that have higher f-stop numbers, generally in the f/5.6 range and above.

Fast lenses are wonderful things to own, but they do come at a higher price. Not only do they cost more than comparable (but slower) lenses, they're also bigger—they have to be to allow in more light. They also weigh more and take up a great deal more room in your camera bag. While weight and bulk may not seem like important factors initially, they will definitely come into play if you're lugging your equipment on an all-day hike. That wonderfully fast lens may end up being your worst nightmare after you've hauled it for a few hours.

FACT

Normal lenses aren't the only prime lenses. Any lens with a fixed focal length is considered a prime lens, so wide-angle lenses and telephoto lenses also fall into this category. Compared to zoom lenses, they generally weigh less and are faster. They can be sharper than zoom lenses as well.

Types of Lenses

Normal lenses, also called standard lenses, are the lenses that have come with basic SLR camera setups for many years. The image these standard lenses "see" is about the same size in the viewfinder as the image the human eye sees. Wide-angle lenses have shorter focal lengths and cover a wider angle of view than normal and telephoto lenses do, and also capture a wider field of view than the human eye can. Telephoto lenses have longer focal lengths and smaller angles of view; they make subjects in the distance look closer and larger.

Normal Lenses

A standard lens for a 35mm camera is typically 50mm, although lenses that range from 45mm to 55mm are also considered within the normal or standard range. A 50mm lens covers a 45° angle of view. Normal lenses are also called prime lenses because they have fixed focal lengths. In the hands of a new photographer, normal lenses capture the images without the distortion a wide-angle or telephoto lens causes. Pictures taken with them look very natural and familiar, which makes these lenses a favorite of many photographers.

Normal lenses are generally very fast and can have maximum apertures as large as f/1.2. This makes them great for low-light situations, especially for taking action pictures in less-than-perfect light.

Like all prime lenses, you can't adjust image size with a normal lens alone. To make images bigger or smaller, you have to move the camera closer or farther away from the subject. When shooting with large apertures, the depth of field on normal lenses is fairly shallow, so accurate focusing is essential.

Wide-Angle Lenses

Wide-angle lenses have shorter focal lengths and cover a wider angle of view than normal and telephoto lenses do. For 35mm cameras, they range from 13mm to 35mm, with 28mm considered a standard wide-angle lens. The shortest wide-angle lenses have the greatest angle of view, starting with 118° for a 13mm lens and going to 63° on a 35mm lens.

There's also a special wide-angle lens called a fish-eye with an extremely short focal length (beginning at 6mm) and an extremely wide angle of view (220°). They create round, distorted images that look like they're viewed through the eyes of a fish. These lenses make distant objects appear smaller, near objects seem larger, and the distance between objects look greater.

Advantages of Wide-Angle Lenses

Wide-angle lenses are definitely the lens of choice in cramped conditions, such as small rooms or other situations where you can't back up far enough to include everything you want in the picture if you use a normal lens. Their wider field of view makes them great for scenic outdoor photography as well, especially if your subject is a sweeping panorama and you want to get as much of it as you can in your shot.

Wide-angle lenses make nearby objects look really big and distant ones really small, so the classic gimmick shot of a person holding a building in his hand is created with a wide-angle lens. They're also good when you want to use perspective for emphasis, such as when exaggerating the space between objects will add to the picture's interest.

QUESTION?

What lens do I need for closeup photography?
Normal or telephoto lenses that can focus extremely close can be used for closeup work. You can buy macro lenses with focal lengths that can also be used as normal or telephoto lenses, or regular lenses with macro capabilities. You can also use an extension tube, which mounts between the camera body and the lens to move the lens closer to the subject.

Disadvantages of Wide-Angle Lenses

It is easy to get distorted images with wide-angle lenses, which makes them inappropriate for taking closeups of people. Wide-angle lenses used for closeups will distort the faces of your subjects. They make the features closest to the lens (like noses) bigger and those farther away from the lens (ears, for instance) smaller. Because they capture more of a scene, people and objects at the edges of wide-angle shots can also appear distorted. This actually happens with all lenses to a certain degree, but it's not nearly as noticeable with telephoto and normal lenses. Wide-angle lenses make it more obvious to the picture-viewer's eye.

Another problem with wide-angle lenses is something called keystoning, a phenomenon in which parallel vertical lines on buildings or other subjects look like they're converging. You can avoid keystoning by keeping your camera facing straight forward—not tipping it up or down—unless you want to deliberately create this affect. Keystoning can be corrected in digital darkrooms.

Telephoto Lenses

Telephoto lenses are basically the opposite of wide-angle lenses. Since they have longer focal lengths and smaller angles of view, they make

subjects look closer and larger. They're great for when you want to get a good shot but can't get close enough to your subject to use a normal lens. Since they have shallow depth of field, they're also good for focusing more attention on the main subject of a picture by eliminating distracting backgrounds and foregrounds. For 35mm cameras, telephoto lenses range from 85mm up to 2000mm, with corresponding angles of view from 28° to an amazingly small 1°.

Advantages of Telephoto Lenses

The most obvious advantage of using a telephoto lens is to make far-away objects look bigger. A 100mm telephoto lens will double the size of the image produced by a 50mm lens; a 500mm telephoto lens will make the same image ten times larger. Because they don't exaggerate the distance between objects—in fact, they compress it—telephoto lenses don't distort features, making medium-range telephoto lenses good for portrait work, because you can shoot at a greater distance. With telephoto lenses, perspective is less apparent because of the narrow field of view. Distant objects, enlarged and more visible with a telephoto, show less divergence and convergence of lines, but the perspective, albeit reduced, is still there.

Telephoto lenses are often used to create photographic compression. Using an extreme telephoto on a distant scene of repeating, overlapping shapes, such as cars on a highway, will make them look closer to each other than they actually are. The narrow angle of view on these lenses is great for cropping out parts of a scene you don't want to include.

Disadvantages of Telephoto Lenses

Since telephoto lenses magnify their subjects, they must be held perfectly still when the shutter is snapped. If they're not, pictures will be blurry as the magnification of the lens also magnifies any movement of the camera. Getting good photos with telephoto lenses often requires using a tripod and a cable release—especially if the lens is longer than 400mm—or a self-timer if your camera doesn't have a cable-release feature. Using fast shutter speeds will help minimize camera shake and subject movement, which is also exaggerated because of the magnification. New cameras with Image Stabilization technology (IS) help to minimize the blurring effect so typical in telephoto shots and are available in both film and digital cameras.

Zoom Lenses

These extremely versatile and popular lenses combine features of the other lenses into one handy piece of equipment. By adjusting a collar on the lens or pressing a zoom button on a point-and-shoot model, you can change focal lengths, make images look larger or smaller, and change your angle of view. For example, a 28mm–70mm zoom will adjust from the wide-angle focal length of 28mm to a slight telephoto length of 70mm.

Zoom lenses come in various focal length ranges. The most common are 28mm–50mm or 21–50mm, covering a wide-angle to normal range; 35mm–105mm or 35mm–135mm, which increases the focal length to the telephoto range; and 80mm–200mm, the medium to full telephoto lenses.

Early zoom lenses were notoriously awkward to use and quite heavy. They also weren't as sharp as fixed-focus lenses. Manufacturers now claim that advances in design and materials have made zoom lenses as sharp as primes. If you never enlarge your images to more than 5" × 7", you won't have to worry that much about the difference in sharpness between zoom lenses and prime lenses. Digital users of telephotos can sharpen a slightly blurry image in their digital darkroom.

Zoom lenses are labeled with their minimum and maximum focal lengths, followed by the largest aperture available at each extreme, such as 75mm–300mm f/4–5.6. When you're zoomed out to 20mm (very wide angle) your largest f-stop is f/3.5. As you zoom in toward normal or telephoto, the largest aperture changes from f/3.5 to f/4.5, which means it lets in less light.

Advantages of Zoom Lenses

The greatest advantage of zoom lenses is their convenience; they can keep you from having to buy lots of prime lenses. They also make it possible for you to make images larger or smaller without having to change lenses or shooting position—all you have to do is adjust the focal length. This makes it easier to compose the perfect shot.

Disadvantages of Zoom Lenses

Zoom lenses—especially big telephoto zooms—are heavier than other lenses. They're also more expensive—although expense is relative. It *is* cheaper to buy one zoom lens than several fixed-focus lenses.

Perhaps the most serious drawback to zoom lenses is that they're slower than other lenses. Buying a zoom with an aperture wider than f/4 usually entails a pretty hefty investment. Because the maximum aperture gets smaller as the focal length gets longer, it can be difficult to use fast shutter speeds. Focusing is also trickier because less light reaches the focusing screen.

Some zoom lenses can also change focus as you zoom. This means that if you zoom in (move to the telephoto setting) to focus and then zoom out, the image may need to be refocused at the new focal length. Autofocus zooms take care of this if there is enough light for the system to work.

Choosing the Right Lens for the Right Job

Professional photographers generally have at least a couple of lenses in their bags that allow them to tailor their lens choices for specific situations or to create certain effects. While there is really no best lens to own, certain subjects or circumstances are easier to handle with specific lenses. Here's a look at some different situations and suggestions for the appropriate lens choices for each.

Photographing in the Wild

If you are out to photograph an eagle's nest in the wild, you will need to stay far away from your subject. A 200mm telephoto lens might work if you can get close enough. If not, you'll need an even longer telephoto lens, possibly 800mm or 1200mm.

If you're shooting a serene landscape scene, go for a wide-angle lens. A 20mm–35mm zoom will give you several composition options.

Portraiture

Before you take a portrait, decide whether the picture is about the person or the person *within the context* of her environment. In other words, do you want the *person* to be the emphasis, or do you want to show how the person relates to her surroundings?

For the person alone picture, use a telephoto lens (95mm–110mm) for head and shoulders and to keep the subject separated from the background. Shooting with a large aperture (f/1.4, f/2, f/2.8) will throw the background out of focus while keeping eyes (usually the most important part) in focus.

For the person in her surroundings picture, select the view you want of the scene and the lens that lets you fill the frame the way you would like. Then position the subject so that her size and pose tell the story (what dominates the scene—the subject, or the room?). Use the combination of lens choice, camera placement, and subject position to tell the story.

Athletic Events

The photographer on the sidelines at a professional sporting event may need a 300mm lens, but if the amateur athlete you are documenting is more approachable, a better choice of lens might be one in the range 85mm–180mm. For sports photography from the sidelines, 200mm–300mm is good.

Indoor Architecture

To photograph interior architecture, select a wide-angle lens with a focal length of 24mm—or even 17mm, which is a super-wide angle. If most of your pictures will be taken inside your home or in a small backyard, you'll be happier with lenses in the wide-angle category.

Stage Shows

Photographing stage shows—or any other dimly lit event at a distance—requires a lens that lets in a lot of light and that has a focal length of 100mm–200mm.

Group Shots

As a general rule, when photographing a group of people who are in several rows parallel to the film plane, a longer lens will produce a more honest picture. The wide-angle lens allows the camera to be closer to the group in order to fill the frame. The people closest to the camera are significantly closer than the people in the back row, so the front row people appear larger. Back away from the group and switch or zoom to a longer focal length. The farther away you get, the more the people in the front row will be in scale with the ones in the back row. Even if you don't switch lenses, the more accurate scale provided by greater distance will still be apparent. The reason you switch lenses is to keep the frame filled with the people, rather than unimportant surrounding scenery.

QUESTION?

What would be a good starter set of lenses?
You want a selection that will cover just about any shooting situation. One possible mix is a wide-angle lens covering about 19mm–35mm, a medium-range zoom in the 28mm–105mm range, and a long telephoto zoom from 100mm–300mm. Adding a 1.5 or 2x teleconverter will lengthen any of these lenses 50–100 percent.

Buying Camera Lenses

As when buying a camera, it's a good idea to research the kinds of lenses you're interested in before making a purchase. For the most part, lenses are divided into three quality categories:

- **Professional lenses:** More expensive, generally sharper, and better built. Faster f-stops, better mechanics, better optical qualities. You even get more contrast and better color from better lenses. The better lenses will stand out, especially when the images are greatly enlarged.

- **Consumer lenses:** Might only be good enough for prints up to 4" × 6" or 5" × 7". Less expensive lenses are also not going to be as fast—their largest aperture may not be large enough and may introduce distortions, such as not portraying parallel lines accurately.
- **"Pro-sumer" lenses:** Offer features and qualities that fall between consumer and professional, priced accordingly.

Learn about variations in model designations or lens series so you know what you are getting and what a fair price would be. Don't pay pro prices for bargain lenses; keep in mind, however, that price is definitely an indication of quality and performance. Lenses with better optical elements and larger maximum apertures will always cost more than lenses with lower quality optics and smaller maximum openings.

Be sure to buy the right style of lens for your camera. Manual-focus lenses won't always work on autofocus cameras and vice versa, although they are sometimes semicompatible. A lens with a mount designed to work on one camera brand won't work on other brands.

Name Brand Versus Aftermarket

The same companies that manufacture camera bodies also offer lenses that match their cameras. These lenses are designed to work with the manufacturer's cameras only, so they can't be swapped between cameras made by different manufacturers. Buying these lenses will assure a perfect interface between camera and body and will virtually eliminate any performance errors that might happen with lenses made by another manufacturer. Professional photographers usually stick with top brand-name lenses that match their cameras.

Aftermarket companies make several versions of the same lens to fit different cameras. The difference between these versions is simply the physical and mechanical interface, which is different for each camera manufacturer. Like the major names, they divide their products into professionally oriented lenses and consumer lenses. Some individual lenses by these aftermarket companies are quite good. Do your research to decide what is right for you.

It is always a good idea to buy a lens from a store that allows returns. You should always test a new lens by shooting a few rolls, or the digital equivalent. You might find the lens is not as sharp as you had hoped, or maybe it has a focusing problem. Even if you don't need to return the lens, be sure to keep the receipt and the box it came in. If you ever want to sell the lens or need to have it serviced, it's a good idea to have both.

Whether your equipment is new or used, be aware that there can be variations in quality between the exact same lenses. One 35mm f/2.8 Yukon may be sharper or softer than the seemingly identical 35mm f/2.8 Yukon sitting on the shelf next to it. A used lens may be on the market because it didn't measure up.

Selecting a Zoom Lens

There is no ideal zoom lens that works for everyone. If you love taking group pictures inside your home, you'll want a zoom that stays in the wide-angle range, like a 24mm–50mm. If you like to do head-and-shoulder portraits as well as shots of small groups indoors, then a 35mm–105mm is a large enough range. If you are into sports and outdoor activities, you will want a zoom that goes at least to 200mm. Keep in mind that the larger the zoom range and the longer the telephoto, the heavier the lens will be. This is a concern if you need to lug your gear around or if you suffer from carpal tunnel syndrome.

New SLR cameras sometimes come packaged with a 28mm–70mm or 28mm–80mm medium-range zoom. These focal lengths cover many picture-taking situations, but they may not be what you want. If so, ask about substituting a zoom that matches your needs or see if you can buy the body and lens separately.

Lens Care and Cleaning

Camera lenses are precision instruments. Like camera bodies, they'll perform best and yield better images when they're handled correctly and properly maintained.

Always protect your lenses against dust and other elements by keeping both ends capped when not in use. A UV filter is a great way to protect your lens when the cap is off. Buy one to fit every lens you have. If you don't store your lenses in a zipped and padded camera bag, put them in lens cases to protect them from shock and dust.

Always check your lenses before shooting to make sure they're clean and clear of dust and lint. If they're not, here's how you can clean them:

1. Get a lens cleaning kit with the following: a blower brush or another type of soft brush, lens cloth (preferably not eyeglass-lens tissues, which can scratch the surfaces), and lens cleaner.
2. Use the brush to clear dust or other particles away from the lens. Some manufacturers say you can use compressed air, but it's possible to blow dirt and dust into the lens with it if you're not careful.
3. Place a drop or two of cleaning fluid on the tissue or cloth and wipe the lens gently. Microfiber cleaning cloths are great for this, as they're soft and lint-free when cared for correctly. Turn the cloth frequently to make sure you're using a clean part of it every time you wipe. Use more of a lifting than a wiping action; the idea is to clear the lens of particles and fingerprints, not to rub them in.
4. Use another lens cleaning cloth to do a final wipe of the lens, again using only clean areas of the cloth for each wiping motion. Use a cotton swab to blot any cleaning fluid that may have worked its way into the edges of the lens.

Don't use lens cleaning cloths for anything but cleaning lenses—doing so might pick up debris that could scratch your camera lens. When they get dirty, wash them with liquid soap or detergent and hang them up to dry so they don't pick up dryer lint. Never use other things—shirttails, napkins—to wipe your lenses; this is the easiest way to damage them.

CHAPTER 10

Seeing the Light

Many different factors go into the making of good pictures. Of them all, light is the most important. Without light, there is literally no picture. It's as simple as that. No matter what kind of camera you have, you can create great photographs if you study light and learn how to use it. Likewise, the wrong lighting can just as easily ruin what you thought would be a perfect picture.

The Power of Light

Simply put, most photographers quickly learn that light is the most important factor in every photograph.

You can learn a great deal about lighting by studying the work of other photographers. Take a look at the images created by such luminaries as Ansel Adams, Yousuf Karsh, Dorothea Lange, Edward Steichen, and Alfred Stieglitz, who were geniuses of light and composition.

Of course, there is more leeway in the world of digital photography, where exposure can be manipulated after the shot is taken, but even digital editing has its limits. This is particularly true when the highlight detail has been overexposed. No amount of normal digital adjustment can put that detail back into the photo.

Properly lit photographs use the power of light to create mood and evoke emotion. They contain details and tones that can only be created if you understand exactly how scenes should be properly lighted and are familiar with the lighting angles that create the best results for achieving these ends. Understanding the basic aspects of proper lighting will give you a leg up on using it to the best advantage in your pictures.

Shining Brightly

Whether you are dealing with natural light or light coming from manmade sources, brightness or intensity is one of the most important considerations. The amount of light is not the same as the quality of light. Brightly lit situations—indoors or outdoors—are wonderful for shooting sharp, clear pictures because you can use slower film, smaller apertures, and faster shutter speeds. But once you have adjusted your aperture and shutter speed to match the brightness of the scene, the quality of the light becomes the most important factor in making a great image.

Difficult Exposures

Dimly lit situations require faster film, larger apertures, and slower shutter speeds, which often result in grainy images that aren't as detailed as those taken in bright light. Scenes that are naturally low in contrast—a sand dollar on a pale sandy beach—may appear too washed out in flat lighting. If you don't want a washed-out look (that is, one with limited tonal range), you can add more light if you want to.

Low-Contrast Challenges

Naturally low-contrast scenes can be photographed without additional lighting, or you can increase the contrast by adding a strong light from any position that casts shadows that the camera will record. In most cases, you'll want a full tonal range from black to white, which means both brightly lit and shadowy areas in your pictures. You can use light in many different ways to create them. Regardless of the relative brightness of a scene, it will always be illuminated by two basic kinds of light. Each of these kinds of light can be effectively used to make different types of pictures, even different types of pictures of the same subject.

Directional Light

Directional light, whether it comes from the sun, a flash unit, or a light bulb, is strong and full of contrast. The direction of the light determines where shadows and highlights will be, and how much of each will appear in the final image.

This kind of lighting casts heavy shadows and can create forceful pictures with strong impact and deep mood. Because it creates so much contrast, it can be difficult to properly expose film to capture the details in both light and dark areas. This is particularly true when using digital cameras, which are notorious for losing detail in the brightest part of the picture, a phenomenon known as blowing out the highlights. Careful attention must be paid to retain highlight detail in these instances.

In the color insert, the photo of snowy dunes at sunset took advantage of a very fleeting moment of opportunity for dramatic directional lighting, capturing a unique quality of light that only lasts a few minutes at that time of year.

Front Lighting

Light from the front is the type of lighting we're most familiar with, as so many pictures are taken with it. Shots taken with this kind of lighting don't have shadows. Since shadows create depth, pictures lit from the front also tend to look flat. People in front-lit pictures often look uncomfortable and squinty because the light is shining directly into their eyes.

Front lighting is often referred to as flat lighting, which refers to the flatness caused by the lack of shadows. Side lighting is generally preferred for the added drama it brings. An example would be a shot taken when the sun is partly rising or setting and directly to the left or right of the subject. This lighting gives subjects depth.

You'll see a lot of front lighting in old photographs. The first lenses and films were substantially slower, and it took a great deal of light to render correctly exposed images. Early photographers were told to shoot with the light behind them so it would illuminate the front of their subjects. Today, front lighting is no longer necessary with most cameras. However, since it's the type of lighting we're most familiar with, you'll still see it used in many pictures, and you probably use it yourself.

Backlighting

Backlighting puts the main source of light behind the subject, shining toward the camera. Backlit scenes can be extremely dramatic and beautiful, but they can also be rather difficult to expose correctly. If the camera's light meter only measures the light behind the subject, then the subject will be underexposed and will appear as a silhouette, which may actually be the

desired effect. If it isn't, readings must be balanced between the subject and the light behind it so the front of the subject is properly exposed. In digital photography, an underexposed photo with the foreground subject appearing too dark can be adjusted with image manipulation software to bring out the shadow detail that was lost. Likewise, overexposed subjects can often be darkened.

◀ FIGURE 10-1
In this backlit image, the bright sunlight behind the semi-transparent flower petals delicately highlights the detail and delicacy of their fragile form, which shows it off to good advantage.

Side Lighting and Crosslighting

Also known as split lighting, side lighting is created when you take a picture with the lighting source at one side or the other. Since it illuminates one side of the subject, it can create fairly dramatic effects. Side light also emphasizes texture, shape, and form. Crosslighting is created by using artificial light to shine on an object from both sides. It's often used in commercial product photography.

Up-Lighting

Up-lighting is created when the subject is lit from below. This can create dramatic images, but be warned that this sort of lighting is usually the least flattering for pictures of people, as the main light for portraits should not come from below the horizon. Sunlight bouncing up from the pavement or other sources is not flattering unless your subject is looking down in the direction of the light.

Down-Lighting

Down-lighting is created when the subject is lit directly from above. It's not flattering for most subjects, but some scenery, especially when captured from a distance, will look good with this type of lighting. When taking portraits, you'll find that down-lighting casts shadows under the subject's eyebrows and chin, making a person's eyes appear as dark splotches.

Nondirectional Light

The opposite of directional light, nondirectional light is created when light comes from all directions and casts no shadows. It can be created naturally by mist or clouds in an overcast sky, but you can also create artificial nondirectional light yourself with a sheet or a reflector covering the entire subject so no obvious direction of light is evident in the scene.

Diffused Light

Diffused light comes from a relatively large light source, such as window light or light reflecting off of a wall. Diffused light creates soft edges between shadows and highlights. It softens textures, lines, and contours.

◀FIGURE 10-2
These flower petals were shot under a tent, which diffused the light and cast only very soft shadows, producing a pleasing, soft effect.

The contrast in diffused light photos can be so soft that the images appear almost dream-like. The diffused golden light in the picture of boats on misty water in the color insert is a good example of this. This kind of lighting, since it softens features, can be useful for taking portraits of people who want to have their skin blemishes minimized.

Don't confuse diffused light with nondirectional light. A diffuse light coming from the side is very directional and can produce deep shadows. But if you light your subject from the front with diffuse light, it fills in shadows, minimizes texture, and dulls highlights.

Disadvantages of Diffused and Nondirectional Light

As pleasant as diffused light can be for certain types of pictures, it can also produce dull images that lack detail. In extremely overcast conditions, the entire sky can act as the light source and completely remove shadows, causing images to look flat. Some shadows are usually desirable, since they give a sense of depth to images.

Measuring Light

Automatic and point-and-shoot cameras usually have built-in light meters that will automatically measure the light's intensity and set the aperture and shutter speed to match it. These light meters are very good at giving you the right exposure in almost all situations. Your camera might not have a built-in meter, or the one it has might not work very well, in which case you'll want to use a handheld light meter. This is also a good option if you want to measure the relative brightness of different parts of a scene.

Light meters are about the size of a cell phone. They contain a light-sensing chip or cell, plus electronics that translate light intensity measurements into a display showing the correct aperture and shutter speeds. They meter incoming or incident light, reflected light, or both.

Metering Incoming Light

Incoming light, or incident light, is the light that naturally falls on a subject. To measure it, you put the light meter exactly where you plan to aim your camera. A light-sensitive chip, sitting inside a white translucent dome that looks like half of a ping-pong ball, measures the amount of light hitting the dome.

If your camera is giving you accurate exposures most of the time, you don't need a handheld meter; it will slow you down. On top of that, if you don't use it properly, your exposures may be less accurate than if you relied on your camera's meter.

Metering incoming light is a great way to preset shutter speeds and f-stops for action scenes. All you have to do is meter the scene before the action takes place. The meter will give you an f-stop and shutter speed that will correctly expose an average subject in the light you measured. If your subject is much darker than average—such as a black dog—open your aperture a stop or two from the handheld reading. If the subject is very light—such as a polar bear—you might stop down one stop or more from the incident-light reading.

Metering Reflected Light

This metering mode measures the light reflected from the subject. This is how all automatic cameras work, TTL or otherwise. Aim your handheld meter at the subject. If direct sun is hitting the metering cell, cast a shadow on it. The reading will be a combination of the amount of light hitting the subject, how much light bounces back from the subject to the meter, and how much of the scene the subject occupies. This is generally an accurate way to meter and set your camera.

Sometimes, however, conditions can make a reflected meter reading inaccurate. Here are some situations you may encounter and the adjustments you can make to correct them:

- **Subject reflects light directly** (such as a window or a shiny surface on a building exterior). Get closer and either take an incident reading in the same light as the subject or move to a spot where there is no direct reflection.
- **Subject is a very small part of the scene** (such as an actor in a spotlight on a dark stage). Get closer and use a spot or incident light meter.
- **Subject is backlit.** Get closer and use a spot meter, an incident meter, or open up one to two stops from the initial reading.
- **Subject is dominated by black clothing.** Shoot as metered if the subject is the clothing itself, or take an incident reading if the subject is the person wearing the clothing.
- **Subject is dominated by white clothing** (such as a bride wearing a wedding dress). Take a reflected reading of the dress only and open up one or two stops, or use the setting given by an incident meter held at the bride's position.
- **Subject is part in shade and part in sun.** The reflected meter should give an accurate reading if the meter is reading both the light and the dark parts equally. You might want to take incident or reflected readings in the shadow and the brightest portion, then set the camera halfway between them.

Working with Directional Light

Directional lighting is great for composing photographs with lots of contrast. It's also useful for compositions in which shadows play a significant role. Any bright sunny day will yield all the light you need for directional lighting outdoors. The only problem might be that it may not be coming from the direction you'd like. In some cases, you can move the camera or walk around the subject to change front light to side light or back light. In others, you'll have to wait until the light itself moves before you can get the image you want.

Directional Light Behind Photographer

Putting directional light behind you in the morning or afternoon will give you scenes with the least amount of shadows. Contrast will come primarily from the natural contrast in the scene, rather than from the contrast between highlights and shadows. Matte surfaces such as stucco may show more color saturation because direct, shadow-free lighting emphasizes color rather than texture. Shiny surfaces, however, may have less color saturation as the direct reflections of the sun or light source dilutes the color with white light. You will get spectacular highlights (direct reflections of the sun or light source), which tells the viewer that the object has a shiny surface.

FACT

Using directional light behind you is good for sports photography because there are no distracting shadows. Uniforms, not being shiny, will look wonderful, and the bright light allows a faster shutter speed. Sunlit scenery stands out against the sky, which appears a rich dark blue in relation to the brightness. Sunny cityscapes or landscapes look their most colorful in early morning.

Directional Light in Front of Photographer

When you face into the sun you are looking at a backlit scene, which can be great for gardens and foliage in general. Backlit scenes are very dramatic, as the lines (such as roof lines) are lit up, emphasizing the lines and outlining objects. Because a backlit scene is naturally contrasted, backlit photos are usually not about shadow or highlight detail but the quality of light.

Remember that this is a time of day when your metering can be inaccurate. If your camera does not have TTL metering, it may underexpose the scene, especially if the portion of the scene it is reading is significantly brighter than the subject. This is why some cameras have a backlight button, which increases exposure by one or two stops to make up for backlit subjects that would otherwise be underexposed.

In cases such as scenes with water, the sun low in the sky creates a large, mirror-like reflection of light from the surface—called a specular reflection—in the water and wet sand. If you expose for the subject, the strong backlighting will overpower the picture, causing flare. The solution here is to deliberately underexpose by taking a reading from the shiny part of the scene. You may want to overexpose one or two stops to keep the sun's reflection truly bright, but not so bright it causes lens flare. This silhouettes (underexposes) backlit subjects without losing the details on the bright surface of the water and gleaming beach sand.

FACT

If you're using an automatic camera to photograph a scene dominated by the sky, set your exposure for the scene, not the sky and clouds. Use exposure lock while aiming your camera at the scenery, then keep it locked as you move the horizon to the one-third line in your frame. (The compositional "rule of thirds" is discussed in Chapter 12.)

Directional Light to the Side

Both morning and afternoon light appear as side lighting when you have your side to the sun. As previously mentioned, this type of directional light emphasizes texture, shape, and form. As you turn the way you point the camera or walk around the subject, you can change the direction from which the light is coming to create the picture you want.

Softening Directional Light

Directional light can be harsh, however, because it emphasizes texture and shine. Human skin tones, for example, are rarely flattered by direct light from the sun. Using a fill light (either a flash or reflector) will greatly improve your photographs of human subjects.

Another way to enhance light outdoors is to bounce the sun off a piece of white board. You will get a more powerful bounce if you use a silver reflector, such as a board covered with foil or even a sheet of galvanized steel. You could also staple a white bed sheet or shower curtain to a fence or the side of a building, or hang it from a rope or clothesline. All of these

are dependent on direct sun hitting the reflector. If you can change the angle of the white or foil surface, you have more flexibility in where you place your bounce card and your subject. Human subjects will appreciate a white board instead of foil or metal, which can be almost as blinding as direct sun.

◀ **FIGURE 10-3**
Light from the side can be very effective in defining facial features and giving a full, three-dimensional effect to the subject. It works equally well on inanimate subjects such as statuary.

Back lighting is a very attractive and natural example of having two lighting patterns. Any subject that is lit from behind but still has light from the front is a candidate for a backlit shot. The viewer understands that one light source creates highlights from the back, while the front of the subject is lit by a second light.

If you're working in sunlight with subjects that are close (five to fifteen feet) to the camera, use fill flash to put some light into the shadows. This

technique will let you properly expose for highlights, with the flash bringing light into the shadows.

Working with Diffused Light

Softer light is almost always more flattering to people's complexions. However, because diffused light softens the edges of shadows, pictures taken with it also can end up looking bland.

Outdoor Shots

When shooting outdoors, overcast or cloudy conditions will reduce color and contrast in most pictures. Any splashes of color will stand out in these pictures, which can make for a nice image. Since large scenes shot with diffused, nondirectional light will lack impact, you might choose to devote any overcast days while you're on vacation to getting closeup detail shots.

Softening Effect

Because it casts no harsh shadows, diffused light can work to your advantage or disadvantage, depending on the circumstances and what you want to achieve in the shot. Lack of drama and contrast are not always a bad thing; sometimes they can add to the ambiance of your subject in more subtle ways, conveying a gentler feeling than an image shot with direct light ever could.

Indoor Light

Indoor lighting differs from outdoor lighting in several ways. To use it well, you need to know how to work with these differences and use them to your advantage.

The most obvious differences between outdoor and indoor lighting are intensity and color. Without a flash, indoor light is usually five to nine stops darker than sunlight. This means that if you were using ISO 100 film outdoors, you'd have to use ISO 6400 film indoors with the same shutter

speed and f-stops. More likely, you'll use ISO 400 or 800 film for shooting indoors without a flash, which means larger apertures (f/2.0) or slow shutter speeds (1/15).

Working with Ambient Light

Ambient light is the existing light in a room. It can be directional or not, depending on the source, and is created by lamps, ceiling lights, window light, light shining in from windows, and so on. Rooms are often illuminated by several lights. Each casts its own pool of light, which means that each can serve as a main light if the subject is in that pool of light. The other lights then become fill lights or back lights for your subject.

You can choose how the various lights in the room will affect your picture through how you meter the scene. If you want to use one primary lighting source and your camera is likely to include a source in the background, then make a closeup reading of the subject with your camera and lock in the exposure. You can also take an incident light reading with your meter at the subject's position and set your camera manually. Make sure the shutter speed is fast enough for handheld work, or use a tripod or other object to steady the camera during the longer exposure.

Dull Lighting

Classrooms and offices usually have overhead lighting, which is very even and often dull. Because of the lower contrast of this type of lighting, you're less likely to be aware of the shadows that it casts under eyebrows, and you may not see the generally muddy look it creates until you get your prints back from the lab. Shooting in these circumstances with a digital camera allows you to be aware of bad lighting and compensate for it.

However, if you're photographing a large scene, such as an entire classroom or a large office space, you'll appreciate the evenness of overhead lighting. There will be no contrasting pools of light such as those you see in your living room.

Throwing More Light on the Subject

Shooting with existing light both indoors and outdoors is called existing-light photography. You can also add artificial light, either with flash units or from other sources. For more on using flash for indoor photography, turn to Chapter 11. Lighting for formal indoor portrait situations is discussed in Chapter 17.

Working with Window Light

It's not totally accurate to characterize window light as indoor lighting; it's really more like a specialized version of open shade. Window light is never direct sunlight streaming in the window. Your light may come from the outdoor scenery or sky. If there is sunlight coming in the window, you will cover the window with a translucent shade or curtain.

You can use color film and get accurate color with window light as long as no incandescent lights are overpowering the window light. Generally, digital shots will accurately portray the color, particularly when shooting with a digital SLR.

You can control the quality of light by the distance of the subject from the window. The closer to the window, the larger the light source; thus, the line between shadow and highlight is softer. As the subject moves away from the window, the contrast usually drops because the bright window light no longer overpowers the existing light bouncing around the room. But the main light becomes more directional because it's a smaller source of light.

More Ways to Modify Light

Lens filters change the way light reaches the camera lens. They can be extremely useful for achieving better color, contrast, and detail in a variety of lighting situations. Some can be used to create special effects or even outlines and wrinkles in portrait work.

Neutral-Density Filters

Neutral-density filters reduce light. They don't change the color of the light; instead, they darken it by one to three f-stops, depending on the filter. If you're using fast film on a sunny day and you're worried about overexposing a brightly lit subject, you can use a neutral-density filter to control the exposure and still shoot with a slow shutter speed or a wide aperture. There's also a neutral-density filter that goes from dark to light gradually. You can use this to control overly contrasting scenes by toning down the difference between dark and light areas. Again, this may be unnecessary in most cases when shooting digital. Contrast adjustment can be very easily done in image-processing programs. The exception to this may be when you are photographing a bright sky and want to ensure that highlight details are not overexposed or blown out, which can happen quite easily in digital photography.

Polarizing Filters

These filters make blue skies bluer, reduce and eliminate glare and reflections, and reduce haziness in both black-and-white and color shots.

ALERT!

Don't wear polarized sunglasses when shooting with polarizing filters, as you won't be able to see how the image will really look. The polarized lenses in your glasses will interfere with the polarizing effect of the camera lens, making it impossible to be sure what you're seeing is correct.

Polarizing filters come in two versions. The linear type is for use on manual SLRs. Circular polarizing filters work with the focusing and metering systems on automatic SLRs. Circular filters can also be used on manual cameras, but linear filters won't work with the systems on some automatic cameras. If necessary, you can use a linear filter if you manually set the exposure to compensate for it. You would also then focus the lens manually or use autofocus before attaching the filter.

Enhancing Filters

Enhancing filters are used for enriching the saturation of certain colors, including reds, rust-browns, and oranges. They're specially designed to make these colors more intense while not affecting other colors in the scene.

Color Filters

Primarily used when shooting with black-and-white film, these filters enhance certain colors in a scene by filtering out some colors and allowing others to pass through to the lens. Yellow filters, for example, absorb the color blue and darken the sky. They also add definition and contrast to clouds. Color filters can be used with color film to create special effects. Color-balancing filters are also used to warm up or cool down the overall colors when shooting outdoors in certain situations. There are also color-balancing filters that let you use daylight film in unusual ways, like indoors without a flash or under incandescent light. Color-balancing filters also allow you to use indoor film outdoors in sunlight.

Digital photographers can find many filters and other controls for color adjustment and enhancement in PhotoShop and similar programs. Color cast and intensity can be adjusted in most good editing software. The capacity for color-correction in these programs usually exceeds what you can achieve using filters on a film camera.

FACT

Since the colors on print film can also be corrected when the film is printed, many photographers only use color-balancing and color-enhancing filters when they're shooting slide film. However, using color filters with print film will give you more control over the colors you get on the front end, lessening the amount of correction necessary after the fact.

Star Filters

Star filters have etched lines on them that convert points of light into stars. Depending on the filter, the effect can be highly dramatic or finer and

less obvious. They're useful for adding sparkling effects to water scenes or for calling attention to a specific aspect of an image, such as the light reflecting off a motorcycle helmet or a crystal goblet.

Soft-Focus Filters

These filters contain a special element that scatters the light reaching the camera lens. Images taken with them are in focus, but the details are softened, hence the name. This effect is widely used in wedding and portrait photography to enhance complexions and smooth out wrinkles. They come in various strengths.

You can make your own soft focus filter by putting a nylon stocking over your lens. Petroleum jelly also creates soft effects—but put it on a clear lens filter instead of your lens. Some people even create soft images by breathing on their lenses and fogging them up.

In PhotoShop and PhotoShop Elements, the "blur" filter can give a similar effect if used with restraint by digital photographers. You will even be able to choose the amount of softening and blur to use and experiment to see what works best for your subject.

CHAPTER 11

Flash Photography

Using a flash unit means more than shedding light on a dark subject. Not only does the light from a flash make it possible to take photos when the light is low, it can vastly improve the images you shoot in other situations. Many photographers say their flash is their favorite light source. Learn how to use it, and it might become your favorite as well.

Learning to Love It

While many experienced photographers love using flash and use it quite a lot, many amateur photographers are less comfortable with this particular piece of equipment. Such feelings are perfectly understandable when you consider how tricky it can be to learn how to use flash well.

Flash can greatly enhance photographs because it eliminates blur due to motion and, when shooting with color film, it has the same color balance as daylight. But it can also ruin pictures. It only lights the scene for an instant, so it doesn't allow you to adjust the lighting or the scene to your taste. Unlike existing-light photography, you won't know exactly what the effects of your flash will be until you see your pictures. In addition, some camera manufacturers place the on-camera flash too close to the lens axis, which causes red eye when you're shooting people or animals. It also creates harsh shadows and high contrast and often gives you overexposed subjects in the foreground while leaving background images cloaked in darkness. However, all of these problems can be overcome with some practice, thought, and extra equipment. If you spend the necessary time to learn about flash, practice using it, and most importantly, get the equipment necessary to use it well, you'll realize that flash can be the best and most consistent lighting for your photographs.

FACT

Electric flash units vary in power. The more powerful the unit, the larger and heavier it will usually be. Flashes also range from very inexpensive to quite pricey, so be sure you know what you want before paying for something you may not need.

How Flash Works

Electronic flash units are fairly simple devices, consisting of a capacitor and a gas-filled tube. Batteries provide the power, which is stored in the capacitor until the shutter is snapped. Then, an electrical charge travels through the tube and makes the gas inside it glow bright white.

Synchronization

At the same moment that the flash fires, the camera's shutter opens up, so that light from the subject (a mix of existing light and the flash) can flow through the lens and onto the film. As soon as the capacitor recharges—usually in just a couple of seconds—the flash is ready to fire again.

Brief and Intense

The burst of light made by an electronic flash unit lasts only about 1/1,000th to 1/10,000th of a second. This makes flash great for delivering sharp photographs because it eliminates blur caused by motion—your own or the subject's. The light created by an electronic flash also has the same color balance as daylight, which is an important consideration when you're using color film.

Types of Flashes

Most SLR cameras—especially automatic models—come with built-in flash units. When shooting in automatic modes, the flash generally switches on automatically when conditions are too dark for handheld shots or when a scene is backlit. In some modes, the flash has to be turned on by the user. Most also have a function called red-eye reduction, which shines a quick spot of light into the subject's pupils and makes them contract a bit before the flash goes off.

Advantages of Built-In Flash

Built-in flash is handy to have, which is why most camera manufacturers include it. It guarantees you'll have some flash capabilities no matter where you are. It's definitely the fastest and easiest way to capture fleeting moments. It also works well for balancing the light when taking portraits outdoors by filling in or adding light to shadows caused by the sun (that is, by acting as a fill flash).

Disadvantages of Built-In Flash

Unfortunately, there are probably more disadvantages than advantages to built-in flash. It's only a little better than having no flash at all. Here's why:

- Limited operating ranges—usually between three to twelve feet—mean that anything farther than the flash's maximum range will be underexposed. Objects that are too close will be overexposed.
- Light is projected directly onto subjects, making them look flat and harshly lit.
- Built-in flashes are notorious for creating red-eye because they are mounted so close to the lens axis.
- Built-in flashes can't be adjusted to create more pleasant illumination, such as bouncing the light off the ceiling to lessen shadows.
- Light reflects directly off subjects, meaning they often create flash glare from glasses, or even skin if it's shiny enough.

Going Beyond Built-In Flash

A flash unit is a must-have accessory if you're serious about your photography. This unit attaches to the accessory shoe (also called a hot shoe) on top of a camera or to a flash bracket that attaches to the camera. Accessory flashes are not only more powerful than built-in units, they're also more versatile. You can make their light more diffuse by aiming them upwards or sideways. You can take them off the camera and move them anywhere you want. They also make possible a variety of special flash techniques that are beyond the capabilities of built-in flash.

There are three different types of accessory flash units:

- **Manual**: As the name indicates, these flash units require you to figure out the correct exposure for your shooting conditions. Because the duration and intensity of the flash from a manual unit doesn't change, you have to adjust lens apertures to control the amount of light that reaches the film. Aperture settings are determined by dividing the flash's guide number (which indicates the flash's light

output) by the distance to the subject. The resulting number is the correct aperture. Most manual flashes have calculator dials or scales for making these calculations.

- **Automatic**: These flashes use automatic sensors to control light output and duration based on the distance from the camera to the subject. When you set the aperture you want to use, the flash will automatically calculate how much light is needed to illuminate a specific distance range, such as three to fifteen feet. Or, the flash unit will have an electric eye that reads the amount of light bouncing back from the subject. When the correct amount of light has been reached, the flash is turned off. Most automatic flashes have several different range and aperture settings and can be set manually as well.

- **Dedicated flash units**: Want to remove virtually all the frustration from flash photography? A dedicated flash will do this and more. They're made to work with your camera's specific electronics (hence the name), and they'll do all the thinking for you, automatically setting the correct shutter speed and aperture and controlling the exposure by regulating flash duration (its intensity).

QUESTION?

If I'm using an automatic or dedicated flash, do I need to know how to calculate flash exposures?
It may seem like an archaic skill in our automatic world, but even the automatic exposure controls on the most sophisticated flash units aren't perfect. There will still be times when you'll use your flash's manual setting, which is when understanding factors such as distance-to-subject and f-stops will definitely come in handy.

Using Flash Properly

Many photographers prefer to keep their flash units on top of their cameras when using them. It's faster, more convenient, and it guarantees that some image will be captured on film every time you squeeze the shutter release. However, using your flash in this way usually doesn't result in the

best possible images. In fact, unless you redirect the flash head away from your subject, your pictures will look very similar to those taken with built-in flash.

Learning the Options

There are times when shooting with the flash on the camera can work fairly well, such as in situations needing fill flash or when you diffuse the flash by aiming it at the ceiling or a wall. However, you'll get better pictures if you move the flash away from the camera lens. If you have a flash cord, you can take the flash off the hot shoe, connect it to the camera with the flash cord, and hold it anywhere you want. You can attach it to a light stand, a clamp, or even have a friend hold it. Mounting the flash on a bracket that attaches to the camera is another popular option. This also requires a flash cord to synchronize shutter and flash operation.

Synching Up

The burst of light emitted by a flash unit is exceedingly short, ranging from 1/1,000th up to 1/10,000th of a second and even faster. To capture such quick bursts of light, the shutter's operation must be synchronized with the flash so that it's fully open at the exact moment the flash goes off. If it isn't, only part of the image or nothing at all will be captured on film.

ALERT!

Some dedicated camera/flash combinations will work together even at very high speeds. The flash fires several times during the exposure; each flash exposes a new sliver of film showing between the two shutter curtains, creating the image slice by slice.

Cameras with focal-plane shutters (almost all SLRs are in this category) only synchronize at certain speeds. (Cameras that use leaf shutters, which expose the image in a different way, work with flash at all speeds.) This doesn't mean you can't use shutter speeds other than the sync speed when

shooting with flash. The flash will also sync with slower shutter speeds than the sync speed. Using those speeds will let in ambient light in addition to the flash. Higher speeds, however, will be out of sync with the shutter.

If you're using a dedicated flash unit, you don't have to worry about flash sync, as the system will do it for you. Most systems will choose the fastest possible shutter speed to lessen the amount of ambient light hitting the film or photo receptors. You'll have to manually set the shutter speed to override this if you want exposures with ambient light as well. With automatic flash units, just attach the flash to the camera and set the shutter speed dial to the proper sync speed (you'll find it in your camera's manual).

Buying a Flash

If your camera has a lot of automatic flash functions, get the matching brand name flash. Owning that matched flash allows you to get all the benefits of investing in that automatic camera. It is worth the extra money. Also, if your camera-flash combination isn't working, you only have to turn to one warranty service center for the fix.

Automatic Flash Tips

Flashes made by the camera's manufacturer for your automatic model are usually the best choice. Instruction manuals for your camera will probably include references to specific flash models that work well with that camera body. This can make the learning curve easier, and you can be certain that all the automatic features are fully supported by the flash unit since they were specifically designed for that purpose.

Manual Flash Tips

On the other hand, if you lean toward manual functionality, you can get a simpler and more powerful flash made by any manufacturer that will fulfill your requirements. This lends more flexibility to your choice of flash and will also give you more choices of models and prices. Searching the Internet for new and used equipment opens up another world of purchasing options for flashes.

Buying a Flash Meter

If you're using a manual flash or you're not sure that your automatic flash is giving you consistent exposures, you might find a flash meter very useful. A good flash meter will cost $200 or more—don't waste your money on an inexpensive model. Your flash meter should also be able to function as a regular light meter, so you are getting two meters in one. Make sure it uses a penlight or nine-volt battery, not some expensive battery only available at camera stores.

◄**FIGURE 11-1**
This photo taken of a garden ornament is perfectly acceptable. There is plenty of detail in highlights, midtones, and shadows.

◄**FIGURE 11-2**
This is the same image photographed with a flash exposure. Did this improve the overall effect or not?

Using Your Flash

As previously mentioned, a good accessory flash unit can be used in a variety of different ways. It can improve lighting conditions in virtually every situation and allow you to create some special effects as well.

Flattering with Fill Flash

This technique adds light to shadows to create better balanced exposures. It also throws light onto the foreground of backlit areas to keep images from appearing as silhouettes. The secret to good fill-flash photography is to balance the light from the flash with the existing or ambient light. The ideal fill-flash setting will provide just enough light to bring the shadows within one or two stops of the highlights. Good flash and camera systems will automatically do this, or you can do it yourself.

You can use fill-flash techniques in a couple of different ways to augment or correct existing light. The following sections provide some tips on how to do so.

Bright Days

You're taking a picture of some kids at a school picnic. The sun is directly overhead, lighting up the tops of their heads and casting unflattering shadows under their eyebrows, cheeks, and noses. Set the camera to expose the sunlit faces correctly, and set the flash to go off about one or two stops less than the ambient light. This technique fills in the shadows but isn't the main light source. Similarly, when shooting digitally, expose for the faces correctly and compensate for the shadows in the image and contrast controls.

Backlighting

You're taking a picture of your aunt and cousin while they're visiting San Francisco. The Golden Gate Bridge is sunlit in the background, and your relatives are in a shady spot. Set your camera to expose properly for the bridge, and the flash to expose properly for them. You may want to bracket your exposures by slowing the shutter down one stop to make the background brighter, and then, if you can, bumping it up to a faster setting to darken the scenery. Changing the shutter speed won't change the lighting

on your relatives because they're only being lit by the flash. In this case, the flash fills in the entire subject but is equal to the ambient light. Because the subjects would otherwise be in shadow, the flash is the main light for the subject.

Indoors with Good Lighting

You're at an evening wedding reception in a hotel ballroom. The bride and groom stop to visit at your table, and you want to take their picture. The room is comfortably lit, but not bright. You're shooting ISO 400 film, or in digital shooting have set your ISO at 400, if possible. You want the shutter to stay open long enough to capture some of the warm ambient light in the room. Choose a large f-stop, say f/2.8 or f/4, match the flash to the f-stop (which an automatic camera will do), and make sure the shutter stays open for 1/15th or 1/30th of a second. The room will not come out bright, but will look warm and friendly. The happy couple will be properly exposed by the flash and not blurred despite the long shutter speed. The reason is that most of their image was put on the film by flash illumination, which will be much brighter than the ambient light.

You can use an accessory flash or a built-in flash for fill-flash pictures. Check your camera manual for information on how to adjust exposures when using built-in flash.

Bouncing Off the Walls (and Ceiling)

Accessory flashes are adjustable, which means you can change the direction of the flash by tilting or rotating the flash head.

Bounce flash eliminates the flat, contrasting deer-in-the-headlights look that direct flash so often delivers. You'll still get good illumination, but the light will be indirect and softer, which makes for much more pleasing pictures.

To set up a picture with bounce flash, rotate the flash head toward the ceiling or to the side so it faces a wall. Low ceilings or walls that are close

to your subject work best for this. If either is too far away, the bounced light might not be strong enough to provide adequate illumination. Using bounced light always requires that you increase exposures by several stops, since some of the light is absorbed or scattered when it hits the other surfaces. If this is the case, you'll need to use a wider aperture or faster film. If you have a connecting cord, you can take your flash off the hot shoe and move it closer to the reflective surface.

It's important to aim bounce flash correctly so the light falls on your subject, not behind it. If you aim the flash at the ceiling directly above your subject when taking a portrait, you might create "raccoon" shadows under your subject's eyebrows.

Using Multiple Flashes

You can use multiple flashes to light a picture. A photo slave, which costs as little as $20–$30, senses another flash firing and instantaneously triggers the flash it's plugged into. If you have a flash meter, you can measure the output. Or, if you use a second flash that has its own sensor, you can aim that second flash at the subject from just about any position that lights up the subject well. Set the off-camera flash at f/8 or f/5.6, and set your on-camera flash at one to two stops less.

A photo slave will fire every time it senses a flash going off, so if your camera uses a flash burst to reduce red-eye, the slave flash will also go off too soon. If you're not the only one in the room with a flash, it will fire whenever anyone else takes a flash picture.

When a Good Flash Goes Bad

Because flash is too brief for us to see how the illumination will look in the photograph, it's easy to take bad flash pictures. When the flash is much more powerful than the ambient light, backgrounds go dark. Mess up an exposure calculation, and subjects nearest the lens are blown out (overexposed). Strange reflections creep into shots when you least expect them. Of course, with today's digital technology, you will be able to review and re-shoot if necessary.

The ultimate solution to bad flash pictures is to just keep taking them. Practice means everything with flash photography. With time and experience, you'll soon learn what works and what doesn't. You'll hone your techniques and figure out how to move your flash around or adjust its settings to take better advantage of what it can do. In the meantime, here are some suggestions for troubleshooting some of the most common problems that erupt with flash photography.

Bad Reflections

Flash travels in a straight line in all directions and bounces off objects, walls, mirrors, and windows. If you're shooting a subject in front of or through a window, remember that you must move up, down, right, or left until the flash doesn't reflect back into the camera.

If you can set off your flash without taking a picture, look through the viewfinder and pop a flash. If you're shooting digital, you probably won't care if you waste a shot. In any case, watch for reflections in windows, glasses, framed pictures, and even glossy paint.

Generally, you can avoid these sorts of reflections by not photographing straight into a wall or reflective surface. Set your subject up so that you are shooting at a 30°–45° angle to any reflective surface. If you absolutely have to be directly in front of a window, try lowering the camera to see if you can get the subject to block the reflection. When two mirrored or shiny walls meet at a right angle, they will always reflect directly back to the camera, no matter what angle you select.

Glasses and Flashes

Some people wear eyeglasses with special nonreflective coatings. However, if the person you're photographing wears the old-fashioned reflective type of lenses, try the following:

- Lowering or turning the subject's head until the reflection disappears
- Raising the arms of the glasses, which will tilt the lenses down without the subject having to drop her chin
- Taking the glasses off

You can prevent some conflicts by making sure glasses are pushed all the way on so the top rim doesn't cast a shadow on the eyes. After you pose your subject, set off a test flash while you look through the viewfinder for objectionable reflections. This may take a few tries if you're shooting multiple subjects wearing glasses.

A flash unit with properly charged batteries should be ready to go fairly quickly after you turn it on. If yours doesn't perform properly, try cleaning the contacts on the batteries and the flash. If they're dirty or corroded, they can affect performance.

Incorrect Exposures

Automatic cameras that sense the flash coming back from the subject can be fooled by subjects that are very light or very dark. This cannot always be prevented, but one simple trick will give you a better chance of getting it right: Eliminate any large gaps between your subjects if you're using an automatic flash. The sensor might be aimed at the empty space between your subjects. If that's so, the sensor will tell the flash to stay on until that faraway empty space is properly exposed, baking (overexposing) your intended subjects in the process.

However, if you try to block the gap by putting your subjects against a wall, you'll get dark shadows behind them, courtesy of your flash. No matter how high or low you place the camera there will always be a shadow behind the subject that the camera will probably pick up. This is a good reason to use a slow enough shutter speed to allow the ambient light to fill in the objectionable shadow.

Weak Lighting/Flash Falls Off

Automatic flashes work best over a certain range that varies depending on the speed of film, the largest aperture of the lens, and the power of the flash.

The reason many flash pictures don't work is because the photographer underpowered the flash. He selected the wrong combination of film speed, aperture, and power for a great distance. To double the effective power or distance, get a film that is four times as fast. Changing from ISO 200 to ISO 800 doubles the distance at which your flash will work.

The light from your flash diminishes (falls off) as it travels away from your flash. This means that a point far from the flash will get less light than a point near the flash. If a subject is beyond your flash's range, chances are you won't see it at all in the picture. The best way to avoid these shots is to know what your flash's effective range is and stay in it. If you know your flash is too weak for a certain situation and you can't move it closer, try using a slower shutter speed to allow more ambient light to enter your lens.

Flash Care and Maintenance

Flash units, just like cameras, should be kept in cool, dry places when not in use. If you're not planning on using your flash for a few weeks or more, take the batteries out to avoid damage from battery leakage. This doesn't happen very often, but when it does it can cause serious damage to delicate equipment.

If for some reason you won't be using your flash for a longer period of time, keep the capacitor working properly by firing it up once a month and discharging the flash a few times.

CHAPTER 12

Taking Great Pictures

Good pictures might look effortless to create, but they very rarely just happen. More often, they are the result of careful planning and knowledge of what goes into making a good photo. Learning these good photographic techniques allows you to express yourself and make pictures that people really enjoy looking at, like the pictures of the swan family in the color insert.

What Makes a Great Picture?

Memorable pictures always have an emotional impact on the viewer—they express feelings and tell truths. Through such factors as good lighting and composition, they clearly express their meaning as well as the intent of their creators.

Meaning and intent are conveyed by how well you use elements such as color, contrast, shapes, lines, perspective, light, and texture in your pictures. In a good picture, these elements work together to tell your story, your ideas, and your emotions. When they are not in balance, you can't tell what the picture is supposed to convey. When a picture has a mistake in its composition, looking at it is very much like listening to a sentence in which the speaker accents the wrong syllables, misplaces punctuation, mispronounces words, or stops abruptly. You may not be able to instantly identify what's wrong, but you can tell immediately that something is not right.

Thinking Artistically

Learning the techniques behind the creation of good pictures expands your creativity and expressiveness. Think of it as learning a new language that gives you the tools to say exactly what you want to say and express who you are and what you think—through the lens of your camera. What Oscar Wilde said about painting also holds true for photography: "Every portrait that is painted with feeling is a portrait of the artist, not of the sitter."

FACT

There is never only one way to take a picture. Learning to express yourself as a photographer means experimenting with all aspects of picture taking. You can choose to use good technique or deliberately abandon it.

Basic Elements of Composition

Composition is the arrangement of shapes and lines within a two-dimensional image. If you're taking a picture of a lamp you want to sell on eBay, you'll want to use the simplest composition possible. You're not trying to communicate how you feel about the lamp; you're just presenting

information. You center that lamp right in the middle of your frame. This type of composition is static: It doesn't move, nor does it coax the viewer to look at it or explore it. It is strictly factual and conveys a view of the subject that is totally objective and uninfluenced by sentiment. This sort of composition is seldom particularly pleasing.

Good composition makes photographs more attractive and compels others to look at your pictures. Get to know the basics of good composition thoroughly and you'll automatically use them every time you look through your viewfinder.

Center of Interest

The most successful pictures are composed around one main point of interest. Whatever it is—a group of trees, your best friend shooting pool—it is the main subject of the photo.

Having a strong point of interest or main focal point in a picture draws the viewer's attention and focuses it on the point you want to make. Compose a picture with more than one strong focal point and you'll confuse the viewer and make the picture's message and meaning less clear.

The point of interest doesn't necessarily have to be just one person or one object; however, the other objects in the picture shouldn't detract from it. Its placement within the composition should move the viewer's eye back to the main subject.

Placing the Center of Interest

Putting the center of interest smack in the middle of a picture is an effective way of focusing the viewer's attention on the picture's subject, but it is also just about the most boring way possible to compose a picture. Though in some instances it may be necessary, this composition should be avoided wherever possible. Try experimenting with a shot of the subject dead center

as opposed to one shot with the subject slightly to one side to see for yourself what a dramatic difference a shift in positioning can do.

Given that it's almost always best to put your center of interest somewhere besides the center of the frame, where do you put the subject? Simply moving your subject off-center is one way to create a more pleasing composition. Putting it at one of the power points of the frame is even better. In the photo of the landscape at sunset in the color insert, the clear center of interest is the stark image of a tree contrasted against a blazing sky.

Going to the Points

This is a very simple compositional tool. Imagine a tic-tac-toe board on your blank composition that divides the frame into thirds horizontally and vertically. The four intersections where the lines cross are your power points. Objects placed at these points make your photos more dynamic.

A single object can go at one of the power points. Place a vertical object (a seated or standing figure) on either of the two vertical lines. A horizontal form (a long building) goes on one of the horizontal lines.

If you have two subjects—a car and its owner—use one power point for the main subject (what the picture is about) and the diagonal power point for the secondary subject. This is a simple example of composition expressing a definite relationship between objects. After you grasp the concept, implementing it becomes virtually automatic and effortless.

QUESTION?

Can I put two unrelated objects on two diagonal power points?
Yes, but you might want to think twice about it. Doing so creates a photo that doesn't succeed. However, this type of composition can also tell the viewer that you see a relationship between two seemingly unrelated objects and want to express it.

The Rule of Thirds

Dividing the image area into thirds for the purpose of centering your subject is also called the rule of thirds. This rule governs where you should place your horizon line in scenic pictures, too, as the lighthouse

in the color photo demonstrates. Putting it at the center is just like putting your main subject there.

Your pictures will be greatly improved if you move the horizon line to the upper or lower third of the frame. Avoid cutting your pictures in half by having the horizon in the middle of the picture, which produces a rather boring and static image. When you want to accent spaciousness, keep the horizon low in the picture; when you want to suggest closeness, position the horizon high in your picture.

Make sure the horizon is level. Nothing gives away an inexperienced photographer more quickly than a noticeably tilted horizon line. You can easily correct this annoying mistake with digital images. Sloping horizon lines are easily straightened out using the rotate feature, and digital cropping can also ensure that your horizon is positioned correctly in the frame.

If your composition includes strong vertical lines, such as the edge of a building, it's also better to place them off center. Use the rule of thirds to guide their placement as well.

The rule of thirds can also be used to compose pictures when subjects are moving. You typically want anything that's moving through the frame—a running animal, for instance—to have space to move into. How much space will depend on the overall composition of the picture, but you would almost never want the object to be so close to the edge that it looks like it's moving right out of the frame. Using the rule of thirds to put space in front of the subject allows the viewer to visualize the subject moving forward into that space. Subjects moving toward or away from the camera also need room to walk into.

It's also generally poor composition to have a single subject looking out of a picture frame. When your subjects are not looking directly at the lens, they will need room in the frame to "look into." Put the subject off center to leave room for the subject's gaze.

Following the Lines

Lines in a picture are used to draw the viewer to the subject or to create specific feelings and moods. Lines can be as concrete as a footpath across a lawn. Lines can also be created by allowing the viewer to visually interpret and connect a repeating pattern in the image, like looking down a row of chess pieces.

Remember that body parts also form lines. Arms akimbo are compositional diagonals. Arms hanging down create vertical lines. A subject standing with feet together creates a single vertical block, while a figure standing with feet far apart creates two diagonal lines.

◀ FIGURE 12-1
Although the gull is almost centered in the shot, it is a little off center and the horizontal and vertical lines create enough visual interest to keep the shot from being too static.

Static Lines

Lines can convey mood and meaning literally. Static lines are straight lines placed either horizontally or vertically in a picture. They denote stability, lack of change, and lack of movement.

Horizontal lines suggest peace and calm. Vertical lines suggest elegance, strength, and majesty. Photos of architecture with strong and long vertical lines, such as the Gothic cathedrals of the sixteenth century, suggest a connection with heaven above. When viewed from the ground, the parallel lines converge, implying that being in or near the church moves you upward toward heaven.

If you photograph a square or rectangular building straight on, keeping the vertical lines parallel will create a picture composed mainly of vertical and horizontal lines. It is static, impressive, and has no movement. It tells the viewer that there is no change happening, that this building has been there a long time and will probably remain there a lot longer, which is often exactly what the picture is meant to suggest.

Straight lines become less static when they converge. Forcing the perspective by tilting your camera makes the lines come together and gives your picture movement and depth. Changing your shooting angle can also make horizontal lines converge to convey perspective and depth.

Dynamic Lines

Dynamic lines move on the diagonal and suggest motion and energy, as in the picture of the rowboat in the color insert. They also suggest tension and distance (think of diverging parallel lines that show perspective). They may appear naturally in a picture, or you can create them yourself by changing camera angles. Shadows can form diagonal lines, which you can use to show relationships and draw the viewer into the picture. They also occur when you place subjects on two diagonal power points in a frame.

Graceful Lines

Curved lines are graceful and often restful lines. They lead the eye into the picture gently and smoothly. If you want to show an infant at rest and being nurtured, photograph the baby in the parent's curved arms, a very natural position and composition.

"S" curves are probably the most visually pleasing elements you can capture in a picture. Keep your eye out for these classic "S" curves:

- **Roads.** Highways and byways often create "S" curves as they meander through landscape shots. An "S" curve in a road viewed at a distance from a hill is a photograph waiting to be captured.
- **Bird necks.** The curve of a bird's long neck is a good example of an "S" curve eager to be photographed.
- **Farm fields.** Furrowed fields, rows of corn, acres of sunflowers—there are "S" curves to be found here as well.
- **Streams and rivers.** Waterways often form natural curves. If they're slight, you can try emphasizing them by using a telephoto lens, which will compress the distance between the curves.

An "S" curve is strongest when elongated and perhaps tilted, producing a diagonal line that has two curves in it, such as the view of the edge of a nicely shaped swimming pool as seen from one end.

If you are fortunate enough to find an "S" curve to photograph, put your subject where the curve leads the eye, not in the middle of the curve itself. It is much more interesting compositionally.

Finding the Golden Triangle

Lines can also be created when the viewer visually draws them between points in a picture. When the lines connect, they create geometric shapes and relationships that can also affect a picture's composition. The photographer's

favorite is a triangle. A compositional rule called the golden triangle results in good pictures. It's generally used to compose portraits, although it can work equally well when photographing either groups of people or objects.

Let's say you're taking a picture of three people. Elevating the middle person forms a triangle. This is good. But what if, instead, you were to elevate one person on the end? Does this create a triangle? Not really. It makes a bent line or an "L," which are generally not visually pleasing shapes.

Now imagine photographing four people. If you put them in a straight row, you'll create a very static composition. If you raise the first and third person you create something that looks a lot like two connected triangles or even a flattened "S" curve, which are generally perceived as pleasing arrangements.

When you photograph groups of objects, look for imaginary lines to connect them into triangles—not right angles, vertical lines, horizontal lines, or a jumble of shapes. One easy-to-remember rule for arranging groups is to never position two heads at the same level.

Avoid stacking people in front of and behind each other when you're taking group shots. The totem pole effect of this arrangement creates an unpleasing vertical line. You can improve it by creating a triangle—one person in front, two behind, and so on.

Leading Lines

A leading line is a very powerful compositional element that leads the viewer's eyes into the picture and to the subject. It can be a structural line, such as a wide staircase, or something more bucolic, such as a plowed field. Strong shadows can also create leading lines.

A good way to envision the power of leading lines is to analyze their opposite. Visualize a person standing in front of the camera, arms at his sides. The vertical lines of the arms lead your eye down, out of the picture.

Vertical lines that drop down from a subject and lead to the bottom of the frame draw a viewer out of the image, literally and figuratively draining the energy out of your picture.

Place your subject at the end of a leading line for the greatest visual impact. Avoid putting your subject in the middle of the line—this bisects the line and diminishes its strength and impact.

Working with Repetition and Texture

Multiple parallel lines that converge on your subject lead the viewer powerfully into the image. Parallel lines that converge at a distant point create perspective. What about parallel lines that don't converge and don't lead out of the composition? These are examples of textures or repeating patterns.

Using Texture and Repetition

Like other compositional elements, textures can be the subject or theme of a photograph, or they can be a background element of the picture. Repetition, which could almost be thought of as texture on a different scale, generally pleases the eye. A distant view of a plowed field might show texture, but a closer view might become a repeating pattern, while closer still might become texture again.

As you read in Chapter 9, a telephoto lens can capture repeating shapes, such as several ridges of mountains, while minimizing the perspective-induced effect of converged parallel lines. Because the telephoto lens enlarges these distant similar objects, you don't perceive depth, but instead enjoy the pleasing repetition of shapes.

Guidelines for Using Texture and Repetition

Be aware that textures and patterns can also be distracting. If their shape causes a lot of contrast, they can overpower pleasing compositional elements such as triangles, similar shapes, and curved lines. In portraiture especially, clothing with a strong pattern distracts, unless the picture is about the clothing. Advise your portrait subjects to wear plain clothing without loud patterns.

▲ **FIGURE 12-2** A long shot of these interesting rocks along Newport's Cliff Walk would not have captured the subtle patterns etched into their surfaces by the action of the waves as well as this closeup does.

It's a good idea to look for repetition and texture when you're shooting; carefully consider how they can strengthen or distract from the overall picture. If the picture is about these elements, think about ways to emphasize them, including the following:

- **Perspective.** Where you shoot from can greatly change what patterns and textures look like. If you happen across a shot that looks just right, take it from that spot. But don't stop there; feel free to experiment! Move in, move out, and move your camera up or down to see what other pictures you might be able to capture from different perspectives.

- **Lens selection.** Just about any lens will work for capturing patterns and textures. A telephoto lens will compress the distance between objects and make patterns appear more distinct. Shooting with a

telephoto zoom lens will allow you to crop the frame without having to move from your shooting position, as in the picture of the beach rose in the color insert.

- **Lighting.** The direction of the light most definitely affects the appearance of textures and patterns. Light coming from the back or the sides will emphasize both. Front lighting tends to reduce texture and pattern, as it flattens the light and erases shadows. Bright daylight also helps accentuate textures and patterns, as it creates stronger shadows than diffused light.

FACT

As a photographer, you look for and/or create the elements of light and contrast that will show the shape and form of three-dimensional objects in your pictures. By changing your position relative to the object, you change the direction of light in your photograph as well, as in the picture of the plant tendril silhouette in the color insert.

Using Color Effectively

Using color is a conscious choice photographers make. Color can either be a picture's best friend or its worst enemy. Bright colors can attract the viewer, but having too many different colors in a picture can totally disrupt its balance and rhythm. Pictures can be about color—just like they can be about texture and pattern—but color can also interfere with these other elements and confuse the viewer.

Color Choices

A color photograph is usually a more accurate portrayal of the subject as an objective observer would see it. Color is most effective when it is used primarily where color is the actual theme of the picture, or when it reinforces the imagery or subject. An amazing spring display of colorful tulips makes the perfect subject for a quick snapshot, as the example in the color insert shows.

Black-and-White

There are times when color simply gets in the way. If you think using color will detract from the compositional elements and distract the viewer, it is time to think about using black-and-white imagery to convey your message. This strategy will put more emphasis on other elements, such as form and texture, and will help you tell a subtler, more personal, or more direct story. Digital photographers will find it helpful to experiment with their options by shooting a series of images in color and then desaturating them or converting them to grayscale in the digital darkroom.

Using Point of View Effectively

The components of a good picture include composition as well as light and form. By choosing where you put your camera, you can modify all these to tell your story.

Don't just walk up to a subject and take your shot. You give yourself more options when you walk around and look at the subject from all angles. Only after you have explored your subject should you select and shoot the best angle for the photo.

Snapshot or Picture?

The perspective, or point of view you choose for taking your picture, can mean the difference between a photo that is merely a snapshot and a picture that involves and moves the viewer. It can definitely alter the scale of a picture and change how images and elements are emphasized and perceived by the observer.

You may need to move your camera only a few inches or a few feet to change the composition. Sometimes this means getting out of your comfort zone, literally shifting your point of view. Imagine being at a baseball game, photographing the pitcher from the sidelines. Choosing a low camera angle would emphasize the rise of the mound, while the rest of the setting—the

field, the stadium, the surrounding scenery—would be a small part of the picture. Choosing a different point of view that takes in these other elements minimizes the impact of the pitcher's mound.

Ways to Alter Point of View

- **Shoot low.** Lowering your camera to ground level creates a worm's-eye view that can suggest a subject is larger than it is. Outdoors, this can provide an uncluttered sky background. Shooting buildings from a low position will cause their lines to converge and make them look more imposing.
- **Shoot high.** Shooting from a high angle will keep most or all of the sky out of your picture.
- **Horizontal versus vertical.** The vertical/horizontal question affects the lines, the sweep, and the size of the sky. Vertical composition, by showing more foreground, can emphasize perspective. But

◀ FIGURE 12-3
The vertical lines of Trinity Church in Newport, Rhode Island, lead the eyes upward toward heaven, while the repeating horizontal lines form a pleasing subtext to the picture.

horizontal composition, with a different foreground and a lower camera angle, does it, too. Always ask yourself which orientation crops out distractions more effectively.

Even if you're limited to shooting from a single spot, you still have several options for your point of view. Placing the horizon very close to the top of the frame expresses the point of view that the land is large and the sky is small; conversely, a low horizon line will emphasize the vastness of the sky. Swinging your camera from right to left as you frame the photo also changes your point of view. In digital photography, you can take a series of photos from left to right in sequence, later stitching these images together to form an interesting panorama.

CHAPTER 13

Taking Your Pictures to the Next Level

Eventually, the day will come when you look at some of your pictures and know you can do better . . . and you're right, you can! Shooting on a regular basis is one of the best ways to learn. But analyzing what you've already shot with a more critical eye will also help you learn what you can do to get better shots the next time you have your camera in your hand.

Fixing Framing Problems

Most beginner photographers don't get close enough to their subjects when shooting. As a result, their pictures have too much space around the subjects. Although you can compensate for this by cropping after the picture is taken, it is better to get the shot right initially. If you practice cropping through your viewfinder, you can overcome this problem quickly.

▲ FIGURE 13-1 The simplicity of this tulip is captured in all of its beautiful detail by letting it fill the frame.

This practice will also result in better quality photos that are easier to print. If you are using film, you won't have to enlarge your pictures and then physically crop them down to create the images you want. With digital images, more information is retained, increasing overall picture quality. The next time you're shooting, take an extra moment before you press the shutter. Check all four edges of the frame in the viewfinder or LCD screen. Crop out background clutter. Move or zoom in so the subject fills up as much of the frame as possible.

It is possible to get a little too close to your subjects. Avoid getting so close that you crop either animal or human subjects precisely at a joint—neck, wrist, knee, ankle, or elbow—or through the eyes; it makes the viewer feel squeamish. It's always better to crop your picture before you take it. Cropping "in the camera" uses the maximum image area, which means that very little is wasted on things you don't want to show in the final picture.

You can see the effects of cropping on your pictures without actually cutting any of them. Make two L-shaped pieces of poster board or another type of flexible cardboard (such as an old cereal box). Use them to form opposite corners of an adjustable rectangle. Place them over your 4" × 6" prints to see how your pictures can be improved.

Other Framing Problems

Filling the frame with the image is a key element in improving your photographs. So is filling the frame properly. Many inexperienced photographers make framing mistakes, and the resulting pictures range from the visually confusing to the downright funny.

If you're photographing scenery and want to include a person clearly in the picture, frame the scenery in your viewfinder first, then bring the human subject (your second subject) close enough to the camera to be clearly identified. The exception to this would be if your purpose in including people in a landscape shot is to show the scale of a tree or other object.

Framing 101

Most portraits are shot vertically, but horizontal composition can work as well. Artful framing, using power points, and the rule of thirds further increase visual impact. Positioning the subject's eyes one-third of the way down from the top of the frame produces a pleasing effect.

If you put your subject's eyes at or below the horizontal middle of the frame, your image suggests the person wasn't tall enough to reach camera level. As you frame your subject for a head-and-shoulders portrait, position

her eyes one-third of the way down from the top of the frame. This works for vertical or horizontal framing and for closeups or full-length portraits. For a powerful horizontal closeup, get close enough so that when the eyes are at the one-third line, you crop out the top of the head. Don't let either of the eyes come closer to the top of the frame than that one-third line.

Look at Me!

It almost never works to have your subject looking out of the frame of a picture. Turn the subject's body toward the center of the picture and have him look at the camera, at the scenery, or toward the center of the scene.

Subject in Motion

Mobile subjects in a static scene leave the viewer unsure of what the picture is about. If the picture is about scenery, do not have people walking across it. On the other hand, if your picture is about the people and the scenery is merely a beautiful backdrop, then having them move across the scenery does work. Putting the direction of travel on a diagonal makes a more interesting, dynamic shot.

Horizontal Versus Vertical Pictures

Compare pictures you've taken that are oriented horizontally with those you've composed vertically to see which tells the story better. Does the composition you've chosen enhance the picture? Did you use the rule of thirds and power points? Use your cropping Ls to see if a vertical composition could have improved a horizontal shot and vice versa.

Another trick to deciding on whether to compose your photo horizontally or vertically is to pretend the "lines" of your photo are moving. Is the motion up and down or sideways? People and trees go up and down, so most often a vertical composition will work best. Landscapes go sideways, so a horizontal format is appropriate.

Leaning Photos

Tilted images that cut diagonally across the frame or horizon lines are the result of tilting the camera while framing the image. It can easily happen if you're distracted when shooting, even to professional photographers. It can also happen if you're tripod isn't sitting exactly level.

If you're not deliberately after a tilted effect, always check to make sure the center of your image is square and level. Tilted images can be easily fixed in digital photography with the rotate image and cropping tools.

Tree Growing Out of Head Syndrome

Framing errors that result in this illusion are a common mistake. Normal and wide-angle lenses used for shots more than six feet from the subject are very likely to have sharp enough focus behind the subject that images in the background, such as telephone poles, look like they're sprouting out of the subject's head. Another unfortunate illusion can occur when you accidentally frame a subject with the horizon line poking into one ear and coming out the other.

Becoming a good photographer takes practice. While it's comfortable to take pictures that you know how to do well, work on your technique by seeking out situations that challenge your abilities. No one but you has to see the results of your practice sessions.

The easiest way to avoid this error is to make sure the area around the subject's head has minimal details. Put the person against the simplest part of the scene, and make sure the horizon is well above or below ear level. Watch your leading lines, too; they shouldn't poke into the subject's face unless they're so out of focus they're obviously not part of the person. Another way to avoid these distractions is to move the camera up, down, or sideways to remove objects that seem to be growing out of the subject. Shooting with a wide aperture can also work, but only if it's wide enough that the background is completely blurred.

Sharpening Your Images and Balancing Contrast

Pictures that look all right when they're printed at snapshot size can sometimes look blurry when they're enlarged. If your images look out of focus or flat and uninteresting, here are some tips for making them sharper and snappier.

Technical Issues and Blur

Shooting with a too-slow shutter speed is a common cause of camera movement. For pictures of still subjects, use a shutter speed no slower than 1/30th of a second for handheld shooting. For fast-moving subjects, use the fastest shutter speed possible, usually no slower than 1/250th of a second.

Don't Depend on Autofocus

Autofocus is a great tool, but it's not foolproof. If you're shooting with auto-focus, check your viewfinder to make sure the lens has focused exactly where you want the focus of your photograph to be. When shooting with a zoom lens, you might find it easier to adjust the zoom (telephoto, normal, or wide-angle) first, then focus the lens. If your lens does not change focus as it zooms, you can focus first at telephoto, then zoom to the composition you want.

Don't take pictures from a moving car, especially if you're driving! Using both knees to steer while shooting is a sure road to an accident, not to mention a great way to create blurry photos due to camera motion and vehicle vibration. If you're the passenger, you can get blurry motion shots this way.

Get Rid of the Shakes

On cloudy days or when you're using slower (ISO 200 or less) film in your camera, it's especially important to keep the camera still when you squeeze the shutter because low light and movement can produce blurry images. Brace your hands or your head against a solid object and breathe slowly as you squeeze (rather than push) the shutter.

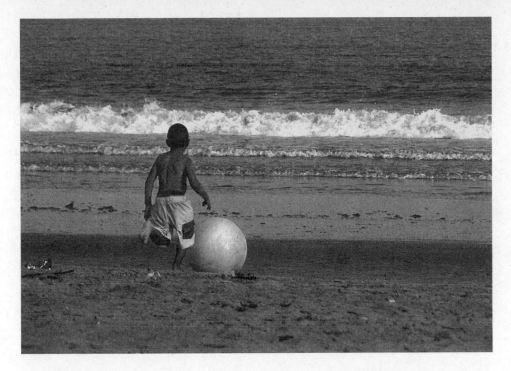

▲ **FIGURE 13-2** It isn't always possible to get good contrast, especially in shots taken on the run, but as this photo of a child playing at the beach shows, having good lighting conditions makes your job much easier.

If you're using a telephoto lens, remember that the magnification of these lenses will amplify the effects of camera movement.

Unless you're shooting with fast film and fast shutter speeds, count on having to work with some sort of a camera support if you're using especially long telephotos.

Balancing Contrast

Sunny weather or working indoors with exterior scenery visible through a door or window can produce photographs in which the brightness levels of your subject and background vary greatly. Pictures like these are about the contrast in the two areas, not about the subject. If the subject is bright and the background dark, this may not be objectionable unless you've lost too much of the detail in the background. To improve these images, try

lessening the contrast by moving the subject into the shade. Or try changing camera position until you find a brighter background that you can place behind the subject. Digital photographers can compensate for over- and underexposure by isolating areas of the image and using the dodging and burning tools available in such programs as PhotoShop and PhotoShop Elements.

Many photographs don't work because the subject doesn't stand out from the background and foreground. Here are some remedies to this problem:

- Move the subject into light that is closer in brightness level to the scenery.
- Use flash to bring a dark subject (within flash range) toward the brightness level of the scenery.
- Change your camera position until you've lined up the subject with a background that better matches it.
- Use a longer lens and larger aperture to pop the subject out of the picture.

You must achieve a difference in tone between your subject and the background. If you're shooting black-and-white film, you're limited to making sure there's enough difference in tones so the subject doesn't blend into the background. Color film allows differences in color to separate subject, background, and foreground. Digital photography allows a great deal of control over tonal values and contrast, but it cannot give back highlight detail obliterated by overexposure.

Bringing Drama into a Cloudy Day

The soft and flattering light on cloudy days can be some of the best for photographing people, as the light doesn't throw harsh shadows. On the other hand, overcast conditions often produce dull, low-contrast pictures because there isn't enough difference between the shadows and highlights.

Warming Dull Photos

Film photographers switching to a warm and saturated slide film can help cheer things up, as this adds contrast and color. Digital photographers can easily do this process in the virtual darkroom. Alternatively, you can put your subjects under a tree or some overhang that will force the light to become more directional. You'll need a fast film for this, and there still might not be enough contrast to make the picture interesting. When shooting with a digital camera, image processing software comes to the rescue with its ability to increase contrast and color saturation.

Capturing Interest

If you have to take pictures on a dull day, you'll generate more interest by capturing strong lines and diagonals to keep the viewer's interest. You can also take pictures that project a mood or a feeling that matches the directionless light. Large scenes can be made incredibly boring by dull lighting. Try moving closer and capturing the details instead.

Masking Cluttered Backgrounds

Good images are often weakened by busy or distracting backgrounds. You can eliminate them by switching to a long lens (85mm or longer) and shooting with a large aperture (f/1.4 to f/4). The closer you get to your subject, the more out of focus your background will be.

Techniques That Work

Many familiar objects are still discernible when out of focus. A distracting cityscape in the background of a picture will usually remain a cityscape in the viewer's perception unless you use a very long lens (150mm or more), use a very wide aperture (f/1.4 or f/2), or get very close to the subject so you can take a tight head-and-shoulders shot. Switching to black-and-white will help disguise possible distractions, such as the obvious colors of taillights.

Digital photographers can employ the same approach and also have many helpful software tools such as blur and cloning tools that can help them mask out distracting background detail.

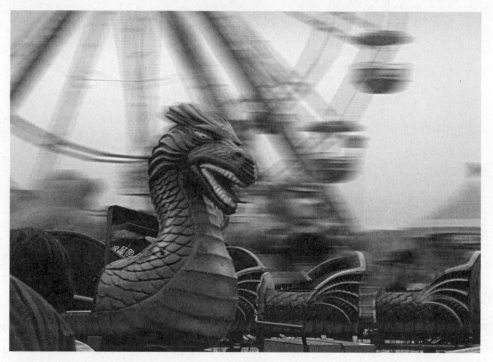

▲ **FIGURE 13-3** The main object in this image is the dramatic figure of the dragon whirling in circles on the midway, not the background clutter that would have distracted from it.

Texture to the Rescue

Look through your photographs to see if you have captured repetition and texture. Have you (on purpose or accidentally) used them as compositional elements? Do they strengthen the photo or distract? Are they the theme of the photo or the background? Texture and repetition can enliven dull photos and hold the viewer's interest if shot correctly.

Gaining Perspective in Scenic Shots

The gorgeous scenery that astounds you when you see it in person may not look as beautiful when you get your prints back.

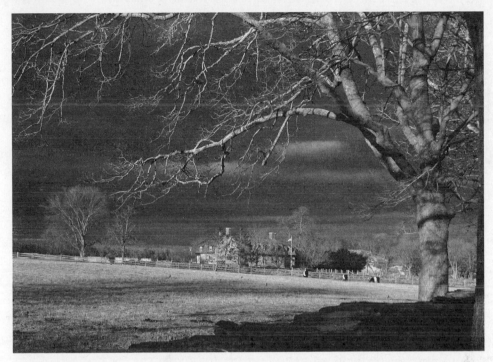

▲ FIGURE 13-4 The bare, outstretched tree limbs frame the scene and give a sense of perspective and depth in this shot of fields adjacent to Hammersmith Farm in Newport, Rhode Island. This image was shot with a telephoto lens without a tripod, but a stone wall was used to steady the camera.

Compare the black-and-white photo with the color version of this shot of Hammersmith in the color insert, where the rich color contrasts can be more fully appreciated.

Helpful Hints

Unfortunately, vistas that unfold in many layers in real life can end up looking quite flat and two-dimensional unless you take certain precautions:

- Include objects in the foreground to add a sense of distance, depth, and dimension.
- Include a person or something that will give a sense of scale.
- Find a frame such as a door to shoot through. This gives the picture depth and keeps the viewer's eyes on the main subject.

When you switch to a long lens, keep in mind that changing your position up, down, or sideways even a few inches will make dramatic differences in the background. Move the camera before you take the picture, not while the shutter is open.

Specific Techniques

Being able to distinguish foreground from background orients and reassures the viewer that all is right with the world. You can differentiate the foreground frame from a distant subject with the following techniques:

- **Selective focus:** foreground frame out of focus, subject sharp
- **Contrast:** foreground lighter, darker or low contrast, subject correctly lit with good contrast
- **Scale:** nearby frame is clearly closer because leaves and branches are discernible, but distant subject has different texture because it's farther away

Shooting with a long lens can make a busy background more visually appealing. The narrow view allows objects in the foreground to stand out more clearly.

Getting the Correct Contrast

Prints that come back from the photo lab too dark or too light are often the result of images that are incorrectly exposed. These are common prob-

lems, especially for inexperienced photographers, and especially for anyone learning how to use new equipment.

Learning about Exposure

One of the best remedies for poor exposures is to read and reread your camera's instruction manual. Learn how to use your camera's metering system and its various modes—center-weighted, spot, or zone—if it has them. Find challenging lighting situations—backlit shots, shots with extreme ranges in contrast—and shoot a number of images using various metering modes. Digital photographers have the advantage of immediate feedback for the shot they have just taken and can immediately remedy exposure and focus problems.

Understanding Exposure Modes

Shooting in auto or program mode works well for quick snapshots, but doesn't always deliver the best exposures. Learning how to adjust exposure by using your camera's shutter, priority, and manual modes will be invaluable in difficult lighting conditions. By learning how to adjust apertures and shutter speeds yourself, you'll have more control over exposure. Bracketing your exposures—that is, taking shots with settings that are over and under the correct exposure—is one of the best ways to ensure a correctly exposed image, especially in difficult lighting situations.

If you're confident that you're exposing your images properly and they're still not turning out correctly, there may be a problem with your camera's metering system. Take your camera into a good shop and have it checked out.

Fixing Bad Group Photos

Do your friends and family members wince or complain when they see the pictures you've taken of them? During fun times with friends and family, it's easy to forget that both camera angle and subject placement greatly affect how people will look in photos.

Shooting Techniques

If you're after better-than-snapshot quality photos of the people in your life, try these techniques:

- Seat subjects only when needed to keep a group from being too wide. Seated bodies are apt to look heavy.
- Avoid shooting from a low camera angle if they're sitting. This emphasizes the size of their thighs and shortens their torsos and upper bodies.
- Use a normal or telephoto lens instead of a wide-angle lens.
- Put larger people in back to both hide and minimize their size.

Even Lighting

Pictures of groups illuminated with flash often result in the people closest to the flash looking too bright and others appearing too dark. To avoid this, position your camera so that every member of the group is about the same distance from it. If necessary, stack some of the group between and above the others; you may have to ask the front row to sit or squat to do this. Have the back row lean forward toward the camera. This will bring them almost as close to the flash as those in the front row. It will also do a good job of getting everyone in focus and eliminate the boring composition caused when people pose in straight rows.

Know Your Equipment

Sometimes images fail through no fault of yours; instead, your equipment fails you. New cameras and lenses can arrive with defects or quirks. Old cameras that have been put away for a while might have shutter speeds that are way off. Each camera is different and requires attention to the details that may affect image quality.

Testing New Equipment

You can prevent equipment failures and nasty surprises by testing all new equipment when you buy it. If it's a new film camera body, load the film

you know the best and feel most comfortable shooting. If it is a digital camera, read the support material and be sure you know where all the important controls are. Test out elements such as the built-in exposure system and various shutter speeds and settings.

Talk to other owners of the same model of camera and lenses. They may have discovered bugs or tricks that will be useful. Check out the technical forums online for tips from other users who have been shooting for awhile with the same model.

As your photography skills evolve, you'll probably find that your tastes will change, and the composition, contrast, focus, lighting, and cropping choices you make today may seem a bit stale or downright boring at a later time.

Some lenses are more prone to flare from bright light hitting the front glass of the lens, causing streaks or blobs of light on the film. Test the limits of your lenses by shooting in the direction of bright light to find out which lenses are more forgiving. Wide-angle lenses will often let you put a bright object directly in the image with no problem. Some telephotos go nuts if you even think about doing a strongly backlit picture. The solution is to only use backlight-friendly lenses when the backlight is intense or to position the camera so the front of the lens is in the shade.

Testing Existing Equipment

Before any important shoot, visually inspect the inside of your film camera body for chips or other foreign objects that may have fallen into it. Check both body and lenses for lint and other matter that might obscure the picture or scratch the film.

Run a roll or two of film through your camera. Test the lenses you plan to use. Also check flash sync. In the case of digital cameras, be sure to clear all old images off your memory card, put in new batteries, and charge your rechargeable battery. Check that your lenses are clean and flash(es) are working properly.

Testing New Film and New Digital Labs

If you're planning to shoot with film that you haven't used before or that you aren't familiar with, shoot a couple of test rolls to get a feeling for it. If you have your film processed at a new lab, find out which films they prefer to work with. Then take an entire roll with a mix of correct exposures plus over and underexposures to find out which turns out best. If you know what your negatives are supposed to look like and your finished prints do not look right, the lab might need to adjust its developing time to give you the results you're after.

QUESTION?

What's the best way to test a new camera?
Take it for a spin. For film cameras, test your equipment with color slide film. You'll be able to see problems more clearly by examining slides than by viewing prints. Both cameras and handheld light meters may produce exposure errors in very bright or very dim light. Test your equipment at both extremes.

While color processing should be uniform at a good lab, black-and-white processing is another story. Many labs are not black-and-white specialists and will overdevelop this film. The film processor's choice of black-and-white chemistry—and there are many—and processing techniques determine the quality of the negative and the final print image.

If you plan to shoot digitally, many processing issues are easier for you to control before you give the files to a processor to have prints made. Dependable digital labs use archival-quality materials to make prints, and files can be uploaded and printed in just days. Some have local outlets where you can pick up your prints within forty-eight hours or less of submitting the files. Comparing prints from three labs of the same sample digital images will quickly tell you which one is right for you. More and more places are offering digital prints at local levels for quick processing and pickup. Quality is generally good, but you will usually pay slightly more for these prints than for the online ones, even with shipping taken into account.

CHAPTER 14

Travel and Nature Photography

Capturing the world around you on film offers limit-less opportunities to get outdoors and enjoy gorgeous scenery. Some vistas are so breathtaking that they'll look great no matter when or how you photograph them; you'll have to work to unlock the full beauty of others.

Getting the Big Picture

Outdoor photography and nature photography are subjects that are as big as the outdoors itself! It includes landscape photography in its purest form—scenic shots in which people, animals, and manmade structures don't appear—as well as pictures featuring a combination of landscape and other elements. It also includes other types of photography where the outdoors plays a role—such as seascape photography.

Practice Makes Perfect

Anyone can take pictures of scenery, but it takes some practice and artistry to turn three-dimensional images into two-dimensional ones and do it well. It also takes some skill to render the sweep and scale of these often bigger-than-life subjects on tiny frames of film or memory cards.

FACT

Eliot Porter was a master at capturing the splendor of nature on film. If you're in search of inspiration for your own work, or just want to see how a master worked with his surroundings, study any of the books that feature his work. A classic is *In Wilderness Is the Preservation of the World*, published by the Sierra Club.

Get Inspired

If you love nature and are a beginner at shooting landscapes, nature, and wildlife, a trip to your public library or local bookstore will help provide inspiration and will eventually yield results in your own shooting style. Look at photo publications and books to trigger ideas you can use in your own shoots.

Choosing Outdoor Subjects

There is no lack of interesting outdoor subjects with which to fill your viewfinder, and there really aren't any hard and fast guidelines for choosing what to shoot. A vista that makes you sit up and take notice may not excite the

next person, but if you follow your heart and find the images that speak to you, you'll never go wrong.

Although it's possible to stumble on a perfect setting that's just begging to be shot, most outdoor photographers spend a great deal of time seeking out their subjects. In the color insert, the two butterflies on one goldenrod plant are a perfect example of this. Patience is definitely a hallmark of this type of photography. Not only can it take some time to find a subject you want to shoot, it also takes time to figure out how you're going to shoot it. Getting the perfect shot often means returning to your subject more than once if you're trying to capture it in specific light or atmospheric conditions.

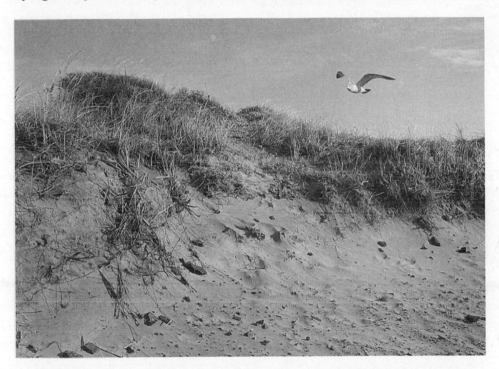

▲ **FIGURE 14-1** Sometimes you happen to be in the right place at the right time to capture a good shot, such as this one of a seagull cruising above the dunes.

How to Evaluate Subjects

When seeking out potential subjects, think about the different ways in which you could shoot them. Consider what the scenery will look like at various times of day and from different perspectives. If you have your camera

with you, look at subjects through the viewfinder to get an idea of how you want to frame and compose your shots. Also keep a notebook with you so you can take notes on the location, the things about it that interested you, potential shooting angles, and the quality of light.

If you go location scouting without your camera, use your fingers to get a rough idea of how to frame subjects. Make Ls of your thumb and forefinger on both hands and put them together to make a rectangle—thumbs and forefingers opposite each other.

If you have a digital camera, you might want to use it to capture a visual record of the setting for future reference.

Color Considerations

Also think about how the scenery will look at different times of year. A forest scene awash with the lush colors and deep hues of thick summer foliage might also make a great shot in the winter with slanting, low afternoon light casting deep shadows on tree limbs, bark, and snow.

Following the Light

How a scenic shot is lit can make the difference between a good picture and a great one. The sun's placement in the sky will light scenes in various ways and cast different shadows, depending on the angle of the light. One day, bright light might bathe your intended subject; the next an overcast sky might act as a giant diffuser, casting a softer light. It may be necessary to visit subjects more than once to get a feel for how they look at various times of the day and under different lighting conditions.

In general, outdoor photography depends a great deal on being in the right place at the right time. While composing your images well is always key to taking good pictures, getting good outdoor pictures is also heavily dependent on knowing how to work with the light and weather. The times of day most convenient for shooting are often not the best times for getting

great pictures. You may not like being outdoors when it's cold and foggy, but you'll miss some great shots if you stay indoors in inclement weather. Just remember to protect your camera under adverse weather conditions, even if it is only with a plastic bag.

FACT

In most daytime scenes, the light source (the sun) is not part of the picture. The exact opposite is true in nighttime scenes, in which the light sources are often part of the story. This makes for a very large dynamic range, from the absolute black of the shadows to the brightness of streetlights and headlights.

At night, with no ambient light to fill in the background or shadows, artificial lighting outdoors will look fake. You can avoid using it by shooting with high-speed film, a wide-open lens, and a long shutter speed (1/30th, 1/15th, or 1/8th of a second), which will capture background lights if you're shooting a cityscape.

Considering Points of View

Outdoor shots can be taken from a variety of points of view—closeup, from a distance, through a frame of trees, shooting upwards, shooting downwards. All are possible, and none is necessarily better than any other.

Choosing a shooting position that shows scale and perspective can help classic landscape pictures seem less flat. Including a focal point, such as a rock, will give the viewer a sense of the landscape's scale.

Scouting Wildlife Subjects

Although you can't ask wildlife subjects to perform on cue, you can plan for action by knowing where to find them. Parks services, local nature clubs, and nature guides are just some of the sources for learning what kind of wildlife is in the area and where the animals tend to hang out. They also might be able to tell you when you can find your potential subjects. Animals follow fairly regular routines, especially when it comes to seasonal

activities like mating, migration, and hibernation. They also eat at certain times of day, and they often come to the same place to do it unless they deplete the food supply there.

Patience pays off when shooting all types of wildlife, and this is especially true of the more elusive mammals, like otters and mice. When they do pop their little heads up from wherever they are, be ready to photograph them by having your camera in position and focused on the spot where you think they'll appear.

Always consider your safety as well as the safety of the animals you're shooting. It's never a good idea to get too close to animals in their habitat—especially during mating season—which is why you need long lenses to shoot them closeup. If you don't have a telephoto lens with you, shooting with a shorter or wide-angle lens will also let you include some of their natural surroundings.

It pays not to be too picky when photographing wildlife. If you're after a shot of a moose and all you're seeing are deer, don't ignore nature's message. It may not be a good moose day; settle for the deer and try for the moose another time.

Working with the Seasons

Avid outdoor photographers will tell you that there's no best season for taking outdoor pictures. Each offers its own take on Mother Nature's glory and provides unlimited opportunities for you to capture its beauty on film.

Spring

Wildflowers poking their heads through carpets of leaves, baby birds begging their mothers for food—this is the stuff of spring photography.

◀ **FIGURE 14-2**
These lovely striped cro-
cuses appear in early
spring and provide nature-
loving photographers an
opportunity to photograph
flowers after months of cold
weather.

The scenery in spring often contains glimpses of seasons past—snow hiding in the shadow of a ridge, brown leaves drifting down mountain creeks. Because the land is still in its winter coat, your surroundings may look somewhat drab and uninteresting at first glance, but look closer and you'll find plenty to shoot, like the patterns made by groves of fir trees among aspen and oaks just beginning to leaf out.

Rainy days are a given during spring. They might result in delicate low-lying clouds that obscure the tops of mountains or merely in wet conditions where the moisture deepens the intensity and hue of the colors around you.

Summer

Trees are lush and green; flowers are in full bloom. Forests are full of animal activity. Lakes shimmer with light.

The sun is high and direct during the summer, and it's best to avoid it at its highest—between 11 a.m. and 3 p.m.—when shooting outdoors. Pictures taken before 11 a.m. and after 3 p.m. will feature more pleasing shadows. Get up early—your shots will benefit from the rich, warm hues of the early morning sun. Late afternoon to dusk is also a great time for capturing scenes bathed in the reds and golds of the setting sun.

FACT

When shooting sunrises and sunsets, set your exposure level to under-expose the scene by one f-stop, which will produce strong, well-saturated color. Underexposing rainbows will produce saturated hues as well.

Fall

Capturing trees and bushes as they change color is irresistible to almost every photographer. It's hard not to get great scenic shots in the fall, but they'll look even better if you deepen their color with polarizing and warming filters, or increase their saturation in the digital darkroom.

It's easy to get swept away by the majesty of the season's brilliant colors and miss the finer details of your surroundings, but there are a lot of great detail shots than can be taken during this season, like the patterns made by field grass heads dancing in the breeze.

Winter

Cold weather often acts as a deterrent to taking pictures outdoors, especially if you aren't cold-tolerant, but if you stay inside you'll miss some really great shots. This is a fantastic time of year for taking dramatic landscape pictures like frost patterns on windows.

It's important for both you and your camera equipment to stay warm when the thermometer drops. Carry your camera underneath your coat or jacket between shots to keep it warm. Cold temperatures also sap battery strength, so be sure to carry a spare battery with you, and be prepared for some of your camera's automatic functions to work more slowly.

◀ **FIGURE 14-3**
Inspiration can be found in the garden even in mid-winter. Snow and ice can provide interesting textures and shapes to photograph.

ALERT!

If it's extremely cold and dry out, wait until you can get to a warmer place to auto rewind your film. Cold and dry conditions can cause static electricity to build up on the film as the camera rewinds, and this can deposit lightning-bolt streaks on your negatives. If your camera has manual rewind, crank the film back slowly.

Light in the early morning and late day is best for capturing winter shots. Bright sun on snow can cause underexposures if you're shooting in automatic mode, which will make the snow look dingy gray instead of bright white. To bring out the snow's detail when taking these pictures, meter the scene, then adjust your exposure one or two f-stops higher than the meter indicates.

Winter skies are often cloudy and somewhat lackluster. If the conditions are too gloomy for your shot, try brightening the sky with a graduated color filter. You can also work around cloudy skies that lack interest by shooting from angles that reduce their prominence in your composition.

When exposed properly, moonlight shots can look just like daylight images, unless lights are in the frame. The longer shutter speeds necessary for moonlight pictures will allow the movement of the water, trees, and moon to blur. The warm color of the artificial lighting of cars, cities, or lit-up windows will make a beautiful contrast to the natural "daylight" balance of the

moonlight. To photograph just the moon requires a much faster shutter speed for correct exposure and to freeze the moon's (actually the earth's) motion.

Another way to get accurate exposures when shooting in the snow is to use a gray card—a piece of gray-colored cardboard that reflects the same amount of light meters are calibrated to read. Focus on the gray card when setting your exposure, and your camera won't be tricked into underexposures or overexposure caused by subjects that reflect more or less light.

Lenses for Outdoor Photography

Many outdoor scenes are taken at a distance, as it's often difficult to get close to outdoor subjects. Zoom lenses are ideal for changing composition and perspective and still keeping your feet in one place. If you have two zoom lenses—a short one and a longer one—you'll be covered for most outdoor shooting situations. If you're planning to take closeups of such things as flowers and other things of nature, lenses with macro capabilities are good all-around choices.

The subtle hues of rainbows are often difficult to capture on film. Try using a polarizing filter to bring out their colors. Adjust the filter and take multiple shots. If you have a digital camera, you will receive instant feedback—you'll be able to look through your viewfinder and see how each adjustment to the filter changes the shot.

Polarizing and color-enhancing filters can be an outdoor photographer's best friend. Warming filters are great for removing blue casts on snow when shooting color film. If you're shooting black-and-white film, you may want to consider using filters to add contrast to sunlit scenes and improve the details in clouds. A red or yellow filter will darken the sky.

Other Equipment for Outdoor Photography

A tripod is essential for capturing many good outdoor shots. Yes, they can be bulky and cumbersome to carry, but you'll miss some great pictures if you don't have one. You'll also lessen the quality of many of the pictures you do take. Carry your tripod on your shoulder with your camera body and lens mounted so you don't have to spend precious moments putting everything together each time you want to stop and take a picture.

Handy Items for Outdoor Photography

- Food and water are essential for all-day hikes and field trips.
- Insect repellent. Choose one that also repels biting flies.
- First-aid kit.
- Good hiking boots. Waterproof boots are preferable.
- Sunblock.
- Field guides help you identify local flora and fauna.
- Extra socks. You can change into them if your other socks get wet. They also make decent hand warmers in a pinch.
- A lightweight rain jacket or poncho comes in handy in an unexpected shower or snowstorm. A poncho will also help protect your camera gear from the elements.
- Cell phone. You'll be glad to have one with you in case of an emergency. Keep it turned off unless you need it.
- Tripod quick release. This allows you to carry your tripod and camera separately and work quickly when you stop to shoot.

Most outdoor photographers find camera bags and backpacks cumbersome and prefer to wear photo vests that keep their lenses and other equipment close at hand. A waist or hip pack is another option for carrying your gear.

Realistic Versus Interpretive Photos

Most outdoor photos, especially landscape shots, are pretty straightforward. They portray their subjects realistically and from perspectives that are familiar to the viewer.

Artistic License

Other pictures take a more interpretive or impressionistic approach through exaggerated perspective, depth of field, and other techniques. These pictures are less about documenting specific information about a subject and more about conveying a mood or feeling about it. Objects may be recognizable, or they may be taken in ways that isolate specific facets or details that tell you more about the subject than about its surroundings.

Sunlit buildings against a blue sky make beautiful pictures. To get deep blue skies and bright white buildings with no loss of highlight detail, expose using the sunny sixteen rule. Set the shutter speed to your film's ISO and the f-stop to f/16. If the sun is particularly bright, stop down to f/22. Deep shadows will go black under these circumstances, but that's in keeping with the contrasting mood of the subjects.

Both approaches have a place in outdoor photography. Most photographers find that shooting a mixture of realistic and interpretive pictures is a great deal more enjoyable than sticking to one style or approach exclusively. The great thing about outdoor photography is that nearly every subject you shoot will lend itself to both approaches in some way.

Digital Expressions

Digital photographers and film photographers who scan their images into digital programs can take even more license with the artistic and impressionistic approach. They can take advantage of the digital darkroom's ability to apply filters that give the appearance of fine art images. These filters can mimic watercolors, oil paintings, and pastel effects. Applied with a deft touch they can be really stunning. Get accustomed to seeing the big picture as well as nature's more finite brushstrokes, and you'll never run out of great subjects to shoot.

▲ **FIGURE 14-4** At first glance, this interpretive photo may seem to be about the window, but in actuality it is about the trees reflected in the window glass that create interesting patterns and shapes.

Travel Photography

Most people think of using a camera when traveling, and many photographers trace their obsession with photography to the moment they became intrigued by shots they had taken when traveling or on vacation.

Unique Challenges

Although it can be similar to nature photography, there are some unique challenges associated with travel photography. What equipment should you bring? Should you bring an SLR or a point-and-shoot? Digital or film? Only you can figure out the answers to those questions, but with a little thought, your decision-making can be simplified.

Take Only the Essentials

If the purpose of your travel isn't exclusively to do photography, you may want to think twice about bringing along an SLR with many lenses and accessories. These items are heavy and expensive, and going through customs and long airline check-in lines with them may be an extra aggravation you don't need or want.

Many good photographers will bring along a good point-and-shoot with a long telephoto lens in these situations. Digital cameras lend themselves to travel, as images from memory cards can be uploaded to online albums and the card's memory cleared for the next day's shooting. Film photographers must be careful that their exposed rolls are not handled poorly or exposed to X-rays during their travels.

Serious Photographers

If the purpose of the trip is primarily to do photography, of course you will bring along your best camera equipment and be prepared to deal with any inconveniences that may arise. Your reward will be fabulous pictures that will undoubtedly be worth the trouble. You will still have to decide whether to bring film or digital, point-and-shoot or SLR, but after reading the previous chapters your decision should be a great deal easier to make. No matter what sort of camera you decide on, one piece of equipment that is absolutely essential is a backup camera. The further you are from home, the more important spares become. Telephotos are essential, too, because if you drop or break one, you lose a lot of shooting capacity. If you bring a lighter, slower, and cheaper zoom, like one of the compact 28–200mm zooms as your one-lens backup system, you are well covered.

Travel Accessories

If you decide to take your camera equipment on the road for some serious shooting, the following list is a good starting place for planning what you'll need to bring:

For All Photographers

- A sturdy camera case
- A shoulder bag, preferably weatherproof
- A sturdy tripod light enough to be easily portable
- Extra batteries and film
- Flash unit

For Digital Shooters

- Extra batteries and memory cards
- Power converter for rechargeable batteries
- Card reader

If you will be traveling overseas, don't forget to bring a converter for your battery charger.

Do Your Research

Obviously, before you decide to spend the money, time, and energy travel photography requires, you need to do your research. There are many options and resources available to travelers. Whether it's a major travel adventure or a family vacation, the more you know about the location, the better your pictures will be.

A major source of information is the library, where you can look through back issues of *National Geographic* for stories on the area you are visiting. This publication is renowned for the quality of its photography and always seems to have photos that can give you a very realistic idea of what to expect visually. Other travel publications abound, such as *Travel and Leisure* and *Cognoscenti*. While you're at the library, see if there is a section containing brochures and travel guides, which can give you a head's up about where to find the most picturesque and stunning scenery.

In addition to print publications, there are numerous online travel magazines such as *Backpacker* (*www.backpacker.com*), *Brave New Traveler* (*www.bravenewtraveler.com*), and *Destination Elsewhere* (*www.destination elsewhere.com*), which can help fill any gaps in your knowledge and steer you in the right direction to capture the local color. The *National Geographic Traveler* website (*www.nationalgeographic.com/traveler*) has tons of good information and links.

Object and Still-Life Photography

There are lots of reasons to take pictures of the things in your life and just as many different ways to do it, from snapping a quick closeup of the details on a piece of furniture to creating a beautifully composed still-life that exhibits all your artistic talent. The better these photographs end up, the more likely they are to become precious treasures that will be handed down in your family.

Objects of Attention

Object and still-life pictures differ from other photos in several important ways. They're generally taken from a fairly close distance, which separates the objects from their immediate surroundings. In some cases, the distance is so close that an object's patterns or textures become the subject of the shot. Although these pictures might look unstaged, they rarely are.

Staging the Natural

In most cases, the photographer has had at least a slight hand in creating photos by controlling the setting, moving objects around, adding and subtracting them, trying different angles, and using different lighting schemes until the image tells the intended story or evokes the right feeling or mood. Even a seemingly casually composed shot taken in natural surroundings has probably been improved upon by moving a twig just so or brushing aside a distracting leaf or two.

◀ FIGURE 15-1
A studio shot of the detail of a vase in a flower arrangement, with side lighting.

Be Your Own Stylist

In commercial photography, a location is scouted out for the shoot, all the props to be used are put in the appropriate place, and every item or person needed for the shot is put in its proper location. This is usually the job of the photo stylist, who also arranges the shot and makes sure everything in the scene appears as it should. You can be your own stylist and try to make sure each item in your shot is in its proper place. This is a creative challenge and takes patience and great attention to detail.

FACT

Getting good object and still-life shots requires both good technical abilities and an artist's eye for composition. They're like painting a picture using the captured image as your canvas and your camera as your brush.

Where to Shoot

Where not to shoot? Options for photographers are everywhere. If you can think outside the box, almost any location can yield photographs that are both interesting and engaging. Using the techniques you have learned, you'll be able to isolate the subject and eliminate background clutter and get a macro (closeup) shot of an interesting pattern or texture others would have overlooked. The key to getting good shots is observing closely and thinking creatively.

Indoor Shots

Lots of still-life pictures are taken indoors, which allows virtually complete control over arrangement, lighting, backdrops, and props. There definitely are advantages to shooting in controlled conditions: You won't have to worry about things being blown away by a random gust of wind or soaked by a sudden cloudburst when you're shooting inside. You also won't have to deal with variable lighting conditions unless you're relying on window light to illuminate your picture.

Exterior Shots

Taking good still-life pictures by no means limits you to shooting exclusively indoors. You can also create beautiful images outdoors. In fact, many photographers prefer shooting outside so they can take advantage of what the outdoors has to offer, such as warmer, more subject-flattering light and natural settings. With a little advance planning, you can troubleshoot the problems outdoor shooting can present and end up with perfectly composed images that will make you proud.

Essential Equipment

Some of the equipment used to shoot objects and still lifes is pretty standard stuff that you probably already own. However, certain shots will require some specialized equipment. If your dream is to enter the world of product photography, you'll need a highly specialized setup that goes far beyond the basics. This kind of photography is beyond the scope of this book, although you'll find some resources to help you in Appendix B.

Lenses

You can use lenses you already own for most object and still-life shooting. Telephoto lenses will let you shoot from greater distances, which is often desirable when shooting closer up might throw shadows on your subjects or otherwise disturb them. Wide-angle lenses exaggerate perspective but let you work closer.

Many object and still-life pictures are taken with a fairly wide aperture to knock out foreground and background images. You can avoid using an artificial backdrop by using a long lens (135mm and longer) and a large opening (f/1.8, f/2, f/2.8), which will drop the background completely out of focus. Closeup shots are taken with smaller apertures (f/16 to f/32), which provide some depth of field for these highly magnified images.

Shooting objects close up requires lenses with focusing ranges that allow you to fill the frame. Macro lenses are designed to render life-size or nearly life-size images on film by making it possible to get super close to your subjects. They come in focal lengths ranging from 50mm to 200mm,

which means they can also be used for regular photography. Macro lenses with longer focal lengths let you work at a greater distance.

True macro lenses will produce life-size images on film (meaning that a half-inch bug will measure half an inch on the negative). This one-to-one reproduction ratio, however, comes at a price. Lenses that reproduce images at one-half to one-fourth life size are less expensive. You can still get life-size images with them by using the following accessories:

- **An extension tube.** These devices mount between the camera body and lens and let you focus more closely by moving the lens farther away from the film inside your camera.
- **An extension bellows.** Extension bellows use the same principle as extension tubes, but you adjust them by turning small knobs. They're more expensive than extension tubes and can be difficult to use.
- **Closeup lenses.** These accessory lenses screw or snap onto the front of your regular lenses. They are labeled by strength, with the weakest being +1 diopter. Usually a +1 or +2 is all you will need.

If you love photographing flowers as you hike through the countryside, using a true macro lens is far more convenient than using closeup attachments. You might take a picture of a large plant and then quickly come in for a macro closeup to capture just a single flower. Having one lens that easily does both is a big advantage.

If you don't have a macro lens, you can shoot closeups by reversing a normal or wide-angle lens. Simply reverse the direction of the lens and attach it to your camera body with a special lens-reversing ring or macro adapter. You can also try holding it in place in very stable conditions, such as indoor shots with the camera set on a table.

Matching Lens to Subject

If you're not taking a super-close shot, a 100mm lens will allow a working distance that minimizes perspective distortion. If you don't have a lot

of room and you're shooting a large object, a wide-angle lens will work. However, shooting too close to the object (less than twice its depth) with a wide-angle lens will result in forced perspective. This means the parts of the object closest to the lens will loom large while those farther away will seem to recede into the distance. This produces a dramatic image, useful in some cases, but not as factual as an image in which a normal perspective produces more realistic lines.

Your lens choice will also help you avoid distortion in object or still-life shots or add it should you want to. Using a wide-angle lens and backing away from the subject will let you place the camera higher (to show the top surface of the object) and keep the camera closer to level (pointing toward the horizon rather than down). If necessary, you can crop out the top of the picture when you have the image printed. Distortion can also be lessened by moving farther away from the subject and using a longer lens (longer than 100mm) to keep the frame filled. These seem like contradictory solutions to the same problem, but both methods are based on the physics of perspective.

If you're photographing a model car, getting close with a wide-angle lens will mimic the distortion that viewers expect when seeing a photograph of a life-size car. Viewers also expect to see a life-size car sharp from front to back, which means you'll have to stop way down (f/11 or smaller) to increase your depth of field.

Camera Support

A tripod or another sturdy camera support is essential for object and still-life photography. First, it minimizes camera motion and makes your images sharper when you're shooting with narrow apertures and slow shutter speeds. In addition, a nonmoving support allows you to set up your shot, check it through your viewfinder, and adjust the lighting without continually having to reframe and refocus each time you make an adjustment. If you're shooting a series of similar objects, using a tripod will ensure the

same camera angle and relative size, just by placing each successive object on the same spot. If you have a series of objects to photograph, sequence them in order of size.

Illumination Equipment

An accessory flash unit will let you try various lighting schemes when taking object and still-life shots. Flash also freezes the action when you're taking pictures of flowers and other natural objects outdoors, and it pops them out of their surroundings by darkening the background. If your flash has variable power control, you can also use it for closeup work. If it doesn't and you plan on doing a lot of closeup shots, you might want to buy a ring light or macro flash. These special flash units circle the lens and provide uniform, shadow-free illumination.

White cards are useful for reflecting soft light onto the front of objects or for lighting transparent or translucent objects from the rear. When shooting larger items, larger reflective devices will provide more even lighting. Professionals use large softboxes with strobes or hot lights, but you can achieve a similar effect with a less expensive setup. A white shower-curtain liner lit by sunlight, flash, or floodlights can make a very good large, diffuse light source. White foam-core board is another good reflective device.

Backdrops

Many object and still-life pictures are taken with the objects in their natural surroundings or posed in settings that are arranged to look natural. There are times, however, when you don't want the background to distract from your subject.

Poster board is cheap, widely available, and flexible. Choose a piece that's long enough so you can scoot some of it under whatever you're shooting. Then curve the rest of the piece upward so the top of the board is higher than your camera angle. Making the curve tighter and bringing the board closer to vertical will change the gradations in the backdrop. When photographing closeup objects, such as flowers, a small piece of colored poster board can be held by an assistant behind the subject to isolate it from a distracting background.

Countertop material is flexible but far sturdier than poster board, so you can use it over and over. It's also available in some interesting colors and textures. Check with a local fabricator or a large building supply store—remnant pieces are often available for a song.

ALERT!

Be sure to anchor your backdrop securely, especially if you're shooting fragile objects. Clamps, tape, even rocks—if their shadows won't show up in the picture—will all work. Don't use anything that will ripple or cause bumps in the board; you want a smooth, seamless surface.

Fabric backdrops range from manufactured backdrops made of muslin or canvas used by professional photographers for studio work to household linens and shower curtains. If you take the time to get them positioned correctly, there's no need to buy expensive background things. You can even buy canvas or muslin and paint it if you like the look of those expensive backdrops.

Forgoing the Backdrop

You can avoid having to use a backdrop entirely by shooting with a long lens (135mm or longer) and a large opening (f/1.8, f/2, f/2.8), which blurs the background nicely. This is an excellent way to isolate your subject from any distracting surroundings. The effect it creates distinguishes the images of many professionals from the photos taken by amateurs who use the wide-angle or normal lenses that come with their cameras. You can use a piece of white material or shower curtain liner over a window to diffuse too-direct light coming in. Poster board also makes for a cheap reflector in a pinch.

Other Accessory Items

It often takes some creative sleight of hand to get good pictures of objects both in the wild and in controlled settings. Photographers who specialize in object shots rely on items like the following:

- **Tweezers.** For rearranging or removing things like leaves, twigs, and pieces of hair. Long tweezers are often easier to work with than short ones. You can find them at hobby stores and some hardware stores.
- **Soft paintbrushes, makeup brushes, cotton swabs.** For removing such things as dust, dirt, and crumbs.
- **Double-sided tape.** For sticking things together and stabilizing small objects. Fine-art clay is also a good thing to have on hand for keeping objects in place.
- **Duct tape.** Where would you be without the stuff? Not only will it adhere to almost everything and stick almost anything together, you can use the roll to elevate objects in a still life.
- **Water bottle.** For spraying flowers or adding condensation to other objects like glasses and bottles.
- **Paper towels.** For drying objects off or mopping up spills. You can also use paper towels for handling shiny objects without leaving fingerprints.
- **Small butterfly clips or straight pins.** For holding fabric folds in place.

The tonal range (from white to black) of light-colored flowers is a fabulous palate for creating black-and-white images. Start with a flower that's not fully open. Keep it alive in a vase, and photograph it over the time it takes to open, capturing it in a variety of lighting and phases.

Choices for Object and Still-Life Pictures

Whether you decide to shoot your still lifes using film or digital technology is really a personal choice. Each option produces a slightly different end product, so you must understand the advantages and limitations of each method.

Slide Film

As finicky as color slide film can be to work with, it's ideal for taking object and still-life shots where color is a critical element in the composition. Slide film is great for rendering crisp, sharp images, especially when shooting outdoors with wide apertures and slow shutter speeds (with a tripod-mounted camera, of course).

Color Print Film

If you're going for a grainy, more painterly effect, switch to fast color print film, which is also a good choice for shooting indoors in artificial light. You can use color slide film indoors as well, as long as you remember to select the right film for your lighting conditions.

Color Digital

Shooting still lifes with digital cameras is great; the flexibility of being able to tell immediately whether or not you got the shot, plus the option of adjusting color and contrast in the digital darkroom, are big advantages.

Black-and-White

Black-and-white photography can yield some fantastic images when photographing things like flowers. Because color balance doesn't matter, you can bring flowers inside and use photofloods or window light to create wonderful shadows and highlights.

Putting Together Your Shot

One of the really fun things about object and still-life photography is being able to create a variety of images simply by moving your camera around. This kind of photography will let you experiment to your heart's delight with camera angles, lighting, distance, framing, and composition.

Angles of Approach

Shooting straight on when taking object and still-life shots is seldom the best approach. Try shooting from a variety of angles—as you change the camera's position, the relative sizes of your objects will change, and the distances between them will appear differently. Shooting from different heights will do the same. You can even place objects on a piece of glass or a glass tabletop and shoot them from below.

Always keep your eyes peeled for found objects to use in still-life shots. Old pieces of wood, rocks, tin cans, shells, and other such objects can all be used to add character, texture, and color to these pictures.

Focusing

Shooting closeups requires some special attention to how images are focused. When you're shooting at normal focusing distances, your depth of field (the zone in which images are their sharpest) extends one-third in front and two-thirds behind your point of focus. With closeup shots, however, it only extends one-half in front and one-half behind your focus point. In addition, since you're working at such high magnification, depth of field is extremely shallow. The difference between being in focus and being out of focus can come down to millimeters, even if you're using a small lens opening. This narrow depth of field can work well to isolate the subject.

You can't rely on autofocus lenses to create well-focused closeup shots. Set your camera for manual focus and then choose your point of focus carefully.

◀ **FIGURE 15-2**
An available light closeup shot of a carefully arranged display in a retail shop. The textures of the olives and snail played off well against the botanical background.

Composition

If you're staging a still-life shot, keep in mind that the best ones usually take some maneuvering to come out right. Choose a dominant object and arrange the other objects you want to use around it. Pay attention to how the objects relate to each other, how their colors and shapes either enhance or detract from the picture you're trying to create. There's really no right or wrong way to arrange these shots, although it's always helpful to follow basic compositional techniques such as power points and the rule of thirds. You may have to elevate some of the objects to create the most pleasing arrangement.

Photographing flowers, mushrooms, leaves, and such brings you close to nature. Shooting these pictures requires a good eye for finding objects that are already arranged fairly well since creating these compositions usually looks artificial. If you get used to looking through your viewfinder when you're hiking through woods and fields, good nature shots will jump out at you. The best subjects are in settings with strong compositional elements, such as pools of water.

When shooting flowers in the wild, keep in mind that they will sway with the slightest breeze, which will cause problems when taking closeup shots. If the flower or flowers move out of your depth of field, you'll get both motion blur and out-of-focus images. Shooting with a small f-stop will increase your

depth of field, but it will also bring distracting scenery into focus. However, if the subject is brightly lit and the rest of the scene is in shadow, your subject will stand out from the background.

When shooting digital, using a small f-stop will still produce an image that may have distracting background scenery in it, but the subject can be isolated in the digital darkroom and the background rendered into a pleasing mass of indistinct shapes through the use of the blur filter.

CHAPTER 16

Getting into Action Shooting

Taking pictures of moving objects frustrates many amateur photographers. Subjects can be blurry beyond recognition, and peak moments may have happened before the shutter actually opened. Whether your goal is to capture that game-winning play at your daughter's soccer game or the excitement on your family's faces as they watch it happen, learning the techniques behind action photography will greatly enhance your chances of getting great action shots.

The Art of Shooting Moving Objects

Taking good action pictures basically requires three things: having the right equipment, being in the right place at the right time, and knowing the photographic techniques that will allow you to capture the moment.

The equipment part is relatively easy. The other factors can be a little more difficult to master, but the challenge is not insurmountable. Like all types of photography, taking good action pictures requires some practice. And, as is the case with most types of photography, the best shots are often the result of careful planning ahead of time.

Getting Equipped for Action

One of the most difficult aspects of action photography is the distance at which many of these shots have to be taken. It can be extremely tough to get close enough to the action to fill your frame with it, which makes shooting with a long lens essential. Low light situations will also call for a telephoto with a wider maximum aperture unless you decide to use slower shutter speeds to blur the action.

Lenses with long focal lengths not only increase image size, they also increase the effect of the subject's movement. If a shutter speed of 1/250th of a second freezes the action when you're using a 50mm lens, you'll need to double the shutter speed to 1/500th of a second to achieve the same results with a 100mm lens.

If the telephoto or zoom lens you already own isn't long enough, consider punching up its focal length by using a teleconverter. If you're serious about action photography, a fast, medium-range telephoto lens with a maximum aperture of at least f/2.8 or an 80mm–200mm zoom lens with as large a maximum aperture as you can afford will be a worthwhile investment. Wide-angle lenses have their place in action photography, too, especially if you want to show more of the surroundings.

Other essential equipment for action photography include the following:

- **Tripod:** Helps you keep the camera steady while panning and lets you follow the action when using slow shutter speeds.
- **Electronic flash:** Useful for freezing action both indoors and out.
- **Lens hoods:** Shade your lenses from the glare caused by bright lights.

Scoping Out the Action

One of the reasons professional sports photographers get such great shots is because they usually know in advance the conditions they'll be shooting in. While they can't control the weather or the lighting when working outdoors, they do know the best vantage points for capturing the action, whether indoors or out. This lets them get their equipment set up in advance so they'll be ready to shoot when the action comes to them.

Being able to anticipate where and when the action will take place is a major factor in being able to shoot it well when it does. If you're photographing a soccer game, you might want to position yourself near the goalie's net. Getting close to where points are scored will also help you catch the peak of the action at football and basketball games. A classic spot for shooting car races is at a bend in the track.

When choosing a shooting location, keep in mind that the angle you're shooting from will greatly affect the types of shots you'll get. Action that moves directly toward or away from you is the easiest to stop, and you'll be able to use slower shutter speeds to capture it. Subjects moving at right angles to your camera are more difficult to stop and will require the fastest shutter speeds you have. It's also easier to stop the action at a distance than when it's close up.

Winning Shooting Techniques

Many action pictures are taken with the fastest shutter speed possible. This freezes the subject's movement and results in stop-action photos with sharp images. Very fast shutter speeds can even capture images that contain more than the eye can see, such as the spray surrounding a diver as he hits the water.

Using fast shutter speeds is just one way to capture fast action. There are several other techniques you can use that will also allow you to shoot in a wide variety of lighting situations and capture pictures that better convey excitement and ongoing action.

Keep in mind that stop-action photos are most effective when the viewer can see something that indicates what the subject is doing. Avoid shooting people as they fly through the air unless you can also include the object they're moving away from or toward. If you're taking a picture of a gymnast doing a dismount from the horizontal bar, frame your shot so at least part of the apparatus is in the picture.

Freezing Action with Flash

Using a flash unit is one of the best ways to get good stop-action pictures in poor light conditions, both indoors and out. The burst of light made by an electronic flash only lasts about 1/1,000th to 1/10,000th of a second, more than enough time to eliminate motion blur in any fast-action situation.

Ask before using flash when shooting indoor sporting events. Since the bursts of light can be distracting to the athletes, many organizations prohibit it unless you're a professional photographer covering the event.

Panning the Action

Another great way to stop action in its tracks is to move your camera along with it. This technique, called panning, will usually result in a blurred background and a sharply focused subject. When a tripod isn't used or the shutter speed is very long, the whole photo can appear blurry.

Panning can be a little difficult to master, but it's worth taking the time to learn how to do it well if you're serious about taking action pictures. Not only do panned pictures convey a greater sense of speed, they can also

be taken with longer shutter speeds—even speeds as slow as 1/8th of a second. The slower the shutter speed, the more blurred the background will be. Flash can also be used while panning to pop the subject out of the background.

Panning Techniques

1. Stand with your feet planted firmly on the ground, facing directly ahead of you. You can shoot from other positions, but standing is usually easiest. Use a long lens, and stand far enough away from the subject to allow you to properly frame it.
2. Prefocus on the place you want to take the picture. An autofocus camera with continuous-focus or focus-tracking mode will make panning easier, as the lens will keep the subject in focus while you follow it in the viewfinder.
3. After you've prefocused, aim your camera toward the direction where the action will appear. Try to only turn your upper body when you're doing this—keep your feet facing your focus point and concentrate on moving your body by twisting your torso from the waist up.
4. As the action approaches, keep it centered in your viewfinder. Keep your feet pointed forward while you move your upper body in an arc. Keep the camera level as you move to avoid tilted images.
5. When the moment is right, press the shutter.
6. Keep following the subject in your viewfinder after you take the shot. This follow-through action is necessary to capture the entire effect of the pan. Don't get distracted by the image blackout caused by the slow shutter speed—just keep moving through the shot.

You can also pan with your camera mounted on a tripod. Some people find it easier to do so for the following reasons:

- **Smoother panning:** The tripod will keep the camera steady throughout the panning action.
- **Better images:** Using the swivel head on a tripod eliminates jerkiness, which can cause vertical blurring in addition to the horizontal effect you're after.

- **Less shooting fatigue:** Standing in place with your camera, especially when you're using a long lens, can tire you out in a hurry.

◄ FIGURE 16-1
A bird on the wing is a challenging shot that can be captured when you have mastered the art of panning.

Since the tripod replaces your body movement, you can follow the same procedure as given above when using one for panning.

Although panning is just about the best way to capture objects while they're moving and make them look like they're moving, it does have its drawbacks. It's not an easy technique to master, nor is it easy to keep things focused as you're moving the camera. Also, it takes some practice to match your panning speed to the speed of the subject, although panning faster or slower doesn't necessarily result in bad pictures, just ones in which the subjects are more blurred.

Adapting to Circumstances

How to approach the type of action or motion shot you're trying to capture is usually dictated by the action itself. Of course, the basic techniques and equipment remain the same, but different circumstances will call for different approaches.

In the color insert, the photo of a woman walking by the ocean on a misty day turned out surprisingly well even though it was shot from a moving car when the subject was in motion.

Sports and Games

When you are trying to capture the action taking place at a sporting event or game, you may be shooting at night from a distance and will need to bring a long lens, tripod, and fast film when shooting with a conventional camera. Flash will not be necessary in these circumstances, as you'll be too far away from the action for it to do any good. If you are shooting digital, set your ISO to a high setting, such as 400, if your equipment will allow you to adjust ISO settings. Sailing, bicycling, and racing events generally occur during daylight hours. You'll still need a long lens, preferably a telephoto that will allow you to zoom in and out of the action.

Arts and Nature

Sometimes you happen to be in the right place at the right time to capture wonderful events spontaneously. If you are lucky enough to be there when Monarch butterflies head south, you will know that time is of the essence if you are to capture these fleeting moments. Always be prepared for these fortuitous events; they are part of the pleasure of photography. A long lens and panning will capture the moment, and an automatic setting on the camera is often all you have time for, as the action happens so fast.

Shooting flowing water at slow shutter speeds will cause the water to blur and give the feeling of motion. Having a static object such as a rock in the shot will really emphasize the motion of the water.

Blurring the Action

Sometimes blurred images are the best way to portray action. You can create them by using extremely slow shutter speeds, even as slow as one-quarter to one-half of a second. If you're shooting with a tripod, only the objects that are moving will be blurred.

◀ **FIGURE 16-2**
A car passing by at night offers an opportunity to hone the skill of panning. This long, handheld exposure captures the image but allows it to blur to clearly convey that the car was in motion.

If you handhold the camera, you'll end up with a shot that's blurry all over, as the lens will also capture any slight movement you make as you take the picture. These pictures might be tossers, or they may surprise you and turn out to be beautiful abstract portrayals of time and motion. Film and digital memory are cheap—don't be afraid to experiment with this technique and explore its many possibilities. You may be very pleased with your foray into the more artsy aspects of shooting.

CHAPTER 17

Photographing People

Taking pictures of people can simply be about recording their appearance or their attendance at a special event. Good people pictures, however, go way beyond just asking people to say "cheese"; they say something special about their subjects. Whether you're taking pictures of kids or adults, the best images depend more on conveying feelings and relationships and less on striking picture-perfect poses.

Getting Great People Pictures

If you're like many photographers, you take more pictures of people than anything else. Maybe you bring out the camera because you want to remember your daughter or best friend just as they are right now. Or you might be celebrating a special occasion, and want to mark the moment by recording the people around you. The way you feel about someone might also inspire you to make him the subject of a photograph.

Planning the Shot

In each of these situations, you could simply take a couple of quick snapshots and be done with it, but you'll end up with a much better picture if you spend a little time thinking about what you'd like it to say about the subject. For example, if it is a birthday, be sure to include a cake or presents, etc. When you include clues to what is going on in the photo, you anchor it firmly to the place, time, and occasion.

Although most pets aren't very good at sitting still and probably won't follow your directions, many of the people-handling techniques discussed in this chapter will work equally well when taking pictures of Fido and Fluffy. A squeaky toy is not a bad idea, either.

Only a Snapshot

There's nothing wrong with snapshots. Frankly, they're sometimes the only way to get a picture on the run or to photograph a subject who's less than cooperative. But people pictures are always better when the photographer builds some rapport with subjects and puts them at ease. This holds true regardless of the setting, whether it's indoors or out, formal or informal, although your considerations will differ a little depending on the setting.

The Smile Factor

Portraiture is about feelings and relationships, not about posing, although getting your subject to meet the camera in a flattering way is important, too. Sometimes this means having your subject smile for the camera. But not always.

Most people look best when they're smiling, as it indicates a cheery disposition and a pleasant mood. As the photographer, however, your job is to get the best picture of your subject. A smile might not be part of the equation, either because it doesn't fit the emotional tone of the picture or it isn't appropriate to the subject's personality.

Putting a Smile on Their Faces

If you're taking a quick informal shot of a child or an adult, and the general tone of the situation is light, getting a smile for the camera is definitely the way to go. Ask your subject to do it, and you might end up with a pleasant expression. Then again, you might not.

Tips and Tricks

Instead of asking for a smile, try to get one naturally by using one of these tricks:

- **With an adult:** Joke a little as you fiddle with the shot, or ask some questions to help them relax. Choose general and pleasant topics. Even if you don't make them laugh in the final picture, traces of earlier jollity will still be evident in their faces.
- **If you're taking a picture of a little kid:** Try wiggling your fingers or making a silly face, or use props such as a ball or stuffed animal to get a response.
- **Smile first:** Just about everyone will return a smile.

Striking a Pose

Getting people to hold their bodies comfortably and naturally is another aspect of portraiture that's largely in the hands of the photographer. Most

people stiffen up and do funny things with their bodies when asked to pose for the camera. If you're staging a people shot rather than grabbing one on the fly, you'll have to tell your subjects what they can do to make their body alignment more pleasing.

Body Language

People seldom look their best when they're photographed straight on. This pose makes their shoulders and torsos look too wide for their heads. Sideways shots are also problematic, as they make the shoulders look too small to support the head.

If you're posing people for a shot, have them turn their upper bodies slightly away from the camera. Anywhere from 15°–50° can work.

Poor posture may or may not show up in a picture, depending on how it's taken. If you're doing a posed shot, it almost always helps to ask your subject to sit a little taller just before you take the picture. In candid shots, it's up to you to find the camera angle and lighting that works the best with the person's posture.

Other common posture problems include these, with some suggested fixes:

- **Shoulder slump:** A very common problem for both men and women. You can correct it by asking them to push their shoulders toward the nearest wall while sticking their stomachs out toward the camera. This straightens the back and opens the chest, which also balances the proportion between the waist and the upper body.
- **Upper-body slouch:** This differs from shoulder slump as it results in the entire upper body leaning too far forward. Correct it by having your subject imagine that there's a string or a rope attached to her head that's pulling her up to the ceiling.
- **Chin tuck:** Men often tuck their chins right into their necks, which causes double chins and makes their necks look short. Ask your subject to point the tip of his nose toward the camera—it will bring his chin forward at the same time without making it jut out unnaturally.

- **Chin jut:** This one's fairly easy to fix. Just tell your subject to drop his chin or point his forehead toward the camera.

Posture problems and other figure flaws can also be solved with creative lighting and by finding more flattering camera angles.

QUESTION?

Is it ever permissible not to show a subject's eyes in a picture?
Like most rules of photography, this one can definitely be broken. If your intention is a character study rather than a classic portrait, it's perfectly okay to obscure one or even both eyes, depending on how the subject is posed.

It's All about the Eyes

Most portraits clearly show both of the subject's eyes, whether the subject is looking at the camera or away from it. This is one of the classical rules of portraiture. This composition is pleasing to the viewer because you expect to see the eyes.

The general rule is to keep the whites of the eyes fairly even when the subject is looking away from the camera. Seeing a lot of white disturbs the viewer. It's also disconcerting if the subject is turned away from the camera, but is turning his or her eyes toward the lens.

In the photo of the beautiful cat in the color insert, as is quite often the case, red eye was a problem until the eyes were digitally retouched.

Those Pesky Appendages

Hands can make or break an otherwise well-posed photo. Bringing the hands to the face can be classic or cliché. Give it a try, but don't make it the main point of the picture unless the subject's hands are an important part of her profession or hobby.

Hands generally look best when photographed from the side rather than from the front or back. For the most natural look, have your subject pretend to hold a thick credit card between thumb and middle finger. Then turn the hand so the palm or the back doesn't show.

Feet and leg position can make or break pictures, too. For a formal, full-frame portrait have the subject assume the classic ballet "T"—front foot facing the camera with the heel of the foot positioned near the arch of the back foot. For more informal poses, anything goes, as long as your subject is standing comfortably and attractively. The "T" position is considered feminine; men can stand with their feet apart.

Taking Pictures of Individuals

Single-subject shots generally fall into two categories: classic portraits, in which the person is the only subject and is isolated from time and place; and environmental portraits, which include the person's surroundings.

FACT

Classic portraits are also called cosmetic portraits, as they focus on the subject's facial features—hair, eyes, lips, nose, and mouth.

Formal Portraits

Most people think of formal studio shots when they hear the term "classic portrait," but the term really describes any picture of a person that focuses more on them than on their surroundings. While formal portrait shots taken in specially equipped studios are also classic portraits, they're beyond the interest of most amateur photographers and won't be dealt with in-depth here. If you're interested in learning more about them, turn to Appendix B for more information.

Informal Portraits

Shooting classic portraits in more informal settings is vastly more fun than shooting in a studio, as you don't have to worry as much about factors such as posing and lighting. For the most part, your subject is going to do what he or she does naturally; your job is to figure out the best way to capture the image.

Setting Up the Classic Portrait

Since backgrounds are secondary when taking classic portraits, you can shoot them just about anywhere. Since you'll be shooting with a wide aperture to blur the background, find a spot where the background color and light will enhance the subject without distracting colors or patterns.

Camera Placement

Classic portraits usually look best if you position your camera a few inches higher than the subject's eyes. This puts the subject's body and head at a flattering angle and puts the eyes at a pleasant spot in the frame. But this is by no means the only camera angle to use. Shooting upward can emphasize the individual's stature or balance unflattering up-light if you're shooting outside. It can also put a different-colored backdrop behind the subject, such as an arbor. Using a high camera angle and shooting down at a subject can make a heavy person look slimmer. Experimentation is the only way to discover the best approach to use in each individual instance.

Not filling the frame with the subject and leaving too much space above the head are common errors in snapshot portraits. Avoid them by putting the eyes at the upper one-third line. Leave just enough room above the head so it isn't crammed against the top of the frame. Back up or zoom out as needed.

Faces look best when viewed at a distance of six to eight feet. Get closer than that and the nose appears larger and the ears smaller. Move farther away and there is a loss of connection between the subject and the photographer. Greater distance can also mean the face is slightly distorted by compression (which results from the absence of some visual cues about depth and perspective). Whether your image will include just your subject's eyes or be a complete head and shoulders shot, keeping in the six-to-eight-foot range will give you the best results. Full-length shots can be done at greater distances with no problems.

Selecting the Lens

The best lens choice for shooting classic portraits is one with a focal length that's about twice the length of a camera's normal lens. For 35mm cameras, a lens with a focal length between 85mm and 135mm (short telephoto) fits the bill for several reasons: It shows people's faces with the least amount of distortion; and it also allows you to fill the frame with your subject without having to be too close for comfort. A zoom with an even longer focal length, say up to 135mm or 150mm, will let you get even tighter detail shots without having to move in.

ALERT!

Don't use a wide-angle or normal lens for classic portraits. They cause too much distortion of facial features, creating warped images that are terribly unflattering to the subject.

Shooting with your lens's largest aperture will give you the shallow depth of field you need to isolate your subject from the background.

Posing Classic Portraits

In the classic portrait, the subject can make eye contact with the viewer or be absorbed in a book. A seated subject is usually the easiest way to do a head and shoulder portrait. Your subject should sit in a seat without the visual distractions of arms or back.

Lighting Classic Portraits

How you light your subject will have a great deal to do with the mood and tenor of the final picture. If you're after a pensive, introspective look, try lighting your subject from the side. If you're shooting indoors, try to use natural lighting whenever possible. If necessary, use a tripod and make a long exposure. Window light can help make some of the most pleasing pictures.

For more on various lighting techniques, turn to Chapter 10.

Environmental Portraits

Unlike head-and-shoulder shots in which the background is secondary to the subject, environmental portraits include the person's surroundings—beaches, a teenager's bedroom—to show the relationship between subject and territory.

▲ FIGURE 17-1 Sometimes you must stretch the rules in order to capture unique shots. Your subject's face doesn't have to be the true focal point. Look for opportunities to exercise your creativity in portraiture.

While not necessarily essential, when composing an environmental portrait it is usually better to have your subject interacting with his or her settings rather than just standing in front of a workspace.

Scouting Locations

Just about any place you want to take a picture is fair game for an environmental shot. Consider both indoor and outdoor settings, and ask the subjects where they feel comfortable. As you're scouting locations, look for the setting that allows your subject to pose comfortably and safely. Think about the size of your subject in the frame. Keeping the subject large and close to the camera is usually a good starting place, given that the most common error in taking pictures of people is not filling enough of the frame with the subject. Experiment with a range of subject sizes: totally filling half or a third of the frame or even doing a full-length shot in which the subject's height is one-fifth the height of the frame.

Parking lots near wooded areas make ideal portrait locations. Not only are they convenient for both you and your subject, they offer pleasant options such as open skies and greenery and adequate illumination to light your subject, as well as a tree canopy to block out direct overhead light. You'll find the best light a few steps into the woods.

◀ FIGURE 17-2
An example of a portrait taken outdoors under a porch, which blocks direct light. The subject's happy face is mirrored by the decorative figures in the setting of a child's 19th-century playhouse.

Working with Outdoor Settings

Gardens, porches, and the woods near your house are all possible places for taking environmental portraits. In fact, just about any location will work, as long as the light is right.

Open shade such as that found under the branches of a tall tree is the photographer's favorite because subjects are lit by the sky and the scenery around them. When looking for these settings, try to find them near something that will reflect sunlight into the shady area since light in the shade often lacks direction. Soft light, not direct light, that comes primarily from one direction is ideal.

> If you have to shoot a portrait with the camera pointing toward the sun, put your subject's back to the sun and use something bright, such as a piece of white cardboard or portable reflector, to light the shadow on your subject's face.

Wherever possible, avoid shooting in overhead light, as it casts shadows in the eye sockets and under the lower eyelids (a particular problem with children). You can erase them to a certain extent by raising the subject's chin. Young faces prone to under-eye shadows might be able to tolerate up-lighting, which eliminates these shadows. Have the subject look down toward your feet or off-camera, not directly into the light.

Improving Outdoor Light

It's often necessary to balance the light in environmental shots. Keep a piece of 2' × 3' (or larger) poster board in your car or bag when you go out on a portrait shoot. Use the reflector to bring light into dark shadows so they don't print totally black, or as a hair light from behind the subject. You can also use it as a fill light to add a bit of light from behind or bring a touch more light into the shadows, so they don't go totally black in the final image.

Flash also works well when shooting portraits outdoors. One neat trick is to take the flash off the camera. Have an assistant hold the flash to one

side, close enough to your subjects to light them. Or, if your shutter speed is long enough (more than ten or fifteen seconds), you can release the shutter then run to the best spot to pop the flash. Feeling really adventurous? Have the subjects hold the flash and light themselves!

Working with Backgrounds

While scenery plays an important role in environmental portraits, it isn't meant to be the main subject of these pictures. Use the surroundings to enhance your subject, not detract from her.

If you're working in color, look for backlit foliage—greens and yellows are great for bringing out flesh tones. Choose colors to flatter your individual subject. If the subject has dark hair, you will want your background to be lighter than the hair so they don't merge. Backlighting can light up dark hair nicely so that it stands out from a dark background, making a dynamic portrait. Keep the background as simple as possible—if it's too busy, it will conflict with the subject.

Sometimes you just have to take a picture of someone right where they are standing—in front of your house, at the airport. Select a camera position that gives you a distant or low-contrast background. If the surroundings are very distracting, you can try a very low or high camera position to isolate your subject against the sky or pavement.

FACT

While you probably won't always be able to consider all these factors when taking shots, keeping them in mind as much as possible can do nothing but improve the photographs you take, even the quick snapshots. Eventually, most of these techniques will become second nature.

Avoid sharp lines poking into or growing out of your subject. The classic goof is to have a tree or telephone pole growing out of the subject's skull. You want to put the cleanest, least distracting part of your background behind your subject's head. If there is a horizon or any strong horizontal in the background, either lower the camera angle to put it above the subject's

head or find a higher vantage point so you can drop the line below the subject's shoulders.

Posing the Portrait

The basic consideration is a simple one: seated or standing? Both poses have their advantages and drawbacks. We'll consider and weigh the advantages and disadvantages which may be associated with either pose, given different subjects.

Seated Portraits

Seated subjects are often more comfortable, and you can use a higher, more flattering camera angle to shoot the photograph. Seat your subject on a bench or other perch without a back, which can be a distracting element in a portrait. Be sure the subject is comfortable, however, or the strain of the pose will show in awkward body language and pained facial expressions. Be sure the hands are relaxed and perhaps holding an appropriate prop, such as a book. Remind your subject to sit tall before snapping the shot. These portraits do not always have to include the entire person, but can be cropped into whatever pose is most flattering and appropriate to the subject.

Standing Portraits

Full-length standing portraits will make subjects appear more slender. However, they can also create a lot of vertical lines (legs, arms, torso), which aren't good. Use props, such as a pair of glasses, to occupy the hands. Men can put one hand lightly in a pants pocket, allowing the elbow to bend gently; the other can rest on the top of a chair so it creates a diagonal line leading up to the head. Another rule of thumb for poses: if it bends, bend it! Cross legs or ankles. Bend the elbows, and let the head tilt just a touch, very subtly. Avoid idle hands that dangle at the side.

Lens Choices for Portraits

You can use just about any lens you own to take an environmental portrait. A wide-angle lens will let you include foreground, medium ground,

and background to give your photo depth. A normal or telephoto lens will cut more of the environment out. While including the environment is essential for this type of photography, you still only want to include the environment essential to your image's composition.

ALERT!

Try to avoid cliché shots when taking portraits. The photograph of the maiden with her hand caressing a tree is so timeworn that the image is likely to look stale. Using that same tree to stage a portrait of a couple of little kids shot from the ground, however, can result in a cute portrait that shows kids doing what they do best—having fun.

Camera Position

Environmental portraits can be shot from just about any camera angle. Try various positions to see how shooting from different angles affects the mood and tone of the picture. Taking full-length shots with the camera at about the height of the subject's midriff avoids distortion.

Shooting a Group or Couple

Pictures of couples, families, or kids with pets fall into both the classic and environmental categories. Most of the techniques used to photograph single subjects also apply to these shots. However, they require some extra finesse when it comes to posing, composition, and lighting. That's because all the factors you have to consider when taking pictures of individuals are now multiplied.

Lighting Considerations

It's often difficult to light multiple subjects equally and well. If you pose two people looking toward each other, they'll each catch the light differently. Shooting with nondirectional light is often the best answer, or you can stay with a strongly directional light and use a fill (poster board or flash) so no details are lost in the shadow. Another option is to make the picture

about just one person, whom you will light well, and let the other person be somewhat obscured in the shadows. For example, if you photograph a mother looking at her newborn, you might light the infant, but let the mother's face be in shadow.

Lighting a large group is always a challenge. If you're shooting outside, your subjects will squint if they face the sun. If you take the picture under noontime sun, the shadows on their faces will ruin the shot. Strong directional light from the side may put some of the people in other people's shadows. Try to time these shots for the hours around sunrise and sunset, which are great times for catching warm yet directional natural lighting. If you're limited as far as the times you can shoot, create a backlit situation by placing your subjects facing away from the sun. Use the backlighting setting on your camera, or manually increase your exposure by one or two stops. Using fill flash to brighten the group and balance lighting between its members is also an option.

When shooting groups indoors, avoid using direct flash. Instead, use the bounce flash techniques described in Chapter 11 to create more pleasant artificial lighting. At a distance of more than ten to fifteen feet, your bounce flash will not be strong enough, so use a direct flash, but aim it slightly higher than the group to even out the lighting.

Posing Considerations

You have two options when taking pictures of groups: spreading them out so they fill the scenery or keeping them close and in contact to emphasize interpersonal relationships. If the picture is more about the setting than the people, you can increase the spacing. Zoom out or back up to include the scenery and the spread-out group. For group pictures at a picnic, family reunion, or celebration, you'll want to come in very close. The closer people are to each other, the larger they will appear in the final image. This is very important if you want to be able to recognize faces in a large group.

Color Choices for Portraits

Some of the most familiar portraits in the world have been shot with black-and-white film, and black-and-white continues to be a popular choice for

classic portraits even in the digital age. However, there's no universal reason to select black-and-white over color or vice versa. For the most part, color choice depends more on what your subjects prefer, what will make them look their best, and what feelings or emotions you want the picture to convey.

A good rule of thumb for relative subject size is to get close enough to the group that if you added two people at each end, you would have to back up the camera or zoom out.

Color Portraits

Slide film will give you beautifully saturated colors, but people with ruddy complexions will look even redder if you use it. The same slide film, however, will do a wonderful job of bringing out the subtleties in the delicate coloring of children's faces.

Digital color shooting will allow you to adjust saturation selectively, avoiding oversaturating areas that don't need it, like overly ruddy complexions.

There are important issues to take into consideration when shooting color portraits. Color print film, which will also enable quick and inexpensive printing, is a good choice for most outdoor color portraits. People with poor complexions may prefer a film that will disguise imperfections. Fast film—ISO 400 and faster—has larger grains that can help hide skin problems. Pictures taken with fast film or with a fast ISO setting on a digital camera will be more about mood and drama, regardless of the setting or the subject.

Black-and-White Portraits

The long tradition of fine art black-and-white portraiture is carried on through both the use of fine-grain film and its digital counterpart. Use the finest setting that lighting conditions will allow—usually ISO 50 to ISO 100. If you're using a good lens and a tripod, and if you focus very carefully, every

detail and imperfection will be obvious in the final print—prepare your subject for a very truthful portrait. If you need to hide some skin imperfections, use a higher ISO for its grainier effect.

Black-and-white allows you to work with light sources (like fluorescent and tungsten) that in color would produce bad skin tones. If your plan is to try some indoor portraits using incandescent lighting, definitely use a fast (ISO 400) black-and-white film, or in the case of digital, a fast ISO setting. Some cameras have settings which can compensate for fluorescent lighting—check to see before you start shooting. Outdoors, you can use slow settings (ISO 100) if you have a tripod, but use a high-speed setting (ISO 400) for handheld portraits.

CHAPTER 18

Photographing Events

Graduations, weddings, birthday parties, retirement parties—life is full of special events worth capturing on film. Just as balloons and confetti are signs of celebration, taking out the camera is often a sign there is something important happening. In fact, taking pictures makes special events even more special.

Know Your Place

Are you a guest with a camera at a formal occasion like a wedding? Or are you the wedding's official photographer, with everyone counting on you? If you aren't the hired photographer, remember not to get in the way of the professional. In fact, professional photographers may have a clause in their contract giving them the exclusive right to capture posed shots. Be sure to check with them before proceeding. However, you should be allowed to photograph all the action and interactions that happen during the event without the professional's prompting or arranging.

It is important that you respect the customs of the faith when taking pictures in a church or synagogue. Keep your movement and noise to an absolute minimum so you don't interfere with the service or detract from the experience of other guests. Are you planning on doing some flash photography? Checking with the clergy and the event coordinator beforehand is a must.

The same cautions hold true for taking pictures at other occasions—school plays, museum or exhibit openings. If you're not the official photographer, stay in the background. Always be respectful of others around you when you're shooting. Always check to make sure it's okay to use flash, and be respectful if the answer is no. A little courtesy will be appreciated and will help enhance your reputation as a photographer.

ALERT!

Museums often prohibit flash pictures; some even prohibit the use of tripods. "Borrowed" exhibits are often restricted from being photographed. Ask what the restrictions are before you start shooting. You might be surprised at the number of places that don't allow photography at all. Always check ahead to avoid embarrassment!

Why Are You Here?

Before you take pictures at a special event, pause a moment to think about why everyone has gathered. Sometimes it is easy to forget that the most

important issue for the people involved is not necessarily to have nice photos in an album, but nice memories of the event, as well.

The True Goal

Be truly mindful that the people gathered together at the event are commemorating a tradition that links all the people in the room, a tradition that connects them to their ancestors and to their great-grandchildren, who will perhaps do the same rituals someday. These events acknowledge connection and joy, and so does good photography performed by a very respectful photographer.

Respecting Boundaries

Don't interfere with the moment; try to anticipate the flow of movement and emotion. What is the purpose of the photograph you are about to take? Is it just a snapshot? Or does it capture a special interaction? Are you taking the photos for your own pleasure or for the honored couple? Who will your audience be? Think about what your viewers will want to see, and what their point of view is, to produce photos that will capture the spirit of the occasion for all.

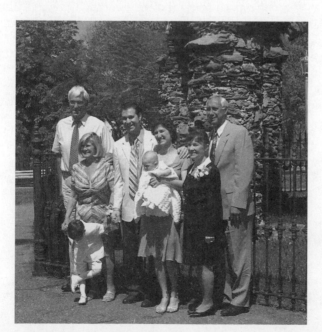

◀ FIGURE 18-1
This group at a dedication ceremony was engaged with the event photographer when this photo was snapped. Some people are looking at him rather than into my camera lens.

Two Approaches to Event Photography

Today's photographers have two operating modes during the special day. One approach is the fly on the wall or photojournalism mode. You are there to capture what happens, but not to change or affect the people or the scenery. The subjects are mostly unaware of your presence. You don't arrange the subjects in your photos; instead, you anticipate events and are in the right place at the right time to capture the moment. If possible, the event organizer should introduce you at the beginning of the event and make it clear that you are photographing with permission.

Subject-aware is the other mode. You help schedule the day, making sure time is set aside for you to take formal pictures. You move furniture, and you are in charge. You direct people where to stand, where to look. You help them appear their best by adjusting the lighting, attending to details, and interacting with them so they enjoy their time with you and look relaxed in the photographs. The subject-aware approach is also called traditional photography.

Mixing Approaches

Event photography is a mix of these two approaches. Develop the judgment to know which mode is called for at the moment. Keep your audience in mind: If there is a professional photographer taking formal pictures and you intend to give your images as a gift to the family, get the moments that the professional is missing, those little glimpses that the family doesn't see. These would be done in the photojournalistic mode. On the other hand, if Aunt Minnie showed up late and missed the formal portraits, you can take a picture of her and the confirmation girl or the groom's father. This might be a traditional or posed picture.

More on the Photojournalism Approach

Let's suppose your goal is to get a picture of the groom and his stepfather. You see the two men talking together in a corridor away from the main action at the event. You find an angle that shows both their faces, or maybe shows one man gesturing and the other responding with an interesting expression. Or maybe you sense the impending hug or pat on the back

and snap enough frames so you can select a group from them that together tells a story about the moment, and then you move on to other subjects.

More on the Traditional Approach

If you're taking the traditional approach, you'll wait until the two men finish talking. Then you'll direct them to face the camera and step to where the light and scenery will make a more pleasing image. You might ask them to put an arm around each other. You'll adjust their ties, jackets, and hair. You'll say a few words to them to get them involved in the moment, then snap the shutter when you sense that they are feeling connected and looking their best.

FACT

Which approach is best? If you're not comfortable directing people, or if your subjects don't like to pose, your best bet is to be a fly on the wall. If you've been asked to take more formal pictures of various event participants, the traditional approach is the way to go.

Essential Images

Whether you're taking pictures for fun or you've been asked to do so, there are some images that are expected, reasonable, or essential. If you think of the different types of images that comprise event photography, you'll avoid getting in a rut or missing something important.

A complete collection of event photos should include the following:

- **Scene setters:** Images that tell the viewer what the special event is.
- **Illustrative:** Images about the event that evoke a feeling or mood.
- **Traditional:** Portraits, from close up to full length, plus group shots and maybe a few staged moments between certain people.
- **Expected moments:** The traditional activities or parts of a special event.
- **Unexpected moments:** Unstaged, unplanned, intimate, or emotional exchanges that naturally take place.

- **Creative:** The unusual angle, the odd juxtaposition of subjects, the single shaft of light, a powerful piece of architecture. Use these to create photographs that are about the day but offer a new way of seeing it.

Tips on Shooting Essential Images

Although there is no right way to photograph an event, knowing how various images are set up and composed will help you know what to do to create them.

Setting the Scene

These are photographs of objects that tell the viewer, "This is the bride getting ready." Look for items that evoke the day, like the bride's shoes. Find reflections of the personalities in objects, like the groom's cufflinks lying on his golfing magazine.

Once you put yourself in this frame of mind, these pictures are fun and easy to take. Since these pictures are usually of stationary objects, use available light and a tripod if necessary, and fill the frame with the subject.

Illustrative

Photographs of events should tell a story largely conveyed by the mood of the lighting, the postures and gestures of the subjects, and the setting. Find natural settings that frame the subjects. Look for S-shaped paths for the bride and groom to walk along. Avoid having the poses look like the couple is following your direction.

Traditional

If a professional photographer is taking these shots, you need not duplicate them. In fact, your clicking the shutter while the official photographer is working may distract both the subjects and the photographer, ruining the pictures the family is paying for.

If you're the hired pro (more on this later), plan on taking pictures of every family member at formal events like weddings, confirmations, bar and bat mitzvahs, and so on.

The following list of images for a wedding will give you an idea of the various combinations you should expect to shoot:

- Bride alone—close up, three-quarters, and full length
- Bride with mom
- Bride with dad
- Bride with both parents
- Just the parents
- Bride with grandparents
- Bride with siblings
- Bride and family (if you include siblings with their spouses, then include the groom)
- Bride with each bridesmaid
- Bride with flower girls
- Bride with bridesmaids and flower girls
- Groom—same family and groomsmen shots as above
- Bride and groom with each set of parents
- Bride and groom with each immediate family and each set of grandparents
- Bride and groom with various aunts and uncles as needed to please the family
- Bride and groom with minister or rabbi (if the couple wants)

As you work with each pose or grouping, remember that special events like these are about love, tradition, and tenderness. When photographing two people, let them be with each other, not simply posed standing together. Hugging and talking strengthens the sense of connection. Direct your subjects to interact, touch, lean toward each other, or tilt their heads towards each other slightly. Exclude distracting items like purses, watches, and sunglasses.

Make group shots interesting. Have people pose naturally. Turn them toward each other, but usually at no more than a 45° angle.

Subjects can be standing, sitting, kneeling, and holding each other—anything but standing shoulder to shoulder. Avoid having the subjects' arms dangling straight down, which makes for a really boring shot. Direct women whose legs are showing to put their feet in third position (feet in a "T") so the camera only sees the front leg. Don't seat heavy people, as it emphasizes their width instead of their height. Slim them down by hiding part of their body behind someone else. People who are sitting should sit forward on their seats; don't let them slump.

QUESTION?

Why should I pose people at an angle (instead of facing straight at the camera) for group shots?
First, it slims the body. Second, it allows you to squeeze in more people. Third, it gets the heads closer together. Fourth, since pictures are about relationships, it is natural to have your subjects turned toward someone they like.

A bride and groom almost always look best if they're at the center of the picture, front row, standing. Don't let anyone cover the bride's dress by standing or sitting in front of her.

Expected Moments

From the priest's blessing at a baptism to the newlyweds driving off in a limousine, there are traditional activities in all special events. Know how the day will flow to catch these moments. There may be an event coordinator, disc jockey, or bandleader in charge of the scheduling. Keep in touch with them instead of bothering the family to find out what's next.

Depending on the event, there might be some traditions that require special setups and equipment. Anything taking place in a small room will require a wide-angle lens. If you're using flash, you'll want to bounce it off the ceiling or a wall. Bouquet and garter toss also require a wide angle. Position yourself so that you can find the angle that shows the entire crowd behind the bride as she throws the bouquet.

The first dance (and father-daughter dance, along with any other special dances) should first be photographed in a way that establishes the scene. Get a full-length shot of the couple. Capture reaction shots as people watch. Get a few closeups of guest's faces, plus detail shots like the groom or dad's hand around the bride's waist. Avoid busy backgrounds like the music speakers. If the moment is magical, don't interrupt to pose the couple.

Look for action and reaction shots. Photograph the parents watching the couple as they're dancing. Capture guests laughing as the cake is cut. Get a picture of the best man's toast, and the groom covering his face in embarrassment. If a speaker gets choked up while making a speech, watch for parents and siblings to be wiping their eyes, too.

ALERT!

Unless you're extremely secure about your abilities as a photographer, and you completely trust your equipment, think twice about accepting an invitation to photograph a wedding. If your skills aren't up to the task, or your equipment fails, it will ruin both the event and the memories for the couple and for you as well. If you do accept, make sure the bridal couple understands your capabilities and limitations. If they want a formal portrait that requires auxiliary lighting and you don't have it, they'll end up being disappointed with your efforts.

Unexpected Moments

Yes, you can plan for these. Just before or after a scheduled activity, such as walking down the aisle or cutting the cake, watch for moments of deep connection between the main people at the event. Capturing these images may necessitate changing how you're thinking and feeling. Rather than anticipating large-scale action, keep your antennae up for the unexpected. Children are great subjects in this area. Watch for the bride to kneel down to talk to the flower girl. Children on the dance floor? Get out the camera and be prepared.

Be Creative

You may have to lie on the floor or hang off a balcony to get an unusual angle. Tilt the camera; take creative risks. Tell yourself the picture might not turn out, but you'll give it a try anyway. Take these images on your own time, after you've shot all the pictures that are important to the event.

Gearing Up to Photograph Events

As previously mentioned, it's best to leave serious event photography to the pros. But let's say you've been taking pictures for a while and you've had the opportunity to do some event photography—enough of it, in fact, to determine that you like it and want to do more. You may even want to join the ranks of professional event photographers.

If so, you'll need the proper gear for capturing the different types of images that comprise such photography: portraits, candid shots, tableaus, action, and so on. Your specific choices depend in part on the location of the event and your preference for traditional or journalistic style.

Basic Gear for the Event Photographer

Fast and easy-to-carry gear makes event photography easier. A fast, auto-focus, motorized 35mm SLR camera makes the job easy, but there are great photographers who work only with manual-focus cameras.

For indoor events you'll need a fast lens, like an 85mm f/1.2 and, if you like zooms, an f/2.8mm zoom. The 85mm is long enough to capture good head-and-shoulder couple shots. While a longer telephoto lens can capture special moments, if you're shooting indoors, you'll probably be close enough to your subjects to do a great job with nothing longer than 85mm or 105mm.

Indoors or out, if you'll be working in crowds, a 24mm lens allows you to get close to the action and still capture all the participants. However, faces near the edge of the 24mm image show distortion, so you might want to go easy on the pocketbook and try the 35mm or 28mm lens to see if they work for you.

If you're shooting outdoors with plenty of light, you may want a 200mm or a long telephoto zoom so you can simplify your composition

by including just one or two people. For the long lenses, especially if they're slow (f/4, f/5.6), you'll need a tripod and maybe even a cable or remote release so you don't shake the camera when you trip the shutter.

A 50mm f/1.8 lens is a good start for the small budget. It's not too expensive, it's sharp, and it can be used in low light. Don't use it for closeup portraits, as it distorts the face, but it's fine for full-length or three-quarter shots.

Here's a modest equipment combination that you can carry to an indoor wedding:

- **35mm autofocus or manual body.** In the case of digital, a second camera; with film, a second camera body for different films or to minimize lens changes. This is optional for guests or nonofficial photographers, but essential if you're the only photographer at the event.
- **Lenses.** 28mm f/2.8; 50mm f/1.4; 85mm f/2.5; or 105mm f/2.5.
- **Tripod.** To eliminate camera shake in low-light situations or when shooting with wide apertures and slow shutter speeds.

Another modest system for working faster could look like this:

- **35mm autofocus or manual body.** Second camera body optional; but essential if you're working alone.
- **Lenses.** 38mm f/2.8; 50mm f/1.4 or f/1.8 or other fast prime lens for low light. (The zoom lenses might be too slow for indoor available light settings.)
- **Tripod.** For the same reason as above.

Keep in mind that your selection of lenses should match your artistic vision and give you the opportunity to stretch your way of seeing. Don't be awestruck by someone else's fancy gear, and don't buy an exotic lens just

because you saw a great picture someone else took with it. If you don't have a practical use for a lens, be creative with what you have.

Filters

Some photographers have a half-dozen filters; others work totally without altering the image. You may need to experiment to find out where your heart is. The following is a basic list of filters for illustrative and traditional event photographers who are primarily shooting film. Digital photographers can produce many of these same effects (with the exception of the polarizing filter) through digital image manipulation programs.

- **Soft focus:** Although most brides wear enough makeup to cover their blemishes, their parents don't. They usually appreciate any wrinkle-hiding help they can get from the photographer. Soft-focus filters also reduce contrast; think about using them when shadows are darker than you'd like.
- **Soft edge:** This filter blurs the edges of images and brings the viewer's eye to the center of the picture where the subject is. It's especially useful when you need to remove an object from the edge of a scene but don't want to crop any tighter.
- **Star:** The star filter is a traditional wedding photographer's staple, but it's not as popular as it was twenty years ago. It can be fun for things like the candle-lighting parts of ceremonies. Be sure to rotate the filter so that the lines radiating from the lights don't cut into people's faces. This filter can also muddy the image, so do some shots with and some without so you'll have a choice later.
- **Closeup:** Unless you have a macro lens, you need a closeup filter. The +1, +2, and +3 diopter lenses are weak magnifying glasses that allow you to focus much closer. Use one or two with a long lens (85mm to 105mm) to get the scene-setting shots of small objects. You probably don't need a warming filter (pale yellow to pale pink) if you are shooting black-and-white or color negative film. If you're shooting slide film, choose one with warm tones or use a warming filter.

- **Warming polarizer:** Useful for darkening the sky and removing glare.
- **Color conversion:** If you want to make really good indoor pictures with no flash and you are using color film under incandescent lights, you may need a color conversion filter to balance the film's color. (Check with a photography store to find the right one for your situation.) Without the filter, your indoor pictures will be orange or yellowish, and the bride's dress won't be white. No correction is needed if the indoor light is actually daylight coming through windows and doors. Avoid shooting under fluorescent light—it's too complex to filter without additional equipment.
- **Vignette filter:** Like the soft-edge filter, this filter brings the viewer's eyes to the center of the picture by darkening the edges of the image. It can darken all edges or just the bottom of the shot. There are also vignette filters that lighten edges, which are useful when the background is light, such as shooting against a white backdrop.

Before you start building your filter collection, consider how often you'll actually use them. If you think you might turn into a filter junkie, think about purchasing a filter holder. This handy device fits on the front of your lens. It also serves as a lens shade, but the best thing about it is that you don't have to screw the filters onto the front of the lens. Instead, you drop them into a slot on the holder. You can easily insert a filter, snap the shutter, then pull the filter out and take an identical picture without it. When shooting, you can easily switch filters to create various effects and versions of the same picture.

Flash at Special Events

Unfortunately, flash plus white subjects, such as a wedding gown or wedding cake, can be a miserable combination. The basic problem is caused by the light source (the flash) being too close to the lens. Whether the flash unit is built into the camera or attached to the camera's hot shoe, it causes the on-camera flash look in your pictures. When used as the main light source, on-camera flash causes red-eye, overexposes the foreground or underex-

poses the background, and produces shadow-free lighting. Without shadows, details in white subjects, like wedding gowns and cakes, disappear.

Many cameras and flashes allow adjustments to lower the flash intensity, making it a secondary or supplemental light rather than the main light. The best option is to combine high-speed (ISO 400) film, weak flash, and proper exposure.

Be the hero who always has a safety pin or needle and thread in your bag. To keep you (and the couple) from fainting with hunger, bring a few protein bars. Tape, rubber bands, and ballpoint and or permanent marking pens (for making signs and labeling film cassettes) are easy to carry. Don't forget a screwdriver that fits your gear, extra flash cords, and an extension cord with multiple outlets so if you need power you can share electrical outlets with others.

Indoors, the weak flash with a slow shutter speed (1/15th to 1/60th of a second) allows the room lights to bring out the details and soften flesh tones. Better yet, pivot the flash so that rather than firing straight ahead, the light goes up, sideways, or backwards to bounce off a white wall or ceiling. For shots of objects, ceiling bounce is fine. For photographs with people, bouncing the light off the ceiling can create objectionable shadows under the eyebrows, so bounce off the wall instead.

Digital and Film Choices for Special Events

Events provide so many opportunities for pictures that you will likely take dozens or even hundreds of images. You will probably want prints that you can look through and sort, and unless you have a convenient and cost-effective black-and-white lab, color print film will be your first choice.

Although this advice applies mainly to film photographers, digital shooters should note the information regarding ISO—the tips regarding the different ISO settings apply to digital as well as film photography.

Slow Shooting

Use slow film (ISO 100) if you'll be working in sunny conditions or will be using a flash at close range, such as across the table or in a crowd. A faster film (ISO 400) doubles the effective distance of your flash (compared to ISO 100) and makes it easier to use available indoor light with just a minimum of flash to fill in the shadows. This shooting speed will give more detail when lighting conditions are correct, although it sometimes isn't flattering to some subjects, so consider the circumstances carefully before shooting at this speed.

Fast Shooting

ISO 1600 and ISO 3200 films are very grainy. They should not be used for the whole day, but they work for times and locations where there is no other way to get a picture—where flash would ruin the moment and there isn't much available light.

◄ **FIGURE 18-2**
At events such as this book signing held indoors under fluorescent lighting, the exposure can get very tricky. A tripod would have yielded a sharper image but was not allowed at the event.

Your subjects will primarily be people, so skin tones are important. Film shooters should select professional portrait film in these circumstances. Available at only select photography stores, it has lower contrast and produces better skin tones than consumer film. Don't worry about refrigerating it, as you'll probably use up what you buy. For best results, have it processed within a few days of shooting, and use a lab that's familiar with your film choice.

Taking Pictures People Want

When a family is relying on you to be their photographer, you must be sure to meet their expectations, both stated and implicit. It is absolutely essential that you meet with them beforehand so they can see your work and understand your approach, style, and skills. It is important to bring a professional-looking portfolio with samples of your work representative of your approach and expertise. This is why amateur photographers sometimes volunteer to shoot events for friends and family. While gaining valuable experience and providing a service, you are also building a portfolio that can help you make the leap to the next level.

Discovering Their Expectations

When people think of event photography, they often have very specific expectations. Find out what style they want and what pictures are important to them. If you understand their expectations, you will ensure that at the end of the day everyone is happy with the results. If they are insisting that a certain approach be used, it also helps if they bring examples of the approach to the meeting. The less ambiguity there is, the better.

Meeting Expectations

Everyone has a different expectation when it comes to the sort of pictures they want of their special day. Don't ever assume you know what people want without a detailed conversation about it. They may want to see traditional images, or they may prefer something new, different, and innovative. Before you agree to be their primary photographer, they must be sure

THE EVERYTHING PHOTOGRAPHY BOOK, 2ND EDITION

your style and quality match their expectations. You must be sure that you have the equipment and expertise to properly do the job. Show them your typical work, and in the case of those who would like to see a more innovative approach, show them your experimental and artistic work as well. After this, both you and they will know whether or not your style suits their tastes and standards. This will help you sleep better as you anticipate the big day.

The Agreement Formalized

If you are being compensated for your work, a written document (in other words, a contract) that specifies the terms of the agreement is always a good idea. In it, all the particulars of what they want and your reimbursement and responsibilities should be spelled out. This doesn't have to be a big deal or drawn up by a lawyer, but it must contain what both parties expect from the other and be signed and dated by both sides.

Picture Planning and Handling

Formerly, when film and processing were quite expensive and most wedding albums looked exactly the same, twenty good pictures of the occasion were enough, and that was all anyone expected. But this is a visually sophisticated society, and people expect to see pictures and videos of everything. Brides today see 120–4,000 images of their wedding day. If you start snapping before the bride is dressed and finish as the caterers are putting away the tables, you will go home with hundreds and hundreds of images—perhaps even thousands.

Practicalities of Shooting

Bring a checklist of the shots you have agreed upon with you to the event. Anytime you set up a picture, regardless of its type, plan on taking at least two shots in case someone blinks or moves. Big groups sometimes require four, five, or six shots, sometimes with a change of flash, shutter, bracketing f-stop settings, or changing of focus, just in case. It is always better to get too many than to discover later that you didn't get enough. Film is

cheap and digital shooting is even cheaper; just be sure to have enough battery power, film, and memory cards to cover any contingency.

If film shooters don't want double (or triple) prints from their lab, they can use the extras as duplicates. Digital shooters can simply delete unwanted files before having prints made.

Proof Sheets and Online Proofs

Although the Internet and CDs make it easy to distribute images to friends and family members all over the world, many people want to handle actual prints.

When using film, the first step is getting proof sheets, which are the first set of prints made from the uncut film. You can order double or triple proof prints if you know you'll have many people wanting the same images. Each print must be labeled on the back with a roll and frame number that corresponds to the negatives from that event.

To keep your film in chronological order, time stamp the film cassettes when they come out of your camera, then sequentially number them when you get home. To keep digital files in chronological order, put the date in the name of the folder that is uploaded and saved, such as "6-10-08SmithWedding."

When shooting film, be sure that when the prints come back from the lab, you number them before you edit them or let anyone else get them out of sequence. Try using a three-digit system—101 for the first frame on the first roll, 201 for the first frame on the second roll, and so on. After they're numbered and the negatives are marked to match, you can edit. Make it easy on the family by only showing them the best images. A box of prints is easier to sort and edit than an album of proofs, but the album is easier to browse through, so your choice of presentation will depend on you and your client's preferences.

If you have shot the event digitally, transfer your files to your computer and name the folders with the pertinent information immediately. Burn

two CD copies of the files and put them in a safe place. These backups are essential. Digital photographers usually shoot many more images at events than their film counterparts. You will need to sort through these images and separate and classify them.

On your computer, open the folder or folders you have just uploaded and use an image browser to check through your shots. Within the original folder, create another folder titled "Best" or "Favorites." As you browse your files, keep track of the best shots and then move them into these folders.

You must then consult your list of shots agreed upon before the event. If you find that you are missing a shot because it is not in the "Best" folder, go back to the original file and see if you can salvage one through image manipulation that you had assumed was unusable. Often you can find an image that can be cropped or worked on which will work after all.

Print Requests and Orders

What to do when people who attended an event ask for prints? Your approach on how to handle print requests is going to be contingent upon several factors. If you are being compensated for your time and or materials, you need to set a per print or print package price and clearly explain that you're a professional. If you shot the event as a favor to your host, not charging for a single print or two is probably the gracious thing to do. The exception would be to ask for reimbursement if you are supplying numerous copies, which you have spent a good bit of time and effort on. Even if you are not a professional photographer, it is reasonable to ask for enough reimbursement to cover your expenses. If people ask for copies, keep a written record of each person's request and label the back of the reprints with the correct numbers.

If you shot the event as a gift to the family, giving the negatives or digital files to them will allow them to make their own reprints, saving them money and you time and trouble. But if you keep the negatives or files and make the prints yourself, you can redo any that are poorly made and learn which images are the most popular.

In the case of digital shots, the pictures can be uploaded to an online album at a photo website you created specifically for the event. After the album is created, you can control who is invited to look at the photos, and if you wish, you can let participants order and pay for their own prints. Professional photographers often use sites where the prints can be ordered and they receive a percentage of the purchase price.

Someday My Prints Will Come

Beautiful photographs are created with properly exposed negatives, slides, or digital images, but this is just part of the equation. To make the most of the time and effort you've put into taking those great pictures, you'll need to find someone who can process your film correctly and make prints the way you want them done. You can also carry the creative process through to its completion and do it yourself.

Printing Options Evaluated

If you're just looking for standard prints, sending your shots to local mini-processing labs or online labs is always an option. However, if you're very concerned and particular about the quality of your prints, you may opt either to send them out to a custom lab or explore the option of printing them yourself. The custom labs cost more and are not as convenient as using the minilab inside your local drug store or big-box retailer. Additionally, they will often take a little longer to get your film and prints back, but they might be well worth it.

There are plenty of fast-photo processors and photo minilabs that do a great job with lots and lots of film. Some will do custom work; however, unless they're really set up for it and are serious about maintaining the quality control necessary to deliver it, the chances are pretty good that you won't always be thrilled with the results. Because they're geared more for processing and printing snapshots taken with a variety of cameras and under a variety of conditions, they're rarely completely capable of handling the demands that serious photographers make of their processing labs. Some are, and they're definitely worth seeking out and using.

Finding a Good Lab

Quality film developing very much depends on how well lab personnel maintain their processing chemistry and machines. If a lab has good machinery and good personnel, then it's worth the time to develop a relationship with them. Together, you and the lab can produce the quality images you want. First, however, you have to find that lab.

Here are some ways to do it:

- Check the Yellow Pages listings in your local directory under "photo processing." Labs that specialize in working with professional photographers or offer custom services will say so in their ads.
- Ask other photographers in your area about the labs they use. This can be the best way to find a good lab; most photographers won't stay with a lab that's not up to snuff.
- Talk to someone in a framing shop or two to see if they can recommend a good local lab.

Once you've found a processing lab or two that look like good possibilities, pay them a visit. Ask how often they check the chemicals in their processing equipment. The answer should be once a day—more often is even better. Ask how often they run a test strip of film and measure the results. Without close attention to these details, a lab will produce color negatives that might be harder to print because the color isn't perfect.

Ask what kinds of film they can process. If you're shooting slide film, you want a lab that can handle it. Most slide film is processed using C-41 chemistry; however, chrome film (with the exception of Kodachrome) requires E-6 chemistry, which takes longer and requires more tests per day to make sure it hasn't drifted out of balance. Some shops can handle both; others send their E-6 processing out.

There are two different types of black-and-white film, and they don't go through the same chemicals. If you're shooting true black-and-white, you need a lab that specializes in processing and printing it. Chromogenic black-and-white film goes through the same chemistry and machinery as color film.

Look for obvious problems in film processing. When possible, watch the lab personnel as they work to see how they handle the film. Do they use gloves and hang up the film carefully or do they carelessly drag it across the floor? You definitely don't want scratches and fingerprints on your negatives.

If lab personnel cut the film into strips, make sure they cut carefully between the frames, instead of into the image area of the film. The negatives should be put into transparent or translucent sleeves, one strip (four to six images) per sleeve, so you can see each negative clearly.

Many custom processing labs offer both machine prints (automated) and custom prints, which are printed by hand so that a human operator actually looks at your negative and determines the best way to print them. If your negatives are good, a machine print will be just about as good as a custom print.

The machine operators should inspect every print and remake those that meet their standards. If the inspection or standards aren't good enough, you can't get consistently good color. Look at some sample prints—a good shop will have them on hand. Don't be fooled by sample prints of colorful hot air balloons and beautiful bouquets—it's easy to produce dazzling colors. What you want to see are clean neutral tones, whites that are white with no loss of detail, blacks that are black and not milky or off-color, flesh tones that are believable, and no overall colorcast.

Mail-Order Processing

The big advantage of working with a local lab is that you can talk face to face with the people who handle your film, adjust the machines, and make and inspect your prints. If you're not pleased with a print, you can show them the problem print as well as one you like. You can discuss what went wrong with your print. Was there a problem at the time the picture was taken, or was there a lab error when your film was processed or printed? If the problem is with your camera, lighting, or light meter, ask them what you can do to produce a better negative.

However, not everyone is fortunate enough to have a custom lab nearby. If you don't, you're not necessarily totally out of luck. Plenty of processing labs do custom work for people like you. Do an Internet search and you'll come up with a number of websites for companies that offer custom processing services. There are also websites that index the companies that offer these services.

Doing It Yourself

Many photographers do their own processing and printing. The good news is that doing so gives them complete control over how their images turn out. The bad news is they have no one to blame but themselves if something goes wrong in the process!

Black-and-white film is relatively simple to process, and the setup for it isn't terribly complex or expensive. You don't even need a darkroom; just a sink with hot and cold running water will suit you fine. Unlike the more finicky color film, processing black-and-white film is a snap. It can handle using many different developers, a wide range of temperatures, and between six

and fifteen minutes for the first chemical bath. These variables, in fact, are what change such aspects as contrast, graininess, flesh tones, tonal gradations, dynamic range, and density in the negatives, which means the film processing itself can change the look of a picture before you even see a print.

Don't expect a low-cost lab to have the time and personnel to satisfy you. No matter what a lab charges, if you aren't happy with the prints and you can't work with them, it's no bargain and you'll have to find a new one.

Directing the Printing Process

The responsibility for producing a pleasing print rests with both the photographer and the lab. If there is anything the lab needs to know about the film before they crack open the cartridge and start to work on it—such as the film needing to be pushed or pulled—this is the time to tell the staff. When you have reasonable expectations and communicate using the same language, you and the lab can work together to make everyone happy.

Pro labs usually offer several grades of prints:

- **Machine prints.** This is the most automated process. The printing machine analyzes each frame and adjusts the color to make sure whites are white, blacks are black, and flesh tones are believable. The sophistication of the machines is what primarily determines the quality of the colors. Cropping and color correction will not necessarily be done to your taste.
- **Custom machine printing.** This process, which necessitates more human involvement, offers better color correction and cropping options. If your negatives are good to begin with, custom machine printing should deliver good quality prints.
- **Custom hand printing.** Ideally, you light, compose, and expose so your image is perfect and can be printed nicely without custom processing. If not, custom printing will take problem images and make good prints out of them, or take good images and get great prints.

Choosing Your Paper

Paper for color prints generally comes in two contrasts. Consumer labs use a high-contrast paper because it compensates for the lower-quality lenses in inexpensive cameras. Professional labs use color printing paper with lower contrast, which delivers more pleasing skin tones and works better for images created under the controlled conditions in which professionals shoot.

Paper for both black-and-white and color prints is now available with glossy, satin, or matte finishes. Glossy prints are better for scanning and reproduction because the fine detail is clearer. Matte paper hides fingerprints but has a tiny bit less detail and contrast.

Giving your lab a sample print with color (usually skin tone) that you like is a very good way to establish a good relationship. Tell them what you like about the print. ("Please make my skin tones look like this; I like this color.") Be as specific as possible. Everyone sees different things, so don't assume they can tell what you like. Ideally, give the lab a couple of sample prints reflecting several lighting situations—direct flash, bounce flash, sunlight, window light, shade, or incandescent.

Once you find a lab that makes good prints, don't abandon them if they mess up occasionally. Unexpected color problems may be due to a change in personnel. Many photographers claim that only one employee can print their negatives correctly. When that employee goes on vacation, they hold onto their film until the employee returns.

The Home Darkroom

Black-and-white printing is the next step after film processing. It requires a room that can be made totally dark (except for a special darkroom red light). You also need an enlarger and a counter or tabletop with space for several trays to hold the developing and fixing chemicals. Bessler, Omega,

and Durst make good enlargers, and you can find used enlargers for relatively low prices. eBay is a good source; you can check out the pictures and then do research online for the models listed. A good, clean lens is essential. Having a sink and running water in the darkroom is very helpful but not strictly required; once your prints have been in the fixative they can be brought out of the darkroom to be rinsed.

eBay is a good source for used equipment, but also try classified ads, yard sales, and your local camera shop. Other equipment you will need includes:

- Lightbox
- Filters
- Paper
- Processing tanks
- Scissors
- Timer (preferably a Graflex with numbers that glow in the dark)
- Thermometer
- Trays
- Tongs
- Measuring cups
- Proofing frame or glass
- Burning and dodging tools
- Paper towels
- Squeegee

It is possible to pick up books that discuss the entire process and lead you through it step by step, which is absolutely necessary, particularly if you have never made a print on your own. Color processing is even more involved than black-and-white and takes several more steps. Neither process, however, is usually anything that beginning photographers want to tackle, and detailed information on how to do them is beyond the scope of this book. If you're interested in learning more about processing your own prints, it's a good idea to take a class and have a pro show you how to do it.

Dealing with Processing Problems

Although the majority of images are processed correctly, which means you'll get the type of prints you want, there are times when processing can go horribly wrong, particularly with film.

Film Processing Problems

If your negatives are spotted, stained, scratched, or discolored in some way, there's a good chance they haven't been handled correctly during processing. They could also have been processed using chemicals that were old, incorrectly mixed, or kept at the wrong temperature. Scratches can also be caused by dust or dirt inside the camera. There's really not anything you can do to save negatives with these problems.

If your color negatives turn out under- or overexposed and you believe you exposed them correctly when you shot them, they may have been over- or underdeveloped in the lab. These problems can be corrected to a certain extent during the printing process, but the prints won't be as good as those made with correctly exposed negatives.

Commercial, noncustom black-and-white labs are likely to overdevelop black-and-white film, which increases the contrast and makes light flesh tones pasty. This problem can be corrected during printing by changing paper grades, which will alter the contrast of the image, or by using a variable contrast filter with variable contrast paper. If your images were taken on an overcast day, increasing the contrast will make the blacks blacker and the whites whiter. However, this can distort other shades of gray, such as flesh tones.

Digital Processing Problems

File compression issues, such as files saved at too low a resolution, bad cropping issues, and images rejected because they look so good the lab suspects copyright infringement are the most common problems faced by digital photographers at commercial labs.

▲ **FIGURE 19-1** An online photosite that maintains your albums is a very good option for digital shooters. You can view and print from these uploaded files.

Before uploading a file or sending a CD to a commercial lab, carefully read the technical requirements on the website or at the lab. The technical data for sites may vary slightly, but the science behind the technology pretty much dictates that such things as minimum resolution and sizes are universal. Do read the help section to make sure you fully understand what you need to do.

Improving Your Prints

People are often disappointed when their prints come back from the lab too dark or too light. They blame themselves, the camera, the film, or even the lighting. Sometimes you just need to have the print made again. With

its great latitude, print film is capable of producing good images even with improper exposure.

Try Reprinting

A print whose murky shadows and highlights are too bright can be printed down (made darker with more exposure in the enlarger) to make the blacks truly black and produce more detail in the highlight areas.

If a print comes out especially bad, it's okay to ask your lab to compare the negative with the print. You may need to explain what the lighting was if it's not obvious. If your film has been overheated or stored too long it may be impossible to correct exposure and color problems. The lab may quite correctly state there is no way to get a good print from a particularly bad negative, but they should offer to try.

FACT

You will be happier when you have the breakthrough realization that you can never get 100 percent accurate color in either prints or slides. They produce pleasing and believable color, but it is impossible for every color in real life to be captured and reproduced perfectly.

Whose Fault Is It?

Obviously, if your negatives are exposed incorrectly, it will be hard for the lab to make a good print. If the blacks in your prints look milky and not truly black, your negatives may be too thin. In order to compensate for your mistake, the printer underexposed the paper, which means not enough light hit the emulsion to turn it fully black. The print is either underprinted or underexposed. Sometimes a printer doesn't know if an image is underexposed or if your subject is supposed to be dark. If the blacks in your silhouette are printed gray and milky, show the offending print and negative to your printer and explain what you want. They should reprint it at no charge. A lab that consistently balks at working with you and trying to make things right probably doesn't need your business.

If your negative is overexposed, the lab will correct the exposure when they are printing. There is a price to pay for extreme over- and underexposure: The color and contrast cannot be totally corrected, no matter how good your printer. But if your negative was properly exposed in good light with the right level of contrast, you can expect and demand good color.

Displaying Your Prints

There's more to being a photographer than merely creating great images. If you don't somehow display your work, you haven't completed the communication process—nor have you shared your visions, your emotions, and your feelings. That is a big part of photography, too. Many new photographers are shy about exhibiting or showing their work because they fear criticism and rejection.

Let Yourself Shine

Far too many amateur photographers get their prints back from the photo lab and throw them into a drawer or a box with the intention of doing something with them later. The problem is, later often doesn't come. Because of this, lots of really beautiful images are never seen by anyone other than the people who take them and the people who process them.

Exploring Your Options

Why bother to take pictures if you're not going to use them, especially in this digital age when there are so many opportunities to do so? Rather than being stuffed into a box or an album, they could be made into mouse pads. They can be uploaded to a photo website and put on T-shirts for a fundraiser. You can even do the old-fashioned thing and frame them.

Figure out what you want to do with your best pictures before you even take them. Having a system for handling your images once they're developed will give them a fighting chance of being seen by someone else, and that could be a very nice thing for everyone involved.

Cull the Crop

Rather than keeping all of your prints and negatives or slides, do your-self and your surroundings a favor by going through them and tossing the bad ones as soon as you get them home. Better yet, if you're a digital photog-rapher, don't upload or print a photo that isn't your best.

You might hang on to a couple for later study if you truly think you can learn something from them, but there is no other reason to hang on to bad pictures. If you're not proud enough of your shots to show them to others, dump them.

After you've pitched the bad prints, go through the rest and think about what you'd like to do with them. If there are some you want to do some-thing with right away, such as mounting and framing, pull the image and the negative and put them in a separate envelope or folder. Be sure to indicate what they are and when they were taken. Many photographers lightly write this information on the back of their prints. If you're working with slides, the slide holders are a great place for this. Mark the ones you're not using as well, and put them away in an organized manner.

If you're working with prints, you can buy specially sized boxes or file cabi-nets to hold them. Slides can go into slide sheets or remain in the boxes they came in. Good labeling is essential to the storage process.

If you're working with digital images, go through your folders and decide whether to keep a file. Do this as soon as possible after you have uploaded your files. Marginal shots can be explored later in PhotoShop; sometimes they can be improved. Backups of all good folders should be made as soon

as possible. Options for this include uploading to a reputable online site such as Dotphoto or WebShots, or backing up to a CD or DVD.

Labeling and Storage

Every print, whether it's from a negative or a digital file, should be marked on the back in pen or a fine permanent marker with a catalog number that will allow you to match it up with the original file or negative at some later date. This is a task that should not be put off; do it as soon as the prints are made.

Film and Slide Prints

When you get prints back from the lab, mark the negative sleeves and the negatives with matching roll and frame numbers so you and your family can easily order more prints later. This is especially important when you have taken several pictures of the same subject but only one of them has the right smile or expression in the eyes. Once you have shuffled the prints, it will be very hard to match up a negative to the print. Number them immediately, before you do any editing. Double check, then edit and sort your prints.

◀ **FIGURE 19-2**
One way to organize your digital files is with programs that come with image processing software such as PhotoShop Bridge. It will automatically find photo files and organize them by the parameters you set.

Digital prints can be handled similarly, with a reference to the date it was taken and a keyword. If you make a point of always including the date in the folder containing your shots, such as "2009-06-27SmithWedding," you will find that your folders line up in chronological order on your hard drive and it will be easy to match prints to files.

Store your negatives in normal humidity and temperature ranges. Hot attics and damp basements will ruin film and prints. Do not touch the negatives except by the edges. Do not get the negatives wet, as they will stick together or pick up dust. If they need to be cleaned, let the lab do it. Do not cut out a single negative from a strip of four or six. It is easier for the lab to handle the larger strip.

Going Big

Should you decide you're going to mount and frame some of your images for display on the walls in your home, you'll probably want to get them enlarged to make them more dramatic and easier to see. This is when having a good photofinisher can really pay off. Take your pictures to someone who has the expertise and is willing to take the time to get them right. This photo lab should understand what it means to lighten (dodge) or darken (burn) an image and also know how to adjust color balance on prints.

FACT

Most custom labs will more than likely suggest doing what needs to be done before you have the chance to say a word. Most quick photo places aren't up to the task unless they also do custom work. For great enlargements, find a shop that does.

If you are shooting digital and you have been using an image-processing program for a while, you will by now have developed your own expertise at correcting your photos. In Photoshop, you can dodge and burn, crop, sharpen, and make color corrections. You can even remove extraneous items such as former spouses from your images before enlarging them.

The three factors that impact print size the most are viewing distance, size of the room, and sharpness of the image. In a large room, you will

probably have a greater viewing distance, which allows for bigger enlargements, even from an image that isn't sharp.

The colors in enlargements can be different from those in smaller prints if different filtration systems are used to produce them. If you like the color and contrast in the smaller print bring it along when you order the enlargement and ask the lab to match it.

Although it's always best to crop your images when you're taking them, you can also improve them by cropping them when you enlarge them. Most photofinishing places have cropping masks that you can place on the print (or on a projected image of your slide, if they can do it) that allow you to explore your options until you get the image you like. You can also mark the crops yourself on the picture or the slide mount.

Digital shooters can explore different crops on their images at home before bringing the file to a photo lab. Photoshop and Photoshop Elements, for example, allow you to move the crop marks into any shape you like. The area of the photo to be cropped out is darkened so you can gauge the overall effect the cropping will have.

Remember: never make crop marks directly on a slide. Slides are first-generation images. As such, when they're printed, everything that's on them—from scratches to ink marks—will show up in the final print.

If you are having your pictures custom framed, you might want to wait to do your cropping until you consult with your framer. The framer can either trim the print so the mat fits around it or cut the mat so it crops the print as you wish.

Mounting and Framing

This is something you can do yourself, but it does take some special equipment and a little time to learn how to do well. For these reasons, it's often a good idea to find a frame shop to do it for you. Whether you're doing the job yourself or having someone else do it, make sure your prints are first mounted on mount or backing board. This stabilizes them and keeps them from wrinkling and curling.

To make a very dramatic statement, mount a series of three or four images that work together, such as a child making faces or a series showing a variety of emotions. These can be matted in one frame, with individual windows cut out of the mat for the images.

Many people find it difficult to decide which mats and frames they should use for their pictures. A good rule is to go as simple as possible and choose colors that flatter your images. With black-and-white prints, white mats with white, silver, or black frames are classic choices. Color prints often look best in wood or gold frames, although a colored frame that picks up and emphasizes a color in the print can be effective as well.

Prints can fade when they're displayed in direct sunlight and even artificial light. Color prints, in particular, are very susceptible to fading. Their color layers react differently to light rays, causing color shift over time. Display your color prints away from bright windows or protect them with UV-coated glass.

Also think about how the images are going to be displayed. If they're going to hang as a series, you'll want the mats and frames on all of them to

match. If the picture is going to be the main focal point on a wall, something a bit grander than your basic mat and frame might be in order.

If you are entering your photos in a competition or a photo exhibit, plan to have your work custom framed, usually in a white or neutral mat and with a very minimalistic silver metal frame. Ask about framing requirements for these events, as they vary by institution and region. Sign both the mat and the back of the print. Regardless of what mounting and framing materials you choose, make sure they're of archival quality. This means they're free of any chemicals that could alter the image's appearance over time.

What Comes Next

What kind of photographer are you? What kind of photographer do you want to be? Is it your dream to take pictures for a living someday? Or maybe you just want to know how to take excellent pictures for your own use and aspire to become even better at what you do? There are many ways to become a better photographer. Keeping up with technological advances can help you, but simple practice will go a long way toward improving your skills.

The Future of Photography

The story of photography is an old and fascinating one. The journey from the first crude images captured by primitive box cameras to today's highly sophisticated computerized cameras has been a long one. But the pace of change is now accelerating very rapidly.

Is Film Dead?

There is currently an ongoing debate about the future of film cameras. With the ease of use and rapidly dropping prices of digital cameras, pundits fear there is a real danger that it is only a matter of time until no one uses film and manufacturers stop making it altogether. Let's examine this issue in light of some very real concerns surrounding the use of film versus digital technology. What distinguishes film from digital cameras according to the critics of the new technology?

- Film is verifiable. If the image is altered, it is detectable.
- The image quality of film SLRs exceeds that of digital.
- No computer technology is needed to shoot and share film images.

Digital experts respond that digital technology has made impressive strides to close the distance between film and digital images. There is now a way to make sure the photo you see has not been altered.

Image verification software embeds a digital fingerprint, applied when a picture is taken, into the image file. If even one pixel is altered, the software will detect it and alert the user. For people who need to know that the image they are viewing or printing is unaltered, this is a huge breakthrough.

The image quality of commercial digital cameras has increased dramatically in recent years. Experts now agree that 11 or 12 megapixel SLR digital cameras can actually have image quality higher than their film counterparts; in fact, some are equal to medium format cameras.

Some points in favor of digital cameras are:

1. **Capacity.** A day spent shooting can easily produce thousands of images. If they were shot on film this would mean a lot of storage capacity for the many rolls, plus the film would have to be handled with care. With memory card storage, you can easily store thousands of images in a small pocket.
2. **Ease of use.** With the ability to take many pictures quickly and cheaply, you don't need to be a great photographer to get the shot. Instant feedback allows you to reshoot immediately.
3. **Price.** Memory cards are erasable and can be used repeatedly. There are no film processing fees. Because bad shots don't need to be processed or printed, you save there as well.
4. **Green issues.** The chemicals used to develop film and make prints can be rather toxic to humans and can be difficult to dispose of safely.

Professional photographers, particularly photojournalists, almost all use digital technology. The ability to quickly process and electronically transmit images has dictated this change. Purists and portrait photographers will probably continue to use film for the foreseeable future, but increasing numbers of event photographers are making the switch to digital.

The Future of Digital

Better cameras, falling prices, and improved printing technology will lure more and more people away from film. Cell phones with 5 megapixel cameras built in will become commonplace and reasonably priced. Digital camera sales have already far outstripped film camera sales.

The biggest surprise in the world of image capture is in the area of the camera phone. It's expected that by late 2008 or early 2009, the number of camera phones purchased will exceed the number of both film and digital cameras bought in the entire history of photography. It will probably reach about 1.5 billion units by 2010! This huge base of camera phone users will have an enormous impact on the way people take photographs, as well as what they do with the images they capture. The introduction of the iPhone and similar technologies has boosted the ratio of camera

phone to digital camera sales to a 6 to 1 ratio in 2008. The technology for these phones means it is not unusual to find 5, 6, or even 8 megapixel camera phones. Camera phone features still haven't caught up with the ones found on good quality SLRs and DSLRs, but the technology gap is rapidly closing.

Learning More about Photography

One of the easiest and best ways to improve your photographic skills, of course, is to keep taking pictures—lots of them! But this is only one way to grow in photographic skill. Raising your proficiency also means spending some time studying the process to learn more about techniques as well as the technical side of picture taking. There is always something new to be learned, particularly in the realm of digital photography, and you have plenty of resources at your disposal. You'll find specific suggestions for most of them in Appendix B.

If you don't have an instruction manual for your camera, buy a how-to guide. Even if you do have a manual, how-to guides are often easier to understand than the manuals are, and they'll present information that goes beyond what the manual can offer.

How-To Guides

Ranging from in-depth discussions on specific aspects of photography such as nature to detailed information on using your camera equipment better, how-to guides let you tackle the aspects of photography that interest you the most. Experts in their chosen field write many of these guides, while some are more general guides published by film and camera manufacturers.

Fine-Art Books

Large-format books on photography are great resources for studying the techniques of the masters, and they may inspire you with new ideas for tak-

ing your own shots. There is a wealth of these books available, ranging from the documentary black-and-white images of early photography to the avant-garde techniques that comprise the photography of invention.

Photography Magazines

There's perhaps no better way to keep up to date on what's going on in the world of photography than reading magazines that cover it. If you're looking for new equipment or new techniques, you'll find them here, along with coverage of new technology and anything else pertaining to taking good pictures. Some magazines focus on a specific aspect of taking pictures, such as studio photography; however, most are designed to meet the needs of a general audience.

Websites

Photography is also a popular subject online, although some of the sites deal more with selling equipment than providing tips and techniques. Remember that you should always take what you read online with a grain of salt, unless the site looks and feels somewhat commercial in tone and content. Some of the websites put up by amateur photographers as part of their personal home pages can be pretty opinionated and ego-driven, but many sites now contain great information about the newest equipment and techniques. Of particular interest are photography forums where people discuss their own experiences with cameras or accessories.

Exhibits and Shows

Many museums regularly include photography offerings as part of their exhibit schedules. Some also have standing photography exhibits featuring images that are part of their permanent collections. Here are a few other public places where you'll find photography on display:

- Art galleries
- Restaurants and cafés
- County and state fairs

- Community centers, especially those that offer community education programs
- Libraries and public buildings

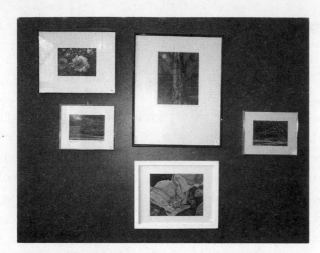

◀ **FIGURE 20-1**
The opportunity to show your work is one you should never pass up. Commercial establishments, restaurants, and coffee shops are often open to letting local artists hang their work, as long as it looks professional.

Taking Classes

Every photographer, regardless of status or experience level, can benefit from taking classes and master workshops. Some might offer a rehash of what you already know, while others will open up new worlds to you. Sometimes it will seem that you have very far to go, but a week later you may find yourself solving a problem with a technique that you wouldn't have known about if you hadn't taken the class.

If you're thinking about pursuing a career in photography, you may want to attend an accredited photography school or a college or university that grants degrees in photography. Some art institutes and museums also offer degree programs.

Investing time in learning can be fun and challenging. You'll be exposed to techniques, philosophies, aesthetics, and business practices. You'll meet people who have the same camera, the same problems, and the same

enthusiasm that you do. Whether you attend a hands-on workshop, a week of lectures and field trips, or an evening slide show, you will enrich your photographic world.

Photography classes are regularly offered as part of college or university extension courses, adult education, local art associations, and community education programs. Other sponsors include local photography clubs, stores, and even equipment manufacturers. Aim for at least one class or workshop a year, and fit in more if you can afford the time and money.

Joining a Club

Just about every city or town has at least one photography club. Even if you're not much of a joiner, these clubs are great ways to learn more about camera techniques and equipment from other photographers. They can also be a good way to get your work shown, as many of them sponsor exhibits and competitions on a regular basis.

Selling Your Work

You don't have to be a professional photographer to sell your work. There are plenty of ways to do so and plenty of places looking for good images taken by good amateur photographers. Here are just a few:

- Greeting card companies
- Stock image companies
- Newspapers and magazines
- Your friends and neighbors

If you love taking pictures, you definitely can do something you love and make a little money at it as well.

The Greeting Card Market

The greeting card industry generates $7 billion in sales each year, and there seems to be a trend toward the e-greeting market and younger customers. There are close to 200 greeting card companies in the United States,

although three companies—Hallmark, American Greetings, and Blue Mountain Arts—dominate the market. Large chain stores may only carry products by one or two of the largest companies. To research the market thoroughly, visit other card outlets, such as gift shops, florists, stationery stores, small bookstores, and other retailers that carry cards by the smaller card companies. Look for a publisher that sells images that are similar to yours. When you find a company that matches, get their address or website and determine their submission guidelines. These will tell you exactly what they're looking for and how they will accept submissions. Don't send any pictures until you get this information.

QUESTION?

Should I call a greeting card company to see what they think of my pictures?
In a word: no. It can take a month or longer for someone to review your pictures, especially if it's a small company. It is far more professional to wait until they contact you.

Don't send the same photographs to another company until you have received a response from the first company. Having the same photograph on cards published by different companies is an unhappy experience for all parties involved.

If your photographs contain recognizable faces, you'll need a model release before you can sell them to a card company. The publisher may expect you to supply a signed release or they may have their own release. If subjects are shown from the back or in profile, they may not be recognizable, but it's still a good idea to get a release just in case.

Every publisher has its own fee structure. Some offer royalties, which means you get paid every time your image is used. Others offer flat fees—a one-time payment that allows them to use your image as many times as they wish without paying you anything further. A royalty agreement is definitely better than a one-time fee if your image becomes a best seller, but the one-time fee will net you more money in the short run.

Stock Image Companies

These companies buy images from photographers and make them available to buyers such as designers and art directors looking for specific pictures. Stock images are classics like flowers, children, pretty landscapes, and so on. As is the case with greeting card publishers, you'll need to get submission guidelines from the companies you think might be interested in your images. Again, don't submit anything until you get these guidelines, and follow them exactly when you do. These companies get queries from thousands of photographers, and your chances of getting your images seen will be much better if you submit your work according to their guidelines.

Online stock photography companies have experienced an extraordinary growth spurt in recent years and are worth a look as potential markets. Simply typing "stock photography" into a search engine will call up literally hundreds—if not thousands—of sites. Be careful to thoroughly check out any site and read their terms of service before uploading any of your images. You want to retain the rights to your photos and be reimbursed for your services. It pays to shop around for the best deals.

The pay scale for stock image companies is similar to that of greeting card companies. A royalty agreement might make you more money in the long run, but a flat fee will put money in your pocket faster.

Newspapers and Magazines

Newspapers and magazines are always on the lookout for good images. Film photographers should take note that publications currently favor the submission of digital images. If you're a film photographer, it might be helpful for you to keep a portfolio of your best images in scanned form ready for submission to potential clients. If you scan your images at 300 dpi, they will meet most publishers' requirements. Be sure to check the publication's website when submitting samples via e-mail. Most ask to see a low-resolution image first and then will ask for one at full 300dpi resolution should they decide they are interested in your work and want to publish it.

If you have a website with an album of your photos, you can send a link to it with any queries to editors. This puts you several steps ahead of those with a less professional presentation.

Your best "in" with magazines and newspapers is knowing someone on staff, but it's also possible to break into these markets if you don't. Get submission guidelines from any publication you're interested in working with. These are usually available on the publication's website.

▲ **FIGURE 20-2** An attractive, eye-catching website that prospective clients can visit says a lot about your commitment to your craft. Here's my website with various albums that I update regularly.

Your Friends and Neighbors

Many amateur photographers are a little nervous about approaching people they know and offering their services for a fee; however, doing just that has launched many a professional photographer's career. People always need pictures, and they are willing to pay for them because of their emotional attachment to the subject, their love of the image, or because they need them for one reason or another. If your skills are good, they'll happily pay you for them.

How to Price Your Work

Many beginning photographers are pleased to get their costs covered as payment. It is exciting to make a sale just for doing something that you love, but you really need to charge for your skills, time, and materials, as well as for the value of the work itself. Unfortunately, there is no one-price-fits-all in the world of photography. Learning how to price your work is similar to learning how to create your work: You start out as a beginner and learn by making mistakes. One way to find out the going rate is to make calls to other photographers and ask what they charge for their services. You can also get a sense of the market by checking the websites of local photographers.

If you sell your work, be very clear about the rights you're giving up and how much you'll be paid for them. There are a number of different rights you can sell; stipulating what they are and how much you'll be paid for them will help prevent legal battles in the future. The rights to your creative work are precious commodities. Never take them lightly.

Going Pro

If your dream is to become a part-time or full-time photographer, running a photography business out of your home or studio is a goal you can achieve. As a business, photography has a relatively low barrier to entry. You've already made the investment in the basic equipment, which is usually a big

part of the startup cost for any business. With a small additional investment of a few hundred dollars a month—and a substantially larger investment in taking the time to further hone your skills and learn the business—you could provide services and products that people want if you charge a fee that can support a part-time or full-time business.

Learning the Ropes

One time-proven way of getting into the photography business is by assisting an established photographer. Even graduates from the best photography schools are often advised to start their career working with an experienced photographer. Among other things, such as seeing the realities of a photographer's life in a day-to-day setting, assisting will let you see if the profession feels right to you. The skills and experience you gain could be invaluable.

Photography is a life-long pursuit. It will grow with you, lead you places, and take you where you want to go. Regardless of where your future lies with photography, there's a lifetime of shooting pleasure ahead of you.

Try to work with a photographer whose work you admire, who makes a good living at it—your chances of being successful are greater if you do. Being a great photographer does not guarantee financial success, and of course there are many mediocre photographers who have thriving businesses. If you take advice from a photographer whose images aren't the best and who does not have a successful business, you will obviously be putting roadblocks in your own path to success.

Networking with Professionals

Every photographer benefits from networking with other photographers. From a professional's point of view, an amateur today might be a colleague tomorrow. Even a professional has something to learn from a beginner. Of

course, the reverse is also true; spending time with a professional in your field is a great way to learn new techniques, business concepts, the latest technology, and the history behind current trends and business practices.

You can join a professional organization, such as an affiliate of the Professional Photographers of America or American Society of Media Photographers. Their monthly meetings feature professionals who share their experiences as well as their unique approach to the business. You can also take a less formal approach. Form a group of four to ten photographers in your area who have a similar specialty. From them, you will learn about the photography market in your area, including accepted business practices, which vendors and customers to avoid, and what equipment works best. If you have an idea of the going rate for products and services, you can see if your pricing structure is appropriate for your unique work, quality, and services.

Always remember the context in which advice is given. Useful advice early in your career may have to be rethought or eventually discarded in order for you to learn more and advance in your field. As you progress, remember that true education consists not only of gaining new knowledge, but of knowing when it is time to discard the old rules you have moved beyond. Keep growing and keep challenging yourself!

APPENDIX A

Glossary

accessory flash unit
a flash unit not built into the camera

accessory lens
a lens that attaches to the front of a camera lens

adjustable focus lens
a lens that can be focused at different distances

ambient light
light that doesn't come from your flash; also called existing light and available light

angle of view
the area that a lens can capture; also called field of view

aperture
the opening that allows light to pass through the lens

APS
the abbreviation for Advanced Photo System

artificial light
light from sources other than the sun

ASA
the abbreviation for American Standards Association, one of two film rating systems replaced by the ISO film speed system

background light
light behind the subject used to separate the subject from the background

backlighting
putting the main source of illumination behind the subject, shining toward the camera

bellows
a flexible accordion-like device used in closeup photography to increase the distance from the lens to the film

bounce flash
a lighting technique in which the flash is bounced off a reflective surface adjacent to the subject

bounce lighting
a lighting technique in which the main source of illumination is reflected off a wall or ceiling instead of being aimed directly at the subject

bracketing
shooting one or two more exposures on either side of the correct exposure using a half or full stop less and more for the exposure

built-in flash
a flash unit built into the camera

cable release
a flexible cable that screws into the shutter release, used to prevent camera movement

camera movement
any movement of the camera that causes images to blur; also called camera shake

catchlight
a small light in the eyes of a portrait subject created by reflection from a light source

center-weighted metering
exposure metering that puts more emphasis on objects in the center of the viewfinder

changing bag
a light-tight bag used for opening a camera in daylight

chromogenic film
black-and-white film that can be processed using conventional color print

circular polarizer
a polarizing filter designed for use on automatic cameras

closeup
a picture taken with the camera close to the subject

color negative film
color film that produces a negative image; also called color print film

color slide film
color film that produces direct-positive transparencies; also called color reversal or color positive film

compact camera
a small, 35mm camera with automatic features; also called point-and-shoot camera

composition
the arrangement of the elements in a picture

continuous advance
a shooting mode that allows pictures to be taken for as long as the shutter release button is depressed

contrast
the range of brightness in a subject

contrast filters
lens filters used with black-and-white film to lighten or darken certain colors

conversion filter
lens filters that allow film balanced for one type of light to be used with other light

cropping
removing unwanted parts of a picture

cross lighting
lighting a subject from opposite sides

daylight film
film that's color balanced for use in daylight and flash situations

definition
the clarity of detail in a negative or print

density
the relative darkness of a negative or print

depth of field
the area of a photo that is in sharp focus

diffused lighting
nondirectional lighting that illuminates objects uniformly; also called soft lighting

digital photography
photography in which the image is stored in light sensors rather than on film

DIN
the abbreviation for Deutsche Industrie Norm, the European film rating system superseded by the ISO system

diopter
the term used to indicate the strength or magnification power of a closeup lens

directional lighting
direct lighting from a concentrated source

Dutch tilt
a technique in which the camera is rotated about the lens axis

emulsion
the light-sensitive coating on film

existing light
see **ambient light**

exposure
the amount of light captured on film; controlled by lens openings and shutter speeds

exposure latitude
a measure of a film's ability to produce acceptable images shot with various exposures

exposure lock
a device that holds the exposure setting until the shutter is released

exposure meter
a handheld or built-in device that reads the intensity of light falling on or reflected by a subject

extension rings
rigid metal or plastic tubes or rings that are inserted between the lens and the camera body to increase focal length for closeup photography; also called extension tubes

fast film
see **high-speed film**

fast lens
a lens with a large maximum opening

field of view
see **angle of view**

fill light
light used to enhance or augment the main illumination source to brighten dark areas in a picture

film cartridge
a light-tight container that holds film before and after it's exposed

film leader
the narrow strip of film extending from the film cassette used to attach the film to a camera's takeup spool or mechanism

film plane
the flat field on which the film captures the image

film speed
measurement of a film's sensitivity to light; see **ISO**

filter
a piece of colored or coated glass or plastic that alters the light reaching the film

filter factor
a number indicating how much exposure needs to be increased when using filters

fish-eye lens
an extreme wide-angle lens that produces circular images

fixed focal-length lens
a lens with only one focal length that can't be adjusted

fixed focus lens
a lens with nonadjustable focus

flash
a brief, intense source of artificial light

flash bracket
a fitting used to attach a flash unit to a camera

flash range
the minimum and maximum distances that a flash will cover

flash synchronization
controls that synchronize shutter movement and flash illumination

focal length
the distance from the optical center of a lens to the point behind the lens where light rays focus to create an image

focus
process of adjusting a lens so images are sharply defined

focusing frame
a set of brackets or circle on a viewfinder that determines the area covered by an autofocusing system

front/flat lighting
lighting adjusted so the main source of illumination falls on front of the subject

f-stop
the aperture setting on a lens used to control the amount of light that enters it

full stop
a change in the lens opening from one f-stop to the next number

graduated filter
a lens filter that gradually changes from clear to colored

grain
the sandy or pebble-like appearance found on some negatives, slides, or prints

gray card
gray-colored cardboard used to make exposure readings

half-stop
a lens opening between two f-stops

high-speed film
film that is very sensitive to light

hot shoe
the slot with electrical contacts on top of a camera where a flash mounts

image processing program
any software that allows the manipulation of a digital image to correct common photographic problems

image stabilization technology
a computerized means of reducing image shake and blur

incident light meter
an exposure meter that reads the light falling on a subject

infrared film
film that records infrared radiation

ISO number
a film rating system set by the International Standards Organization that indicates how sensitive film is to light

keystoning
image distortion caused by tilting a camera or projector upward

lens axis
the imaginary line that runs from the middle of the film through the middle of the lens

lens hood
a metal, rubber, or plastic shade that shields the lens from direct light

light balancing filter
a lens filter used to balance the color of a light source with the color the film registers

light leak
a gap or defect in light proofing (in camera, film cassette, or darkroom) that allows stray light to strike the film, or the resulting defect on the processed film

light meter
see **exposure meter**

long lens
a lens with a focal length greater than a normal lens

loupe
a magnifier used for looking closely at negatives and prints

macro lens
a lens that allows close lens-to-subject focusing for closeup photography

manual exposure
an exposure set manually by the photographer

maximum lens aperture
the widest opening (f-stop) of a lens

medium-speed film
film that is more sensitive to the light than slow film and less sensitive than fast film

memory card or stick
storage medium for digital cameras that can be reused repeatedly

neutral density filter
a transparent piece of glass or plastic that cuts down the light entering the lens without changing its color

normal lens
a lens that produces an image similar in perspective to what the human eye sees

off-camera flash
a flash unit not mounted on a camera

online gallery
places on the Internet where digital photos can be uploaded into albums and then printed

overexposure
too much light reaching the film

panchromatic film
black-and-white film that is sensitive to all colors of light

panning
following action in the camera's viewfinder

parallax error
a framing problem common in cameras with viewfinders that see subjects at a different angle than the camera lens does

perspective
how objects appear relative to their distance and position

PhotoShop and PhotoShop Elements
image processing programs from adobe that create an environment in which digital images can be color corrected, cropped, and retouched

point-and-shoot
a camera that has a fixed lens that does not show the subject directly from the viewfinder but by a series of mirrors that carry the image to the viewer

point of focus
the specific spot at which a camera lens is focused

polarizing filter
a lens filter used to eliminate glare and reflections

power points
points created by the intersection of lines that divide an image area into thirds horizontally and vertically

prime lens
a lens with a single focal length

pull processing
developing film for less time than usual

push processing
developing film for a longer time than usual

red-eye
the effect caused when flash illuminates the retina

red-eye reduction
a camera feature that reduces red-eye with a preflash or a steady beam of light before the actual flash

reflected light meter
an exposure meter that reads the light reflected by the subject

resolution
the amount of detail in a digital or film image

ring light
a flash unit used for closeup photography that encircles a camera lens

rule of thirds
a compositional concept that divides the image area into thirds

saturated color
color that is rich and uncontaminated

selective focus
bringing the viewers attention to a subject by using shallow depth of field

shutter
the device that regulates the amount of time that light reaches the film

shutter speed
the length of time that light exposes the film

side lighting
illumination aimed at the side of the subject and roughly perpendicular to the lens axis

single lens reflex camera
a camera with a viewfinder that shows subjects through the same lens used to record images; commonly called an SLR camera or just SLR

slave flash
a flash unit used to supplement light from a main flash

slow film
film that is less sensitive to light than medium or fast film

spot metering
an exposure mode that reads only a small area designated by a circle in the middle of the viewfinder

stop
see **f-stop**

telephoto lens
a lens with a longer focal length than a normal or wide-angle lens

through-the-lens metering
a metering system that reads the light coming through the camera lens; commonly referred to by the abbreviation TTL

top lighting
lighting coming from above the subject

tungsten light
light produced by an artificial light source such as a light bulb or a halogen lamp

ultraviolet filter
a lens filter used to diminish the amount of ultraviolet light reaching the film; also called haze filter or skylight filter

underexposure
the result of not enough light reaching the film

vanishing point
the point at which parallel lines appear to converge in the distance

vignetting
a darkening of the corners of a picture, either accidentally or intentionally

wide-angle lens
a lens with a shorter focal length than a normal or telephoto lens

zoom lens
a lens with multiple focal lengths designed to bring far objects closer

APPENDIX B

Additional Resources

Magazines

Aperture
www.aperture.org

Digital Photographer
www.digiphotomag.com

Nature Photographer
www.naturephotographermag.com

Outdoor Photographer
www.outdoorphotographer.com

PHOTO Techniques
www.phototechmag.com

Popular Photography
www.popphoto.com

Shutterbug
www.shutterbug.com

Websites

www.kodak.com

Kodak's commercial site is full of information on Kodak products, of course, but it also has a great guide to photography.

www.photographytips.com

This information-rich site will tell you everything you want to know about virtually every facet of photography, from equipment choices to shooting techniques.

www.photo.net

This online photographers' community offers discussion forums, information, and articles for the rank beginner to the seasoned pro, classified ads, and opportunities for posting photos for review.

www.photographyreview.com

This site features equipment reviews and price comparisons, although with limited educational content.

www.shortcourses.com

A site with helpful links to many good film/digital photography websites for new and experienced users.

www.fotophile.com

All things photographic. A site with galleries, reviews, forums, links, and a bookstore.

Books

Allen, J.J. *Posing and Lighting Techniques for Studio Portrait Photography*. (Amherst Media: 2000). If you're interested in doing studio portrait work, this book will tell you how you can do it by using available and affordable equipment. Also covered are lighting setup and poses.

Angel, Heather. *Flowers*. (Morgan & Morgan: 1976).

Arndt, David Neil. *How to Shoot and Sell Sports Photography*. (Amherst Media: 1999).

Baker, Robert. *The New Ansel Adams Photography Series*. (New York Graphic Society: 1981). Composed of three books—The Camera, The Negative, and The Print. Introduces you to Adams's techniques and is renowned as containing some of the best and most accessible writing on the technical aspects of photography.

Burian, Peter K. *National Geographic Photography Field Guide: Secrets to Making Great Pictures*. (National Geographic Society: 1999). This guide covers the essentials of photography in the field including composition, equipment, and techniques.

Carucci, John. *Capturing the Night with Your Camera: How to Take Great Photographs After Dark*. (Amphoto: 1995).

Hicks, Roger. *Travel Photography: How to Research, Produce and Sell Great Travel Pictures.* (Focal Press: 1998).

Nichols, Ron. *How to Take Great Pet Pictures: Recipes for Outstanding Results with Any Camera*. (Amherst Media: 2001).

Peterson, Bryan. *Understanding Exposure: How to Shoot Great Photographs*. (Amphoto: 1990).

Shaw, John. *John Shaw's Landscape Photography*. (Amphoto: 1994). Shaw is a master of this genre. Any of his books are well worth reading; this one presents more how-to-do-it information than some of the others.

Wolfe, Art. *The Art of Photographing Nature*. (Crown Publishers: 1993). This is one of the classics on nature photography written by a legendary nature photographer.

Lilley, Edward R. *The Business of Studio Photography: How to Start and Run a Successful Photography Studio*. (Watson-Guptill: 2002).

Oberrecht, Kenn. *How to Start a Home-Based Photography Business*. (Globe Pequot: 2002).

Photos That Sell: The Art of Successful Freelance Photography. (Watson-Guptill: 2001).

Poehner, Donna, ed. *2008 Photographer's Market*. (Writer's Digest Books: 2008). Published annually, this guide contains thousands of up-to-date market listings, including magazines, stock agencies, advertising agencies, newspapers, and more.

Willins, Michael. *The Photographer's Market Guide to Photo Submission and Portfolio Formats*. (Writer's Digest Books: 1997).

Other Photography-Related Books

ASMP Professional Business Practices in Photography. (American Society of Media Publishers: 2008).

Engh, Rohn. *Sell and Resell Your Photos: Learn How to Sell Your Pictures Worldwide*. (Writer's Digest Books: 2003).

Evening, Martin. *The Photoshop CS2 Book for Digital Photographers*. (Focal Press: 2005). An impressive collection of techniques in Photoshop that can greatly improve digital-image management.

Heller, Dan. *Profitable Photography in Digital Age: Strategies for Success*. (Allworth Press: 2005).

Heron, Michael. *ASMP Stock Photography Handbook*. (American Society of Media Publishers: 1990).

Heron, Michael and David MacTavish. *Pricing Photography: The Complete Guide to Assignment & Stock Prices*. (Allworth: 2002).

Index